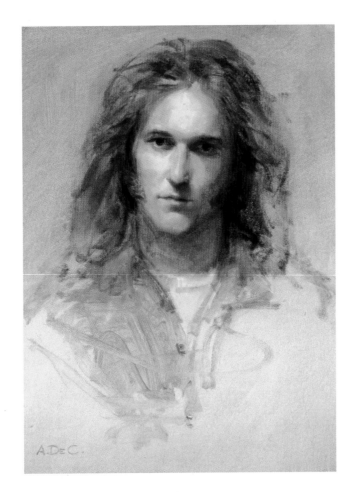

Alla Prima

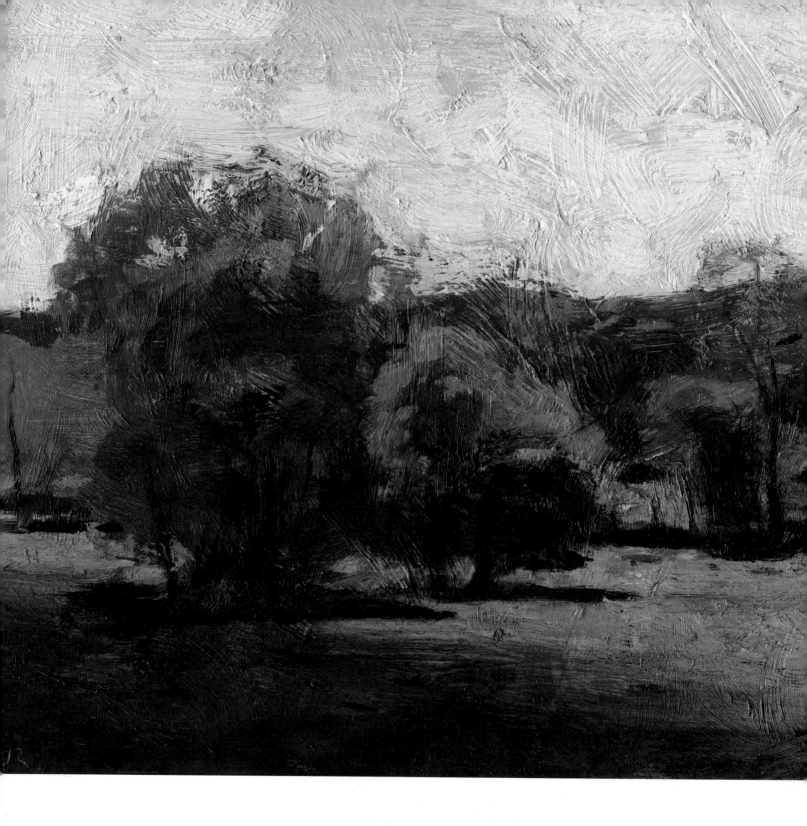

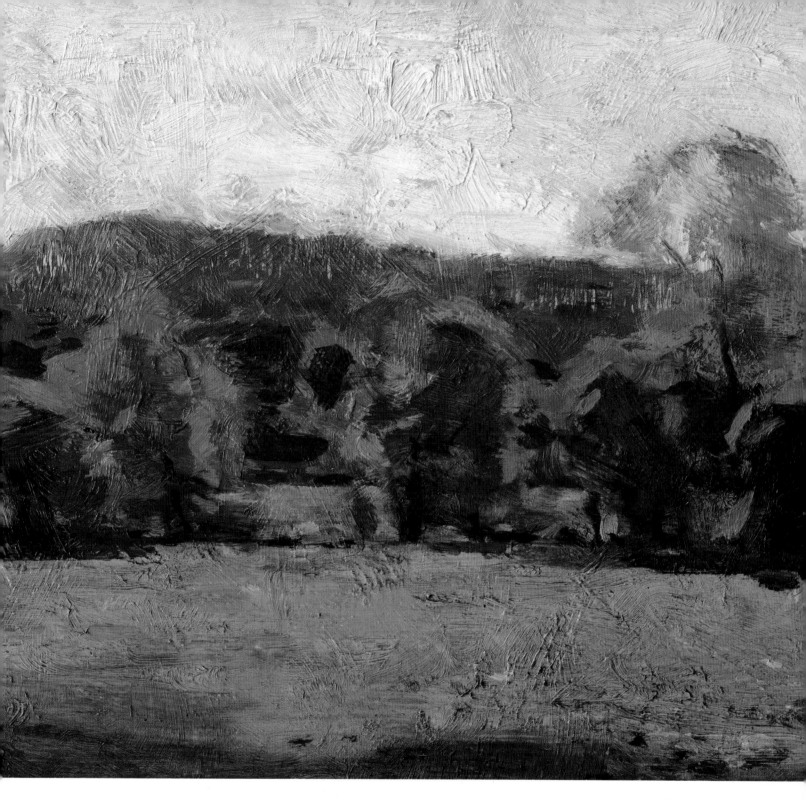

Alla Prima

A Contemporary Guide to Traditional Direct Painting

Al Gury

WATSON-GUPTILL PUBLICATIONS | NEW YORK

PAGE 1: Arthur DeCosta, *Portrait of a Young Man*, c. 1970, gessoed watercolor paper mounted on panel, 24 x 18 inches (60.9 x 45.7 cm). Courtesy of the Pennsylvania Academy of the Fine Arts, Philadelphia. School collection

PAGES 2–3: Jon Redmond, *Landscape*, c. 1990, oil on canvas, 10 x 10 inches (25.4 x 25.4 cm). Courtesy of the artist

PAGE 5: Al Gury, *Peonies*, 2007, oil on panel, 12 x 9 inches (30.4 x 22.8 cm). Collection of the artist

PAGE 6: Al Gury, *Birches at Twilight*, 2007, oil on panel, 12 x 9 inches (30.4 x 22.8 cm). Private collection

PAGE 22: Al Gury, *Riverbank*, 2007, oil on panel, 8 x 10 inches (20.3 x 25.4 cm). Private collection

PAGE 34: Al Gury, *Summer Light*, 2006, oil on panel, 8 x 10 inches (20.3 x 25.4 cm). Private collection

PAGE 66: Al Gury, *Red Dawn*, 2006, oil on panel, 11 x 14 inches (27.9 x 35.5 cm). Private collection

PAGE 114: Al Gury, *Deep Woods*, 2007, oil on panel, 11 x 14 inches (27.9 x 35.5 cm). Private collection

Executive Editor: Candace Raney
Senior Development Editors: Marian Appellof and Alisa Palazzo

Art Director: Timothy Hsu
Designer: Christopher Cannon, Eric Baker Design Associates, Inc.
Production Director: Alyn Evans
Unless otherwise noted, all photography by Peter Groesbeck

Published in the United States by Watson-Guptill Publications
an imprint of the Crown Publishing Group
a division of Random House, Inc., New York
www.crownpublishing.com
www.watsonguptill.com

Library of Congress Cataloging-in-Publication Data

Gury, Al.
 Alla prima : a contemporary guide to traditional direct painting / Al Gury.
 p. cm.
 Includes bibliographical references and index.
 ISBN-13: 978-0-8230-9834-7 (hardcover)
 ISBN-10: 0-8230-9834-6 (hardcover)
 1. Painting—Technique. I. Title.
 ND1500.G87 2008
 751—dc22

 2008025029

ISBN 978-0-8230-9834-7

Printed in Singapore

10 9 8 7 6 5 4 3 2 1

First Edition

A Note on Health and Safety

Taking appropriate care to preserve one's health and safety while painting is extremely important. All the methods and procedures described in this book should be used in a safe manner. Proper ventilation, cleanliness, and minimal exposure of materials to skin should be striven for at all times.

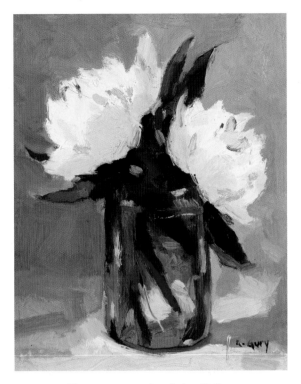

To my parents and to Arthur DeCosta

ACKNOWLEDGMENTS

The information in this book has been inherited and accumulated through the generosity of many former teachers, mentors, and friends. The teaching traditions of the Pennsylvania Academy of the Fine Arts have provided a tremendous legacy of experience and wisdom. Much was passed down from teacher to student for generations and filtered through my own experiences as a teacher and painter. This lineage most recently included Arthur DeCosta and Louis Sloan, both mentors during my student days and after.

Dr. Miriam Kotzin has been an invaluable writing coach and guide, and my assistant Brian Boutwell has done an excellent job of keeping documents and requests organized.

Thanks also to Pennsylvania Academy's rights and reproductions manager Barbara Katus and museum registrar Gale Rawson for providing images for this book and answering my many questions with patience and humor.

Peter Groesbeck is a consummate master of the art of photography. His steady attention to detail and quality illuminates large sections of this book. It wouldn't have been possible without him.

Behind the scenes, James Lynes, friend and former student, checked my inaccurate sentence structures and helped to clarify concepts. He understands the core of this project and uses many of its concepts in his own beautiful painting.

My good friend Bob Byrd, the great children's book illustrator, was a wonderful source of moral support and professional experience. Thanks also to models Logan Blanco and M. Johnson.

Finally, thanks to Steve Doherty at *American Artist* magazine for his support and encouragement, and to Candace Raney at Watson-Guptill for her guidance and patience.

Many friends, students, and family members have supported me in this endeavor, and I am grateful to them.

Al Gury

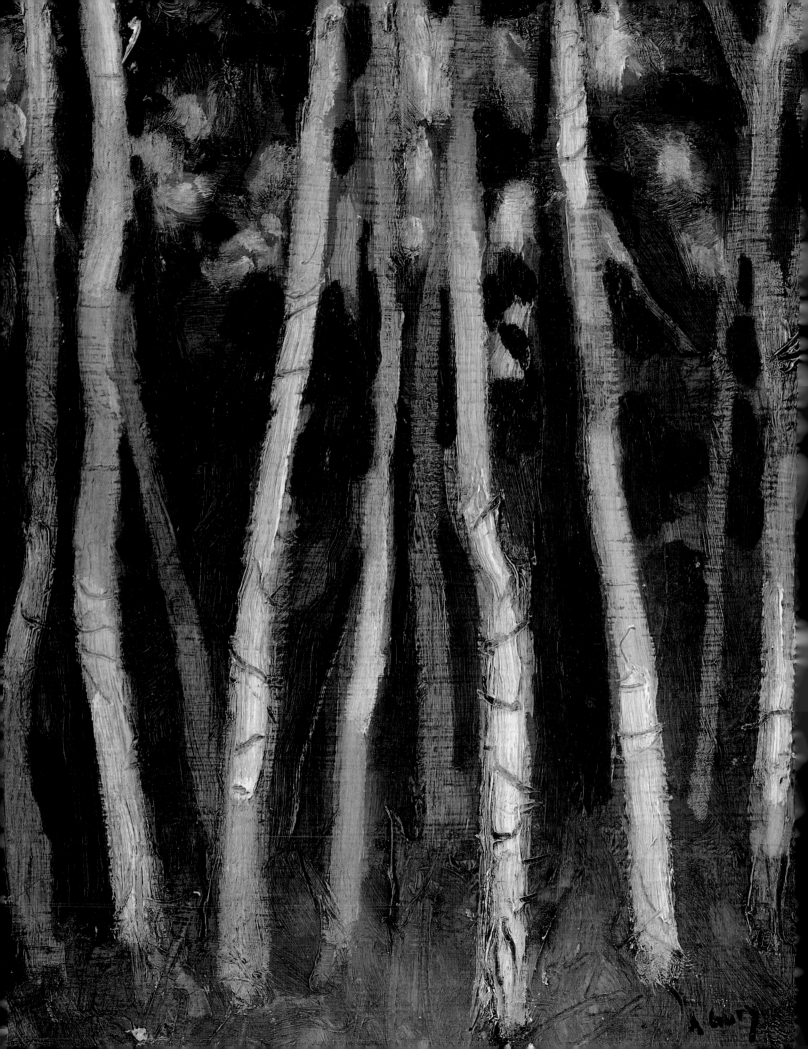

Contents

FOREWORD

Alla prima painting appeals to painters of many different styles and techniques. The term, in the strictest sense, refers to making paintings "at the first go," or in one session. It is such an instinctive and natural way of painting that some artists use it as their only method. But it is the foundation for all painting methods that do not rely on elaborate underpaintings or layering (as well as many that do) and instead aim to create an expressive effect directly and immediately.

Alla prima painting requires a very skillful manipulation of the tools and mediums of paint. Done well, it results in a miraculous sense of completion, order, and finish, with a minimum of time and advance planning. Instinct and training are more important than exactitude and predetermined execution. Suggestion, rather than detail, is used as a part of the expressive effect. The artist responds directly and instinctively, and works with a great deal of improvisation. An alla prima painting, or sketch, often consists of a single continuous layer of paint, usually applied opaquely without the use of glazes, scumbling, or other layering effects—though the finished works of many alla prima masters do exhibit these methods. It often has areas of the ground left unpainted or showing though the painted areas. Preparatory sketches are used sparingly or not at all; underpainting or compositional underlayment is minimal. Colors are mixed opaquely on the palette and on the canvas in direct response to impulse and observation. Mistakes are wiped out or painted over.

Because the classic goal of an alla prima painting is to achieve a final look in one session, it requires a careful selection of materials and tools and a working procedure that will allow improvisation and spontaneity. Alla prima paintings are often small, measuring just a few inches, though much larger works are common. The surface of the support, whether canvas or panel, is chosen to allow a finished appearance with only one layer of paint and is likely to be incorporated as part of the overall work; so, it is often oil primed, toned, and minimally textured. Brushes and mediums reflect the requirements for speed and versatility. Pointed sable brushes; long, soft brushes called riggers; or even the handle end of a paintbrush allow the creation of line and detail. Stiff, hog-bristle brushes and small, flexible sable brushes let the artist push and drag the paint for a variety of spontaneous effects, while the painting knife makes it possible to create careful edges and delineations of tone. Oil painting mediums, such as linseed oil, permit the artist to vary the thickness and opacity of the paint and allow the ground to selectively show through the final layer of paint in order to increase the hue and value range.

The ideal medium for alla prima painting is oil paint because it has a slow drying rate, mixes easily, and can be used with mediums to modify its natural viscosity, all of which make it possible to create textures, densities, edges, and subtle transitions of tone and color unmatchable in any other type of paint. It permits the artist to work wet into wet, thin to opaque, dark to light, and in full to low saturation in the effort to achieve a final expression in a single session of work. Oil paint exists in an almost limitless spectrum of colors, from the purest full-saturation hues to the subtlest neutrals, allowing the artist to create a broad range of values, from shining darks to nearly perfect whites.

As a manner of and approach to painting, alla prima has had a long and illustrious history, with its own pantheon of accomplished masters. The practice originated as a part of traditional techniques that involved elaborate preparatory drawings, underpaintings, and many other stages of development and planning meant to lead to a finished work. In the studios and workshops of the Renaissance and Baroque painters, alla prima paintings were thought of as sketches in preparation for larger, more elaborate "complete" paintings. They were done to size up compositional ideas, develop overall tonal structures, and try out coloristic ideas; artists such as Rembrandt and Peter Paul Rubens routinely completed small, improvisational paintings intended as sketches for larger compositions or as guides to workshop assistants, who used them as references in preparing final works. They tended to be small and less finished than larger pieces and, as such, were of particular interest to other artists who liked to have an inside view of the master's working process.

At a later stage in history, the alla prima approach came to be associated with landscape and figure paintings done from life. The alla prima landscape sketches of John Constable, J.M.W. Turner, Eugène Delacroix, and other artists of the Romantic period came to be valued as a special form of painting all their own. Constable's alla prima oil sketches on paper, Delacroix's small paintings of models, and Camille Corot's masterly Italian land-scapes became as valued as the elaborate and much larger studio paintings shown in the great salons. Alla prima became the core technique for many portrait painters, from Frans Hals in the seventeenth century to John Singer Sargent in the nineteenth and early twentieth. In art school life classes of the nineteenth century, students learned direct alla prima painting by capturing the model each day in one session, with previous layers of paint being scraped or wiped down. This approach, which involved drawing in paint directly on the canvas and mixing tints and tones on a large, handheld palette, was the primary method Édouard Manet, Sargent, and James McNeill Whistler employed for their portrait paintings.

Many of the great early Modernists, including Henri Matisse and Giorgio Morandi, also used alla prima painting extensively. The emphasis on freedom, spontaneity, and improvisation that are the hallmarks of this approach became identified with some of Modernism's experimental goals. The early Impressionists made their great revolution with paintings done alla prima, and the direct, sometimes visceral methods of alla prima painting were the foundation for the gestural and instinctual works of Robert Motherwell, Jackson Pollock, and the other Abstract Expressionists. The modern ideal of the painter as being free to develop a personal and extemporaneous style, working gesturally with oil paint on a clean, fresh canvas, is one that we today take for granted. But it would have been surprising to any Renaissance painter, who was used to working with drawings and a planned underpainting. Our contemporary approach to painting is one that encourages experimentation and an individual touch, and one that finds its most imme-diate manifestation in the techniques and expressive possibilities of alla prima painting.

<div align="right">

JEFFREY CARR
Dean of Academic Affairs,
Pennsylvania Academy of the Fine Arts
November 30, 2007

</div>

INTRODUCTION

There is a theory that artists gravitate toward methods and materials that suit their personalities best. Also, if they are lucky, they find the techniques that help them state most clearly the ideas and aesthetics that are in their hearts and minds. Alla prima painting has represented at least half the personalities of painting in the Western world since the Greeks.

As a student I was enamored of the work of the early Renaissance painters and the portraits of Jean-Auguste-Dominique Ingres. These elegant layered paintings appealed to my intellect. When teachers introduced me to the vigorous work of Velázquez, Rubens, and Manet, I felt as if my mind and heart were united in a methodology that I could grow with as an artist.

My definition of alla prima is expanded in this book to include the varieties of painters and approaches that make up the idea of direct or painterly painting. Alla prima painting is often defined as a work done quickly in one session, painted "wet into wet"—that is, without waiting for the lower layers to dry before the finishing or top layers are applied. This definition is correct in its present meaning; however, in practice, alla prima, or direct, painters have always used a richer and broader set of methods to accomplish their goals. This book is designed to help the student and artist better understand the basics of these methods in their history, variety, and nuance.

One tradition of teaching suggests that when lessons are clearly laid out with goals in mind, a student learns quickly. Structured education and the accumulation of knowledge will free a person to explore his or her own creative hopes with a solid grounding to stand on. This tradition is followed at the Pennsylvania Academy of the Fine Arts. This book is meant to be seen as a series of lessons that can be taken as a whole or in part; it is also to be used as a general studio manual for the student and the practicing artist. The historical information and references provided will be valuable to students of art history, gallerygoers, and the general reader who is interested in art. Not least, the reproductions throughout the book represent this essentially flexible painting method in its gloriously wide variety.

Arthur DeCosta and Alla Prima Painting

An individual teacher can have an enormous influence on how the traditions of painting are preserved, taught, and understood by students. Arthur DeCosta (1921–2004) helped me find my own voice, both as an educator and as a painter. As his grateful former student, I hope to transmit what I learned from him and what I have added from my own experience.

Arthur DeCosta taught painting and drawing at the Pennsylvania Academy of the Fine Arts in Philadelphia for more than twenty-five years, from the 1960s to the 1980s. His classes in life painting, color theory, and cast drawing were settings for elegantly executed demonstrations and lectures on alla prima painting and classical drawing methods.

DeCosta entered the Pennsylvania Academy as a student after World War II following his military service in Europe, where he had been exposed to the great collections of English, Italian, and Dutch paintings. During a very exciting time to be an art student in America, DeCosta studied with the great Pennsylvania Impressionist landscape

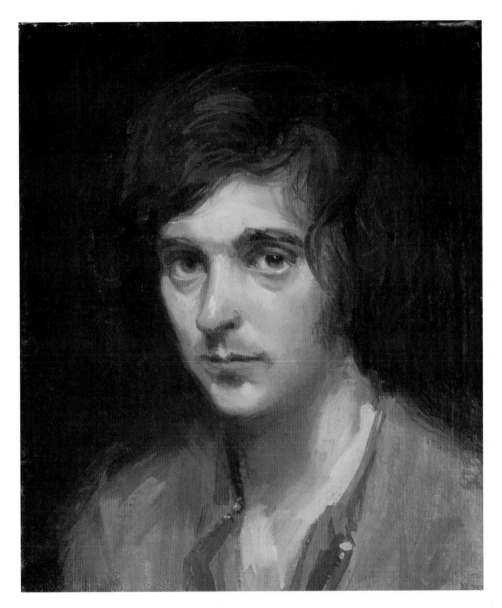

Arthur DeCosta, *Portrait of a Young Man,* c. 1970, oil on canvas mounted on panel, 10 x 8 inches (25.4 x 20.3 cm). Courtesy of the Pennsylvania Academy of the Fine Arts, Philadelphia. School collection

painter Daniel Garber (1880–1958) and utilized the Academy's famous painting collections to scrutinize the techniques and styles he had admired overseas.

The 1950s and '60s in America demanded that young painters develop an original voice. While many were finding direction in the language of Abstract Expressionism and the theories of Clement Greenberg, DeCosta followed a different and very controversial path. Modernist dictates suggested that an artist's work should be an authentic, personal, and self-determined journey. Arthur DeCosta embarked on just that by following his love of the human figure and simple still life objects done in a direct painterly manner. His muses were such painters as Italian Renaissance artists Titian and Guercino, and British and American portrait painters Henry Raeburn (1756–1823) and Thomas Sully (1783–1872).

The subtle and complex problems of how light affects form and color became lifelong sources of study and inspiration for DeCosta, as they had been for his early role models and his teachers at the Academy, like Garber.

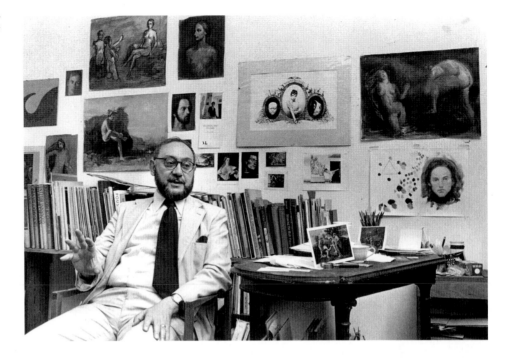

Romantic by temperament and precise by nature, DeCosta combined a scholarly study of methods, theories, and materials with a wholly personal exploration of figure compositions, still lifes, and portraits. The heroic world of American art after World War II and its theories and battles became a crucible in which DeCosta formed and clarified his aesthetic sense and a body of work that spoke of an individual following his heart's path.

By the 1970s DeCosta emerged as a painter of elegance, subtlety, and skill, and as a highly respected teacher and mentor for great numbers of painters appearing on the horizon. His works of this period show an intimacy—a directness of contact—with his subjects as well as with the aesthetic and theoretical concerns of atmospheric and illusionistic alla prima painting. A small-scale painting of a rose in a water glass exhibited all the traits of his passionate devotion to observation, the organizing elements of method and theory, and the intense focus of a lover on a beloved subject. Portraits of friends and students have the formal elegance of early Flemish portraits and the sensuality of the Italians. During this time, DeCosta produced a large body of work that exemplified his thoughts and passions about painting and clarified his pedagogical approaches in the historic setting of the Pennsylvania Academy of the Fine Arts.

His studio at the school, which was open to students, was filled with his works in progress and demonstrations of painting techniques and color palettes. Students were warmly welcomed in to ask questions or just look at the materials. The only time the studio was off-limits was when DeCosta was painting.

DeCosta became a role model not only as a painter but also as an educator who took the proactive transmission of the artist's craft very seriously. In the classroom, he was well known for clear and exciting demonstrations of painting concepts and methods, as well as for his entertaining and informative practice of giving running commentaries—while painting—of what and why he was doing what he was doing. Stories of famous artists and anecdotes from their lives enlivened the already stunning presentations of

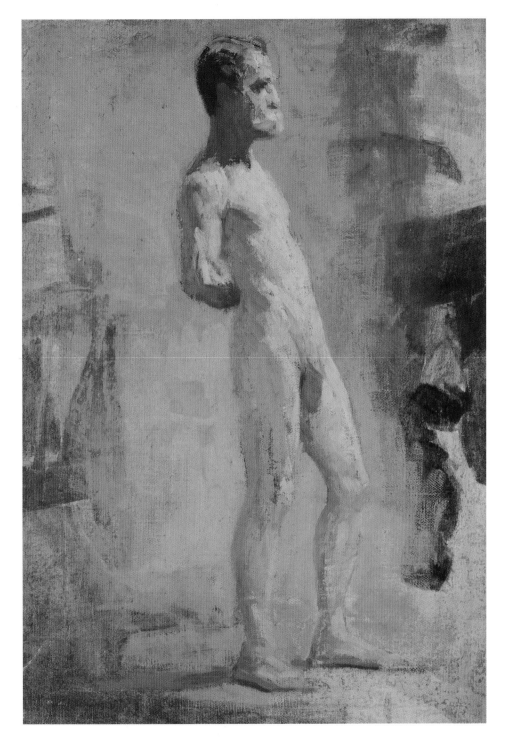

Thomas P. Anshutz, *Study of Model*, oil on canvas, 19¹⁵⁄₁₆ x 13¹³⁄₁₆ inches (50.6 x 35.1 cm). Courtesy of the Pennsylvania Academy of the Fine Arts, Philadelphia. Gift of Mrs. Edward R. Anshutz

craft. A whistled Mozart melody would sometimes fill in periods of concentration and gaps in the commentary.

DeCosta had an audience among both the representational painters and the abstract and experimental artists. The connecting factor among the diverse personal directions his students took was the Academy's tradition of classical training and DeCosta's emphasis on solid grounding in information, observation, and seriousness of intent.

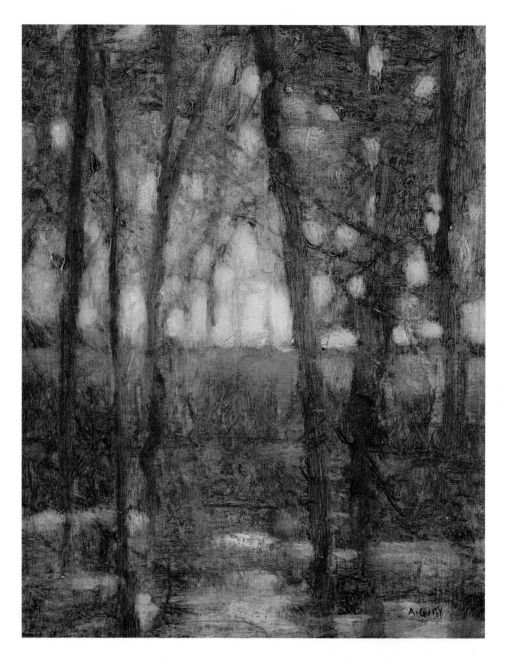

Unlike some artists, Arthur DeCosta did not jealously guard his in-depth explorations of the history of painting and drawing methods. Rather, he saw himself as a transmitter of knowledge to new generations. His membership in the "lineage" of the Pennsylvania Academy was clear. His teacher Daniel Garber was a student of Thomas Anshutz (1851–1912), who was a student of Thomas Eakins (1844–1916). Eakins was descended on the one hand from Thomas Sully and Charles Willson Peale (1741–1827) in America and from Jean-Léon Gérôme (1824–1904) and the Renaissance academies on the other. DeCosta's students follow in that lineage.

In the 1980s and '90s, DeCosta's focus was more and more on the intimacy and simple strength of figure compositions. One, two, or three figures would be combined to create a visual tension of shape, color, light, and form. Inspired by Titian and Veronese, elegant

and beautiful compositions emerged. The psychological tension and subdued sexuality between a male and female figure reached a height of clarity in these late works. A superficial glance might see and dismiss the figures as merely classical. A keen observer, however, will find subtleties that speak of intense relationships and suggested passions between the figures. The combination of sensuality and intellect characterizes not only the compositions but also the painter.

Alla prima painting was a central concern of Arthur DeCosta's painting and teaching. It is both a core approach to understanding form, drawing, light, and color, and an important aesthetic direction in historical and modern painting. The materials, methods, and concepts contained in this book exemplify the legacy of Arthur DeCosta and his career as an artist. The traditions of alla prima painting are as inclusive, dynamic, and forward-thinking as were the insights, teachings, and contributions of Arthur DeCosta. These continue today in the Academy School, where a vigorous history is linked with an exciting future.

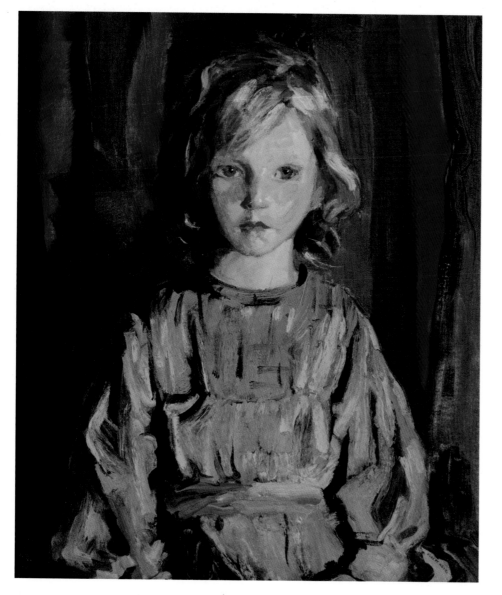

Robert Henri, *Wee Maureen*, 1926, oil on canvas, 24 x 20 inches (60.9 x 50.8 cm). Courtesy of the Pennsylvania Academy of the Fine Arts, Philadelphia. Gift of Mrs. Herbert Cameron Morris

HISTORICAL PERSPECTIVE:
A BRIEF OVERVIEW OF DIRECT PAINTING

by K. Malcolm Richards

The story goes something like this: During the first half of the nineteenth century, a young group of artists including Jean-Baptiste-Camille Corot, Théodore Rousseau, and Charles-François Daubigny began working directly from nature in the open air (*en plein air*, in French). Becoming known as the Barbizon school (after the region where they worked and resided), these artists served as mentors and exemplars to subsequent generations of artists, including the Realists, Impressionists, and Postimpressionists. In the countryside of Fontainebleau, away from the cultural hub of Paris, these landscape painters set a precedent for working not only "outside" but also outside the Académie des Beaux-Arts system. Under this system, students trained in the ateliers of academy members to prepare for the competitions (such as the esteemed Prix de Rome) that were part of the curriculum of the École des Beaux-Arts. The school was administered by the academy, making its teachings the standard. The next step on the road to artistic success—indeed, an artist's career largely depended on it—was showing in the Salon, a biannual (at times, annual) juried exhibition held by the academy and the most prestigious event in Western art. The jury was populated with members of the French Academy and their associates, making the academy a powerful and, at times, authoritarian institution that enforced strict limits on what was acceptable to be shown in the Salon. The Barbizon school demonstrated that artists could work outside the academic system, inspiring the likes of Jean-François Millet, Gustave Courbet, Édouard Manet, Claude Monet, and others to break free from its strictures. And so, Modernism is born.

The turn to direct painting is also frequently explained in relation to technological changes in Europe during the early nineteenth century. The development of a portable ("French") easel and premixed paints in tubes facilitated the artist's mobility, as did the nascent rail system. Corot, Rousseau, Daubigny, and the other artists of Barbizon could rely on the railroad to bring them to their urban patrons. These patrons were an emerging class, the bourgeoisie, who were enjoying the opportunities presented by an age of industrial growth. The fruits of industrialization, however, also bore the *fleur du mal* that would distance the urban bourgeoisie from their experience of nature, feeding a growing sense of alienation within the modern world. The paintings of the Barbizon school offered a nostalgic reminder of a mythic "elsewhere," a place where life was simpler than in the city and where one could have direct access to nature.

Other accounts might call direct painting a response to the development of photography. With its objective verisimilitude, photography is often presented as one of the factors leading to the demise of traditional academic art. In the age of Jean-Auguste-Dominique Ingres and his students, French academic art was noted for meticulous mimetic idealism rooted in the forms of the classical past. The ease with which photography could give a record of the world posed a challenge to the labor-intensive achievements of the academic Salon painters. In response to the "objective" realism of photography, artists working outside the bounds of the academy offered a "subjective" response to the world by directly recording their eyes' sensation through painterly strokes, an "instantaneous"

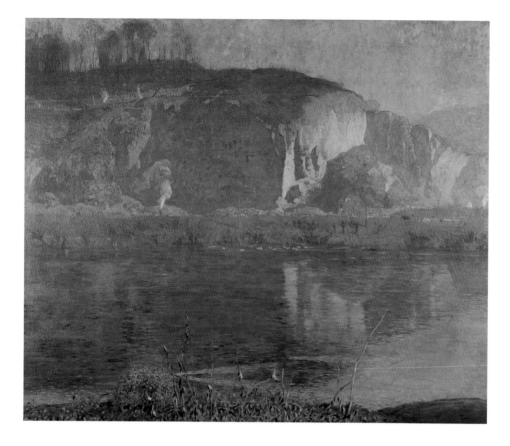

Daniel Garber, *Quarry*, 1917, oil on canvas, 50 x 60 inches (127 x 152.4 cm). Courtesy of the Pennsylvania Academy of the Fine Arts, Philadelphia. Joseph E. Temple Fund

moment. Through the direct application of paint, the subjective experience of the immediate impressions made on the artist's eye is recorded, presenting a humanized view of the world that potentially challenges the limits to the technological eye of the camera. The apotheosis of this phenomenon is the work of Monet, who was, as described by Paul Cézanne, "only an eye, but what an eye."

Photography was also related to another important nineteenth-century phenomenon of early modern visual culture: the diorama. Louis Daguerre, who announced his photographic process to the public in 1839, began his career as a painter of dioramas, an early form of immersive entertainment utilizing canvases that were stretched on specially designed frames and housed in circular buildings created solely for the display of these paintings. The audience for the diorama was situated at the center of this interior and the canvas was slowly turned, giving the effect of spatial movement and, through lighting, the effect of temporal movement. Dioramas could depict exotic lands or historic battles and were a popular success. For the German philosopher-critic Walter Benjamin (1892–1940), the diorama was one of the defining characteristics marking Paris as the capital of the nineteenth century; it also prefigured the rise of cinema in the twentieth century. The powerful visual experience provided by the diorama led the painter Jacques-Louis David to tell his students that if they wanted to study nature, they should go to the arcades (a progenitor of the shopping mall) and paint the landscapes presented in the dioramas.

David's exhortation to his students reveals something about the distance from nature in Neoclassical aesthetics and the challenge that painting directly from nature posed to

academic doctrine. Direct painting, as practiced by the Barbizon school, responds to academic Neoclassicism by asserting a direct relation to nature, echoing some of the ideals espoused in the philosophy of Jean-Jacques Rousseau. Rousseau made an appeal to "primitive" man, an ideal state of human existence before civilization. He called for a "return to nature" in order to rid the self of the corrupting fumes of the modern world. Implicitly a critique of institutions, Rousseau's thought has often been related to the Barbizon school and its members' artistic descendants as sharing an affirmation of the subjective self in the face of industrial progress. In questioning technological advancement, direct painters of the nineteenth century addressed not only challenges facing art but also the human condition within a world marked by ever more prevalent means of mediated interrelation. But that's the usual story. More or less.

At the Margins of Art History

What is often left out of the usual story are some important details concerning the "rebellious" nature of direct painting. First and foremost, direct painting was not a technique developed outside the official art institutions of the nineteenth century but was part of the very academic process taught in the ateliers of the time. Whether under the Italian rubric *alla prima* or the French term *premier coup*, direct painting was a studio practice used in training prospective students for the École des Beaux-Arts. Most of the Barbizon artists (as well as the Realists and Impressionists) were affiliated with an academic atelier at some point in their course of study, during which they would likely have been exposed to the practice of direct painting. For instance, during summer breaks, students were expected to continue honing their craft, and instructors encouraged them to paint landscapes *en plein air*, the technique later associated with the Impressionists and the Barbizon school. The academic training many of these artists were rebelling against provided them with the very tools for this rebellion.

Second, the canonical story of direct painting in the nineteenth century rarely discusses the aesthetic issues at stake. According to the standards of the French Academy, only works possessing a high level of finish were considered worthy of exhibition. Developing the fetishized "licked" surfaces treasured in the Salon paintings of such artists as Léon Gérôme, William Bouguereau, and Charles Gleyre (literally, his surfaces have a glare) took time, requiring a laborious process of thin glazes. The high finish of these works testified to a standard of craft enforced by the members of the Academy (who also happened to be its chief practitioners). While direct painting was part of academic practice proper and could serve to explore pictorial concepts, it was not thought proper to display works executed in such a manner. Many critics began to question this ideal of finish, as they felt that with some artists the finished works often killed, or "finished," the vitality of the initial study. A growing number of critics began to champion the fresh energy of the *premier coup*. In artists such as Delacroix, the Barbizon artists, and Realists such as Courbet, Honoré Daumier, and Millet, critics found proponents of an alternative aesthetic that challenged the prescribed academic standard. Such aesthetic issues became the subject of many newspaper cartoons of the time, depicting the battle between the "Ancients" and the "Moderns."

Third, the aesthetic debates of the nineteenth century were often marked intimately by political undercurrents. At times this led to odd alliances, such as the privately

temporal permanence within a world of decay. However, photographs and paintings decay, as do the bodies that use the tools to make them. On one level, most works of art reveal that nothing is permanent, even in a culture of the seemingly infinite archive promised by digital technology. In the end, direct painting and blogging merely represent two extreme attempts to re-present the instant, all bound to the premise of the instant, an instant bound to time and place, as well as bound to conventions resting on precarious experiential ground. Even in the newest instantiations of the instant, nothing that appears appears permanent.

Direct painting also offers a tradition that passes through the work of Cézanne, an artist who helps bring the nineteenth century to a close while opening up the history of twentieth-century art. The questions addressed by Cézanne's use of direct painting continue to be mined and mimed, if even on occasion maimed. Beyond the artistic visions and versions of Cézanne lurks another view: that of the French philosopher Maurice Merleau-Ponty (1908–1961), in whose essay "Cézanne's Doubt" the artist serves as a protophenomenologist. Here, Cézanne's practice of directly representing visual sensation without regard to familiar forms offers a model of Merleau-Ponty's own philosophical project of trying to describe the experience of sensual phenomena at a primordial level of existence. Cézanne's visual explorations become a means of trying to access the phenomenological world directly, an ideal driving Merleau-Ponty's theoretical questions. At the same time, Cézanne testifies to one of the problems facing direct painting—namely, the tradition of painting: "Today our sight is a little weary, burdened by the memory of a thousand images . . . We no longer see nature; we see pictures over and over again."[3]

To begin to paint directly, according to Cézanne, one has to forget all the representations that mediate our perception of nature, a nature that is always defined in relation to human nature. Today, in a culture mediated by the screens of real-time technology, our acts of direct perception become all the more tenuous and rare.

Beyond these philosophical considerations, Cézanne raised the question of whether it is possible to represent the world directly in painting. In direct painting, there is an attempt to break free from the directives of one's artistic predecessors, removing the burden of tradition while at the same time trying to continue on with a tradition worth carrying as a burden. In turning to direct painting, artists such as Cézanne found a way of liberating themselves from the onus of pictorial conventions. Today, in a culture inundated by mediated images, direct painting still attempts to tackle head-on the fundamental questions all forms of representation face even in a world growing ever more distant from direct experience. How do we represent the world, how does how we represent the world convey our experience, and how direct is any form of artistic representation? These are merely a few of the questions that continue to be posed by the tradition of direct painting.

Notes

1. Friedrich Nietzsche, *Human, All Too Human: A Book for Free Spirits*, trans. R. J. Hollingdale (Cambridge, UK: Cambridge University Press, 1986), 150.
2. Monet to Gustave Geffroy, June 22, 1890, in Steven Z. Levine, *Claude Monet* (New York: Rizzoli, 1994), 5.
3. Quoted in Malcolm Andrews, *Landscape and Western Art* (Oxford, UK: Oxford University Press, 1999), 177.

the Ashcan School, and other traditions that continue to flourish in American academies today. For instance, in the region of Pont-Aven, artists such as Robert Henri, Edward Redfield, Henry Ossawa Tanner, and Cecilia Beaux rubbed shoulders with Paul Gauguin, Émile Bernard, and the Nabis. Americans such as Theodore Robinson, John Twatchman, John Leslie Breck, and Willard Leroy Metcalf brushed up against Monet at Giverny, imbibing from the French master's reflecting pools for their own acts of artistic experimentation with direct painting. As Eakins passed on the tradition of the French Academy, these Americans passed on the European traditions of direct painting that continue to thrive today.

Being Direct in the Twenty-first Century

While no longer possessing the political significance it did in nineteenth-century France, direct painting is still relevant in the hypertechnological milieu of the twenty-first century. Historically interpreted as a response to the emergence of industrialization, direct painting remains a viable approach to the world, yielding unique handmade objects that bear witness to particular moments in time and space and defy the dominance of the mass-produced. Direct painting poses enduring questions concerning the way we as humans represent nature. In art, we are not presented with nature itself but with a nature represented through human eyes. Nietzsche offers a powerful assessment of our vested interest in representations of nature: "Nature, if we subtract our subjectivity, is a matter of great indifference, most uninteresting, neither the mysterious original ground, nor the enigma of the world disclosed; [. . .] the more we dehumanize nature, the emptier and more meaningless it becomes for us. - Art is based entirely on humanized nature, on nature enveloped in and interwoven with errors and illusions which no art can disregard."[1]

At one level, direct painting represents a continuation of a nineteenth-century tradition, but at the same time, it addresses questions central to artistic explorations in photography, video, and a wealth of other new media. In part, these questions surround the possibility or impossibility of adequately representing a particular moment in space and time. The premise of the "Kodak moment" is that of capturing the "instant." Today the Kodak moment has given way to YouTube and MySpace, representing the latest attempts to archive the present instantaneously. The idea of capturing the instant, a promise made by photography and film, underpins an aspect of art that has been and continues to be explored through direct painting techniques. For Monet, attempting to capture the moment became the obscure object of painterly desire exposing the limits to any static representation: "I have taken up things impossible to do: water with grass that undulates in the depths, it is admirable to see, but it is enough to drive one mad to wish to do it."[2]

Monet's moment was partially a construct built around the premise of direct painting. While marketed as being the instantaneous records of Monet's encounter with nature, his works (after being initiated outdoors) were carefully worked in the studio to attain the appearance of instantaneity. The idea of a painting as the record of an artist's immediate subjective experience may even be seen permeating the rhetoric of nonrepresentational art. For example, the drips of Jackson Pollock frequently have been discussed as directly recording the actions of his physical self, an archive preserving a trace of the artist's presence. These captured moments, these creative artifacts, become bearers of

conservative Delacroix's association with Republican values during the 1830 French Revolution, with which his painting *Liberty Leading the People* (1830) is historically linked. During the events of the 1848 revolution, Delacroix appeared embarrassed by his association with that of 1830 and the politics of the left. Likewise, Millet, an artist closely tied to the direct painters of the Barbizon school and an occasional practitioner, too, found himself encamped in the 1850s with more politically radical artists such as Courbet and Daumier. Direct painting, in not conforming to the academic sense of finish, became perceived as a politically radical aesthetic choice, one intended to subvert institutional values. While the association of politics and aesthetics is represented canonically through the opposition of Delacroix and Ingres, linking direct painters with a potentially revolutionary political stance was not a far leap for many critics of the era. However, the political implications of direct painting differed from region to region and historical period to historical period, something that is occluded in most introductory discussions of the topic.

Fourth, the canonical introduction to direct painting, which presents it as a French phenomenon, also precludes a deeper engagement with its origins. Direct painters of early nineteenth-century France were responding to a tradition being followed in contemporary England. In the more eclectic Royal Academy of London, artists such as John Constable, J.M.W. Turner, and John Robert Cozens put into practice a heritage of naturalism utilizing techniques of direct painting to explore landscape painting. As with the Barbizon School, English naturalism can be seen as a reaction, in part, to the advent of industrialization, whose effects were first felt in England during the eighteenth century. The British tradition of naturalism was also a response to its own indigenous Romanticism, as witnessed in the work of William Wordsworth. French painters such as Courbet and Manet drew upon Dutch painters of the seventeenth century who used techniques of direct painting to achieve a greater naturalism in their work. Dutch genre painters such as Frans Hals provided historical alternatives for artists seeking to reject Italianate classicism. Interestingly, Dutch naturalists were responding, at one level, to a dramatic period of historical change in the seventeenth century: the birth of a new republic. The wealth of the Dutch Republic was rooted in international commerce, leading to its emergence as the financial center of Europe in the seventeenth century. In such a climate, an art market arose, fueled by the prosperous merchant class that supported the direct painters of the time. While Dutch genre painters offered direct painting alternatives for nineteenth-century French artists working in the shadow of the Academy, sixteenth-century Italian artists such as Caravaggio used direct painting techniques in the shadow of the Renaissance. Even during the time of Leonardo, Michelangelo, and Raphael, artists such as Hieronymus Bosch used alla prima techniques. The roots of direct painting are myriad. No single story line can fully explain the traditions of direct painting.

Fifth, as a result, most accounts omit the presence of Americans within the traditions of direct painting in England and France. The American roots of direct painting, however, find soil in some of the rich French terrain covered cursorily in the canonical survey texts. While Thomas Eakins (along with James Whistler, John Singer Sargent, Mary Cassatt, and Winslow Homer, the most visible Americans in the survey books) may have sided with Gérôme in his aesthetic ideals, plenty of other Americans found opportunities to cultivate the seeds that would give rise to the phenomena of American Impressionism,

Basic Materials

Understanding the materials in one's
toolbox is essential. By knowing
what they are supposed to do and
then practicing with them with
specific goals in mind, a painter will
quickly become comfortable with
the use of a wide variety of basic
materials. In this chapter I briefly
discuss the essentials: oil paints,
the implements used to apply them,
mediums and thinners, various
types of palettes, and the supports
and grounds to which the paints
are applied.

OIL PAINTS

Oil paints have evolved in a confusing variety of manufacturers, recipes, and quality levels. Most fall into two major categories: professional grade and student grade. Professional-grade paints suggest higher pigment density, finer grinding, and more paint for the money, while student grades suggest economy in the amount of pigment used relative to filler and in the general manufacturing process and cost to the artist.

Students often ask if there is one brand or grade that is the best; the answer, in my experience, is no. Many different kinds are useful and need to be explored before one can make a real decision. My own paint box and those of several of my colleagues contain numerous brands and grades of oil paints based on personal taste and cost. Most painters I know use paints made by a variety of manufacturers, selected according to what each color does and how it works with each artist's palette and aesthetic goals.

There is a wide variation among colors that go by the same common name but are made by different manufacturers. For example, burnt sienna made by one company will be very reddish and transparent, while another manufacturer's burnt sienna will be a duller brownish red and less transparent. In summary, choose tube colors based on their properties, economic value, and your aesthetic goals.

Basic painting materials. From foreground to background: painting knives, paintbrushes in an array of shapes (flats, brights, rounds, and filberts), tubes of oil paint, and, from left to right, stand oil, linseed oil, resin medium, thinner, a brush washer, and a palette cup.

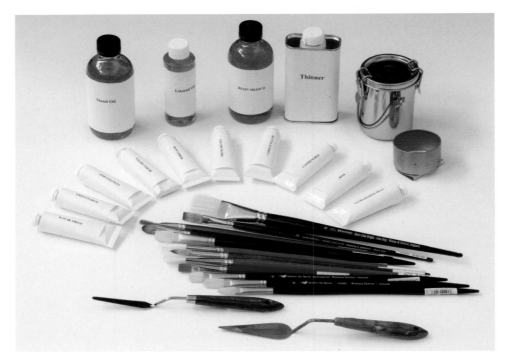

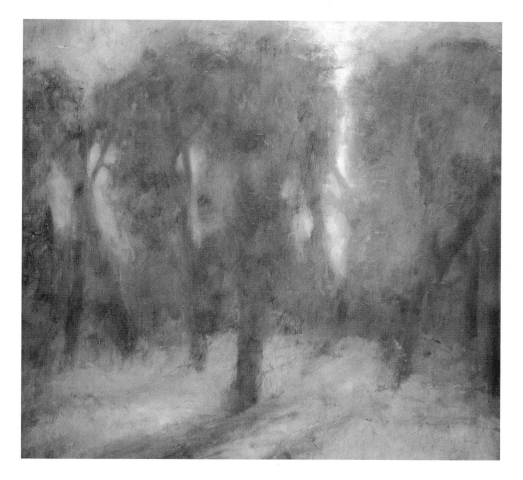

Al Gury, *Early Dawn*, 2004, oil on panel, 24 x 24 inches (60.9 x 60.9 cm). Collection of Fraidoon Al-Nakib, Philadelphia

I used bristle brushes of three different sizes to layer the direct paint in this landscape: a 1-inch brush to block in the masses, a ½-inch brush to draw tree structures, and a ¼-inch brush to define edges and soften transitions. I applied a final, unifying glaze over the dried paint surface with a broad bristle brush. This composition also makes use of a limited palette, which consisted of raw umber, titanium white, Naples yellow, burnt sienna, and ivory black. The soft atmospheric effects are a direct result of the "scumbles" applied with the bristle brushes. (See page 88 for an explanation of scumbling.)

PAINTBRUSHES AND PAINTING KNIVES

Each type of oil painting brush helps produce specific kinds of calligraphy, layering, and paint surfaces. Understanding what each type does and choosing the best kind for one's work becomes essential. The main variations among them are fiber, shape, and cost.

There are two basic types: hard and soft. Hard, or bristle, brushes are made from hog or horse hair and allow for a dense paint paste and facilitate a vigorous application of color. These are the kind direct painters have been using most commonly for centuries. Some artists use bristle brushes all through a painting, while others employ softer brushes as well for certain other effects. Soft brushes are made with softer animal hair, such as badger or sable; direct painters often use these for surface details and blending.

Regardless of fiber type, paintbrushes come in five basic shapes: flat, bright, filbert, round, and fan blender. Flats are flat, wide, and squared at the tip and are typically used to make rectilinear strokes; they hold a lot of paint. Brights are similar to flats but with shorter and stubbier fibers, meaning they hold less paint. Filberts are flat but have a rounded, rather than squared-off, tip. Rounds are made with fibers that form a round shape; the tip may be pointed or dulled. Fan blenders are flat, with fibers forming a fan shape; they are used dry, applied lightly across the surface to gently blend colors.

Painting, or palette, knives have a long history as practical tools for cleaning the palette, mixing color, and applying and manipulating paint layers on the painting surface. These implements come in a variety of shapes and flexibilities. Typically, they have a flat blade (whose tip may be pointed, rounded, or otherwise) that bends below the handle, enabling the artist to apply paint parallel to the painting surface. Just as brushes create specific kinds of strokes, the painting knife lets the artist spread, scrape, and build up paint in numerous ways. Some artists mix the use of the brush and the knife in the same painting.

Paintbrushes and painting knives should be washed with soap and water after each painting day to keep them in good condition. Brushes should be replaced as soon as they can no longer apply paint with flexibility and ease.

MEDIUMS

Oil paint is formulated to be all-inclusive in its mixing, layering properties, and drying times and, technically, doesn't need any additives to do its job. Nonetheless, since the nineteenth century, artists have experimented with and invented many mediums of various merits to modify a paint mixture for spreading or layering purposes, as well as for speeding or slowing drying times. Typical mediums are light drying oils like linseed oil for additional spreading properties, heavy oils like stand oil for additional body, varnishes for quicker drying, and, more recently, alkyd resins for additional density and quicker drying time.

Mediums are not cure-alls. As a general rule, use them sparingly and only to achieve the effect required by a specific painting method. In the interest of creating sound paintings that will stand the test of time, conservators recommend a "less is more" approach to medium usage. Many Impressionist works were done with little or no mediums or thinners and are among the most stable of paint surfaces.

Glazing and its related mediums are particularly shrouded in myth and confusion. I will discuss them and their relation to alla prima painting in the techniques chapter (see page 94).

THINNERS

Thinners such as gum turpentine and mineral spirits are used to thin paints or to mix with other oils and mediums, as well as for cleaning brushes. Like mediums in general, thinners should be used sparingly. Following a practical "lean to fat" approach, a first layer of a painting could have some thinner in it, and the upper layers should have little or none. Glazes are usually a full oil medium with a tiny amount of thinner or none at all.

Thinners have corrosive properties, and some have very strong odors and can cause light-headedness. Good ventilation is required. Many of the modern "odorless" thinners are good substitutes for the more traditional gum turpentine. Choose thinners that are made for artists' use and support health and safety standards.

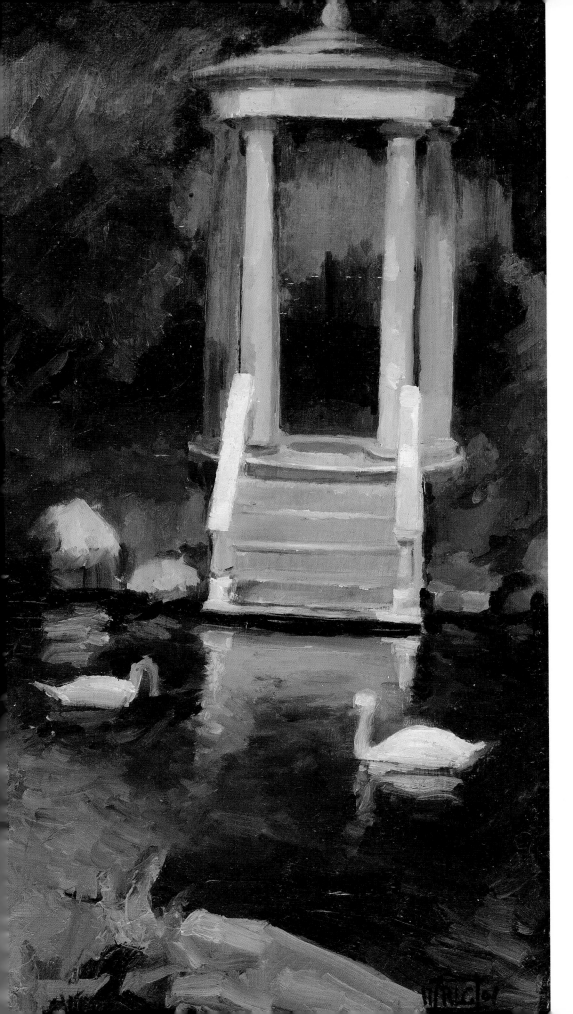

Rachel Constantine, *Swan Pond*, 2002, oil on gessoed rag board, 12 x 7 inches (30.4 x 17.7 cm). Courtesy of Artist's House Gallery, Philadelphia

The amount of thinner, oil, and so forth added to the paint has a profound effect on the quality of the brush calligraphy and the details in a painting. Here, broad scumbled masses provide the setting for paint that has varying degrees of oil added to it. The gazebo, water reflections, and swans achieve their clarity because they are rendered with brushstrokes that are more thickly loaded with paint and also because that paint has a small amount of oil added. This follows the "lean to fat" concept of layering. The "fatter" final, detail touches sit on top with clarity due to the added oil, which creates a sharper edge over the less oily paint beneath.

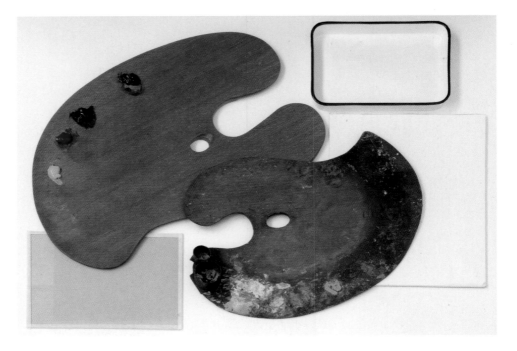

Palette types. Clockwise from bottom left: glass palette with a gray backing, two curved wooden Beaux-Arts palettes, an enamel tray, and a pad of disposable paper palettes.

PALETTES

Mixing surfaces, or palettes, have varied tremendously over the centuries. Palettes are usually either a tablelike surface or an easily movable "arm and thumb" type. The main criteria for a palette are that it be big enough and that it suit the location of the studio or workplace.

Some artists prefer traction on the mixing surface and use wood or even painted surfaces; others prefer a glossy or slick surface like glass or enamel. Either way, both need to be impervious to the oil in the paint so that it doesn't soak into the palette.

Palettes are sometimes keyed to match the gessoed surface of the painting support. For example, an artist who paints on a brown ground will use a brown palette. The purpose of this is to maximize the translation of color mixtures to the canvas. A glass palette can have a white or colored backing attached to achieve the same effect.

Disposable paper palettes are very good and practical; they come in pads. When you are finished with one sheet you simply tear it off.

Palette types affect mixing and, ultimately, the outcome of the painting. Most artists experiment with the classic types until settling on one they prefer.

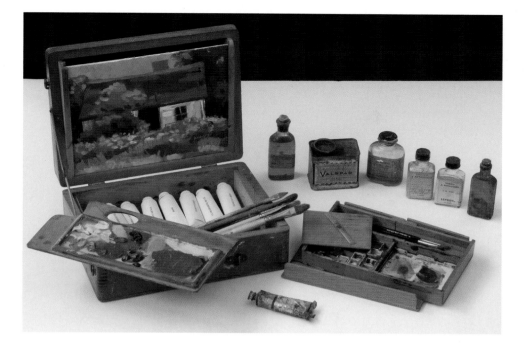

Antique pochade boxes and medium bottles. Still available and used today, the pochade is a compact, portable painting studio in a small box that is ideal for quick sketches and plein air work. Typically it has a hinged lid that serves as an easel and painting carrier, a palette that slides out, and a compartment for paints and brushes.

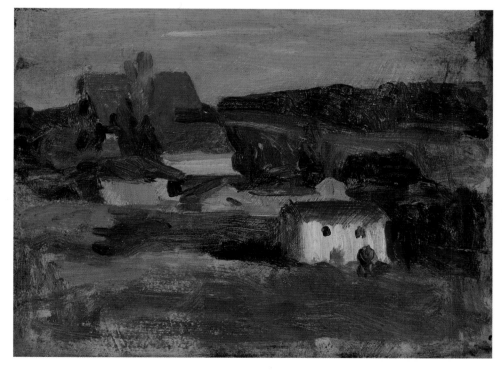

Thomas P. Anshutz, **Landscape with Buildings**, c. 1900, oil on cardboard, 7½ x 9¹⁵⁄₁₆ inches (19 x 25.2 cm). Courtesy of the Pennsylvania Academy of the Fine Arts, Philadelphia. Gift of Mrs. Edward R. Anshutz

This lovely Anshutz study is typical of a work of the pochade size done en plein air. Done very quickly, it is typical of the alla prima sketch style. For outdoor sketches like this, Anshutz used a small pochade box and a limited color palette of titanium white, black, umber, burnt sienna, yellow ochre, cadmium yellow, cadmium red, rose, ultramarine blue, Prussian blue, and viridian green.

SUPPORTS AND GROUNDS

Alla prima painting is done on a variety of supports and colored surfaces. The most common supports are cotton or linen canvases, wood panels, fiberboard panels, and paperboards.

Wood panels and plaster walls are among the oldest supports for paintings of all kinds. Greek artists working in Egypt during occupation by the Roman Empire created encaustic mummy portraits (known as Faiyum portraits, after the location where many were found) on wood panels from about the early first to the third century AD; later, fine wood panels served as supports for altarpieces painted in tempera and oil. Many such panels are cradled on the back for added support and to prevent cracking and warping.

Frescoes from the Egyptian, Greek, and Roman empires through the Renaissance often exhibit some of the most fluid alla prima brush calligraphy in both *fresco dura* (water-based colors applied to wet plaster) and *fresco secco* (water-based colors applied to dry plaster) methods.

With the widespread use of stretched canvases in the fifteenth and sixteenth centuries, supports became easier to transport and also cheaper. The combination of movable supports and the flexibility and elasticity of oil paint caused oil painting techniques to flourish, including the alla prima methods discussed in this book.

The main criteria for a support are that it be the right surface texture for the work at hand and that it be sealed with a ground to prevent absorption of the oil paint. Unless linen or cotton canvases are sealed, the oil soaks into the fabric and causes it to become brittle and inflexible. Traditional grounds for canvases or wood panels involved sealing the surface first with an animal-hide glue, like rabbit-skin glue, and then coating the surface with one or more layers of white chalk mixed with glue (gesso). Today, modern acrylic gessoes make perfectly sound sealers and grounds.

Examples of supports. Clockwise from lower left: stretched cotton canvas, toned wood panel, cradled wood panel, linen.

Colored grounds are very commonly used in alla prima painting. According to an old story, El Greco scraped up the remaining wet colors on his palettes and used the resulting brown mixture for his grounds. Colors of grounds vary according to the artist's approaches to drawing and painting, and according to local traditions. For example, northern European panel painters of the sixteenth century typically worked on a white surface, covering it completely with elaborate underpaintings. Such artists tended to practice what is known as a "closed form" approach—that is, focusing on line and using layered techniques. Impressionist painters often used white grounds, which added luminosity and reflectivity between their paint strokes. Many students find a white surface confusing if their goal is to achieve strong tonality—a strong sense of sculptural form and space that relies on light and shade. In that case, a white ground needs to be covered and built up.

Painters who work in "open form" (focusing on atmosphere and direct techniques) or tonal methods most often use toned or colored grounds. Toned grounds can range from off-whites and beiges to various warm or cool tans (often called a chamois ground)

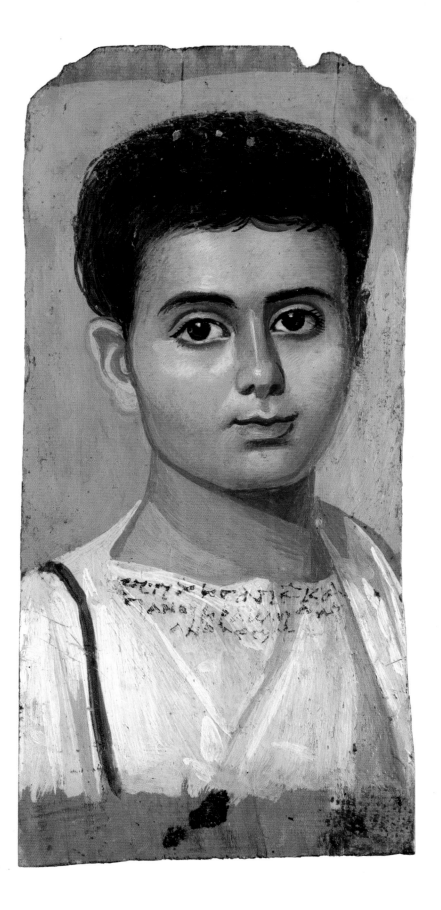

Portrait of a Boy, Egyptian (Faiyum possibly), AD 100–150, encaustic on wood, 14⁵⁄₁₆ x 7½ inches (38 x 19 cm). The Metropolitan Museum of Art. Gift of Edward S. Harkness, 1918

Image © The Metropolitan Museum of Art

Alla prima techniques date back thousands of years. There is a strong, long-standing continuity of materials and methods throughout art history. One example is the Faiyum portrait. Faiyum portraits were traditionally painted on wood panels, as was this famous one in the collection of the Metropolitan Museum of Art in New York. They frequently exhibit the brushy effects typical of painting styles that did not develop in earnest until many centuries later.

Al Gury, oil drawing on gessoed Masonite, 14 x 11 inches (35.5 x 27.9 cm)

Here, the beige ground provides the middle tones, while the dark drawing lines and white highlights let me create the sense of form easily. Also, note the support, which is Masonite.

OPPOSITE: El Greco, *Fray Hortensio Félix Paravicino,* 1609, oil on canvas, 44⅛ x 33⅞ inches (112.1 x 86.1 cm). Museum of Fine Arts, Boston. Isaac Sweetser Fund

Photograph © 2008 Museum of Fine Arts, Boston

Legend has it that El Greco made his grounds from the still-wet paints left on his recently used palettes.

to grays and dark browns. Venetian painters of the late sixteenth century often used a dark brown ground. This facilitated a quick development of dramatic chiaroscuro (strong light and shade) and a heavy loading of paint. Middle-tone grounds (halfway between white and black in value) are probably the most common and were very popular with Baroque painters. Toned canvases help the artist create form in much the same way colored papers do in charcoal and pastel drawings. The paper provides the middle tones, while the dark drawing lines and the white chalk highlights complete the sense of form quickly. Good examples of this are the oil studies and drawings of Rubens and Rembrandt.

In nineteenth-century Europe, grounds varied tremendously according to painting process, due to the variety of methods and philosophies that flourished in the academies and art communities of the time. These ranged from strongly tonalist to highly colorist in nature. All types of grounds are in use today. The desired final effect is a well-sealed support with a surface layer of the proper absorbency and color to suit your aesthetic goals.

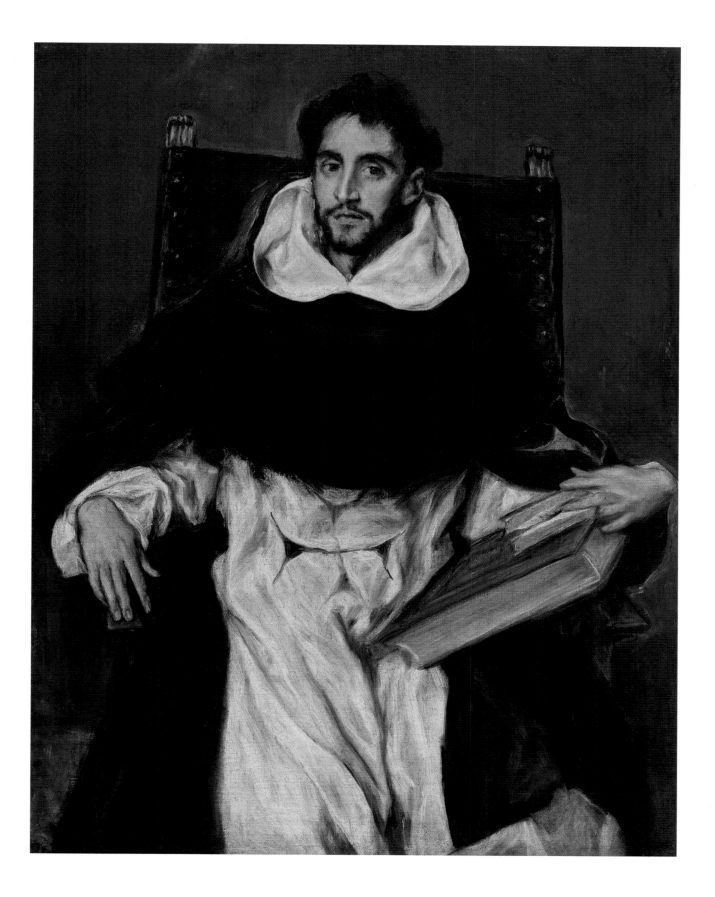

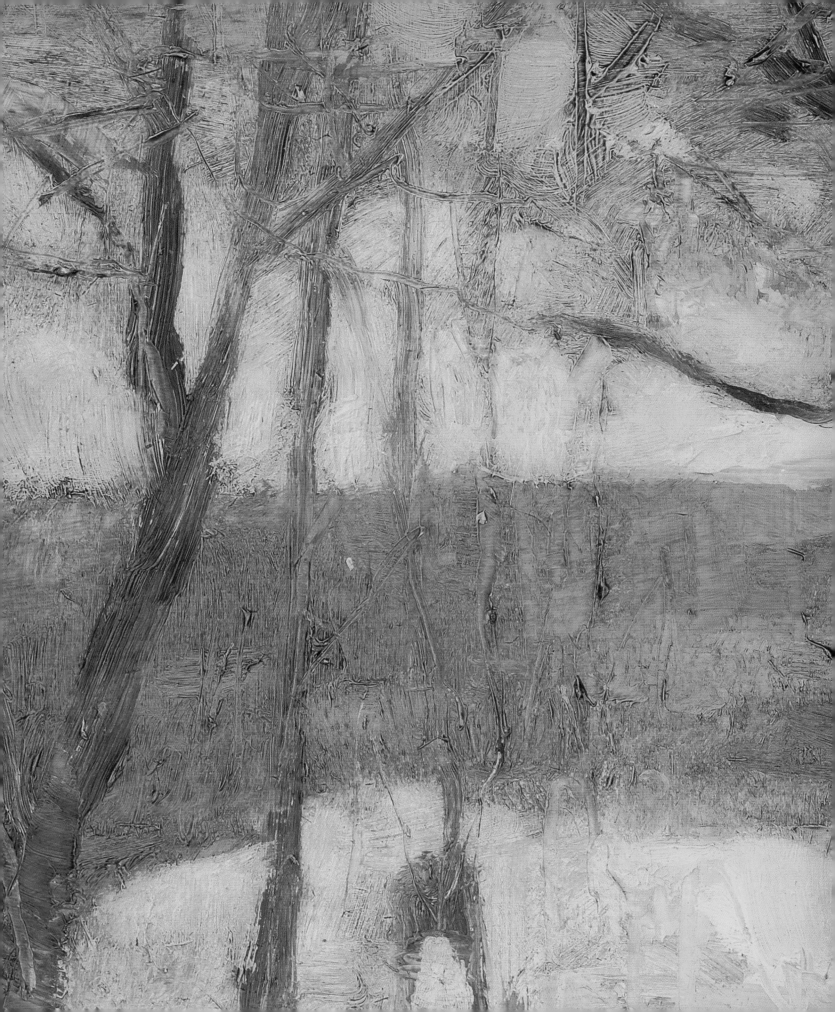

2
Color

Color can be the most confusing and frightening aspect of painting. Since the end of the nineteenth century, so many theories and personal approaches have been brought forward that it's difficult to understand how to proceed. However, a historical approach combined with practical exercises and information will allow us to organize the experience of color in observational alla prima painting.

The history and practice of color can be broken down into three parallel tracks: theories, palette colors used in the studio, and the artworks made as a result of the theories and palettes.

A BRIEF HISTORY OF COLOR THEORY

Aristotle provided one of the first descriptions, however romantic, of how color works to be used in the Western world. He also suggested a palette of colors to be used relating to his theories. His treatise *On Color* (*De Coloribus*) lays out color ideas that would be used for the next two thousand years.

The Romans generally followed Aristotle's guidance. The writings of Pliny the Elder are especially illuminating concerning recommendations for color palettes and the natural history of color in the antique world. The medieval world used Aristotle as its theoretical foundation while endowing color with a symbolic language that helped teach Christian theology.

Leonardo da Vinci ushered in the first modern theories of observational color. Even though Aristotle's ideas would continue to be highly regarded until the end of the nineteenth century, modern theorists increasingly turned to hard evidence from observation. Sir Isaac Newton (1642–1727) provided the first coherent description of primary and secondary colors. For the next three centuries, dozens of artists and scientists would engage in describing theories of color and color interaction. Medical science would also add the basics of how the human eye perceives color.

The late nineteenth and early twentieth centuries added important and practical theories to the canon. In his works *A Color Notation* (1905) and the *Atlas of the Munsell Color System* (1915), artist and teacher Albert Munsell (1858–1918) set forth concepts of hue (color family—for example, red, yellow, blue), value (tonal range— that is, lightness or darkness), and intensity

For centuries, great thinkers have been considering color— and publishing their opinions and theories about it, as these antique reference books show.

(brightness or dullness) that became a basis for understanding color in the modern sense. The great theorist and artist Josef Albers (1888–1976) made an elegant abstraction of the practicalities of color interaction that had been known by practitioners for centuries; his work provided concepts that have guided modern artists and the teaching of color for decades up to the present. Psychoanalysts Sigmund Freud and Carl Jung added another symbolic language of emotional and personal color interpretation to the earlier traditions.

TONAL AND POLYCHROME COLOR

Parallel to the development of theories of color, we see two basic areas of color practice by painters, from the Greeks to the end of the nineteenth century. This involves the color palettes used in the studios and the ways artists organized color in their works. Artists have used two basic approaches: tonal (or monochrome) color and polychrome color.

Tonal color is represented by forms and spaces in a painting created by gradations of color from lighter to darker, and brighter to duller or grayer. This relatively simple concept of form description allows the artist to make coherently drawn figures, still lifes, and so forth that make clear sense to the viewer and that exist in a space that the human eye perceives easily. To accomplish this, a classic color palette is used that consists of a short list of brighter or prismatic colors and a limited grouping of neutral or earth colors. An example of this type of palette can be seen in Dutch painter Frans Hals's *Portrait of a Member of the Haarlem Civic Guard* on page 74. Hals used warmer and brighter color in the lit area of his portrait subject's face and duller neutral colors in the shadows and receding areas of the face.

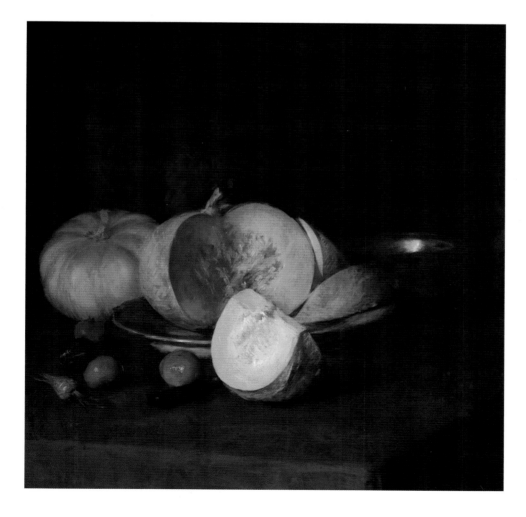

William Merritt Chase, *Autumn Still Life*, oil on canvas, 40⅜ x 40¼ inches (102.6 x 102.2 cm). Courtesy of the Pennsylvania Academy of the Fine Arts, Philadelphia. Gift of Joseph Nash Field in memory of his wife, Frances Field

Applicable to any genre, the tonal approach to color informs this still life by William Merritt Chase, which is a clear example of tonal volumes created by both light and dark, and brilliant warm colors graded to neutrals.

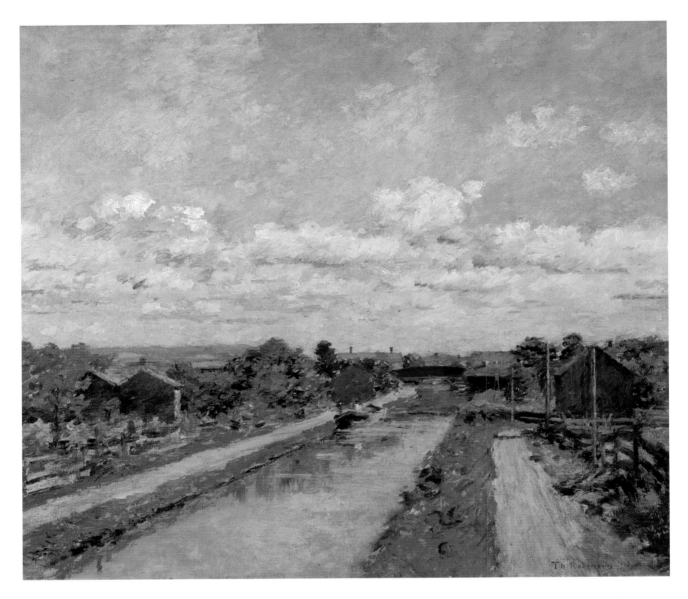

Theodore Robinson, *Port Ben, Delaware and Hudson Canal*, 1893, oil on canvas, 28¼ x 32¼ inches (71.8 x 81.9 cm). Courtesy of the Pennsylvania Academy of the Fine Arts, Philadelphia. Gift of the Society of American Artists as a memorial to Theodore Robinson

Impressionism exhibits a variety of alla prima methods, from tonal and drawn studies to optical mixing using scattered warm and cool touches. Robinson uses a mix of tonality and open "spots" of color.

Polychrome color is characterized by colors that are "broken" and scattered over the field of the canvas to create an illusion of space, light, and harmony. Many Impressionist artists used this color approach to great advantage. While earlier works by the French Impressionist painter Manet, such as *Olympia* (1863), were solidly tonal in their structures and color, his later works, such as *The Railway* (1872–1873), exhibit loose strokes and daubs of a variety of colors on a white canvas. The shadow colors are highly reflective of the colors of the surrounding atmosphere. Tonality is less important than the color interaction and organizing qualities of ambient light in this type of painting.

Since the nineteenth century, both these approaches to color have been used extensively and often intermixed. Early modern painting quickly absorbed the polychrome concepts. Become familiar with the history of color and the resulting types of paintings. Choose your approaches based on the desired outcome of your work.

Arthur Beecher Carles, *White Callas*, 1925–1927, oil on canvas, 50¾ x 37¾ inches (128.9 x 95.9 cm). Courtesy of the Pennsylvania Academy of the Fine Arts, Philadelphia. Gift of Harry G. Sundheim, Jr.

Carles was very much affected by his encounters with Impressionism and early moderns like Matisse. His academic training at the Pennsylvania Academy of the Fine Arts provided a tonal base for his use of color. Later, he added the atmospheric color touches offered by Impressionism as well as the color compositional and expressionist ideas contributed by European moderns. His painting and use of color helped build Modernism in America and, in particular, added to the "Philadelphia" school of colorists.

COLOR PALETTES

Painters have mostly worked with very practical selections, or palettes, of colors that are economical in their type and variety. Nonetheless, myths persist that an artist's palette must contain "magic" colors that make for successful painting, much in the way we often feel that the perfect brush or medium will solve all our pictorial problems. When we observe a painter who seems to have a mastery of his colors and color mixing, it is usually because he has an intimate experience of how those colors work and relate to their subject. This can be achieved through good information and guided practice.

Our knowledge of the colors used in art goes back almost thirty thousand years. The first colors were made from simple organic and inorganic materials such as clay, burnt sticks, chalk, plant juices, and metals. These largely earth-hued palettes were gradually extended by colored stones, precious and semiprecious gems like lapis lazuli and malachite, ground in a medium. For example, an ancient palette might be made of white (chalk), ochre, umber, a red oxide, black, a bright blue (ground lapis), a bright green (ground malachite), and a bright red made from madder root.

Over the centuries, color palettes varied from artist to artist, period to period, and style to style, but they remained remarkably simple and cohesive. In the nineteenth century, new industries and scientific methods produced a broad range of new colors and color variants. Some painters of the time expanded their palettes, as did French artist Eugène Delacroix (1798–1863), who began his career working with a simple limited, or "classic," palette but experimented by adding as many as forty new colors to the list he generally used. The history of color shows that from the fifteenth century to the twentieth the vast majority of painters have used some variety of the classic palette. This includes a white, ochre, umber, red oxide, black, brilliant yellow, brilliant red, bright blue, and brilliant rose. Other colors were frequently added to extend this selection. They include a green earth and a great variety of earth reds, and bright, or "prismatic," colors such as variants of the bright yellows, reds, and blues, as well a range of greens and purples. Black, used to tone or deepen colors, has occurred on almost all palettes, and white, for lightening colors, is considered the most frequently used pigment in the world.

In summary, most historical palettes can be described as being relatively limited in the number of colors, containing a mixture of earth and prismatic hues and relying on colors that are easily intermixable and compatible and easily extendable as needed. While some painters have used mainly earth colors, others have opted for only prismatic ones, and still others have only used red, yellow, and blue. For any artist, a basic, classic palette is a good start. Adjust your color list according to your subject matter and aesthetic goals.

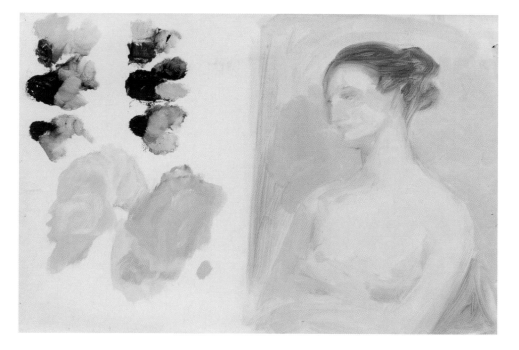

Both images: Arthur DeCosta, limited-color exercise, oil on gessoed watercolor paper, 14 x 20 inches (35.6 x 50.8 cm). Courtesy of the Pennsylvania Academy of the Fine Arts, Philadelphia. School collection

DeCosta used just two colors plus white to create this first figure study: burnt sienna and ultramarine blue. Even with such a limited palette it's possible to achieve a wide range of color mixtures and tones. For the image below, the artist worked with an earth color triad of yellow ochre, ivory black, and red oxide.

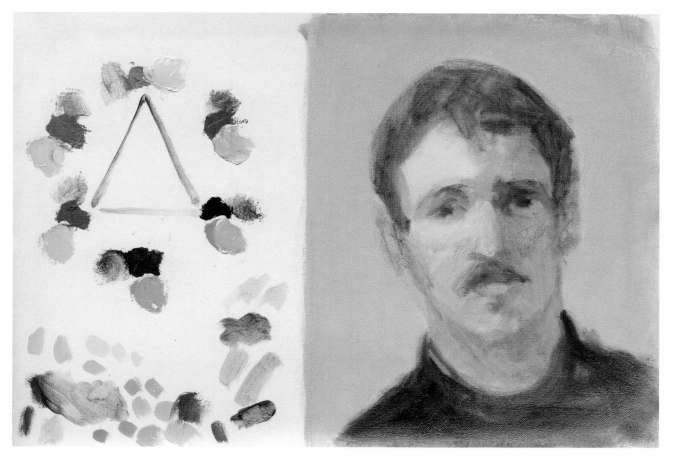

Selected Historical Palettes

Titian (Tiziano Vecellio)
Italian, c. 1488–1576
- lead white
- ultramarine blue
- red madder
- burnt sienna
- malachite green
- red ochre
- yellow ochre
- orpiment (a yellow)
- ivory black

Peter Paul Rubens
Flemish, 1577–1640
- lead white
- orpiment
- yellow ochre
- yellow lake
- madder red
- vermilion
- red ochre
- ultramarine blue
- cobalt blue
- green earth
- vert azur (a blue-green)
- malachite green
- burnt sienna
- ivory black

John Constable
English, 1776–1837
- lead white
- yellow ochre
- umber
- red earth
- emerald green
- ultramarine blue
- Prussian blue
- black

Francisco José de Goya
Spanish, 1746–1828
- lead white
- Naples yellow
- yellow ochre
- brown ochre
- light red
- vermilion
- burnt sienna
- crimson lake
- cobalt blue
- raw umber
- burnt umber
- ivory black

Thomas Sully
American, 1783–1872
- lead white
- yellow ochre
- burnt sienna
- ultramarine blue
- vermilion
- Indian red
- raw umber

Eugène Delacroix
French, 1798–1863
- lead white
- vermilion
- Naples yellow
- yellow ochre
- Verona brown
- ru ochre (a light brown)
- raw sienna
- red brown
- burnt sienna
- crimson lake
- Prussian blue
- peach black
- ivory black
- Cassel earth
- bitumen

Camille Corot
French, 1796–1875
- lead white
- yellow lake
- cadmium yellow light
- Naples yellow
- raw sienna
- burnt sienna
- vermilion
- Verona green
- rose madder
- Robert's lake (a brown)
- cobalt blue
- Prussian blue
- emerald green
- umber
- Cassel earth

James McNeill Whistler
American, 1834–1903
- lead white
- yellow ochre
- raw sienna
- vermilion
- Venetian red
- Indian red
- burnt sienna
- umber
- cobalt blue
- mineral blue
- black

Camille Pissarro
French, 1830–1903
- lead white
- chrome yellow
- vermilion
- rose madder
- ultramarine blue
- cobalt blue
- cobalt violet

Pierre-Auguste Renoir
French, 1841–1919
- silver white
- red madder
- red ochre
- cobalt blue
- emerald green
- Verona earth
- Naples yellow
- yellow ochre
- raw sienna
- ivory black

Paul Cézanne
French, 1839–1906
- white
- brilliant yellow
- Naples yellow
- chrome yellow
- yellow ochre
- raw sienna
- vermilion
- burnt sienna
- red madder
- crimson lake
- burnt lake
- Veronese green
- emerald green
- Verona earth
- cobalt blue
- ultramarine blue
- Prussian blue
- peach black

Thomas Eakins
American, 1844–1916
- white
- cadmium yellow
- cadmium orange
- vermilion
- light red
- rose
- burnt sienna
- permanent blue
- Vandyke brown
- black

Arthur DeCosta
American, 1921–2004
- titanium white
- yellow ochre
- ivory black
- burnt sienna
- transparent red oxide
- Venetian red
- lemon yellow
- vermilion
- permanent rose
- ultramarine blue

Recommended Classic Palette

- titanium white
- cadmium yellow light
- cadmium red medium
- permanent rose
- ultramarine blue
- yellow ochre
- raw umber
- burnt umber
- burnt sienna
- Venetian red
- Indian red
- ivory black

Additional Colors to Extend the Classic Palette
- cadmium orange
- lemon yellow
- cadmium red deep
- dioxazine purple
- cadmium green
- chromium oxide green
- viridian green
- Prussian blue
- green earth
- greenish umber
- red oxide
- transparent red oxide
- Mars yellow
- Mars violet
- raw sienna

Note: There are many beautiful prismatic and earth colors that can be added or substituted. These vary according to manufacturer, grade, and price. Colors should be added or substituted as you experiment with different types.

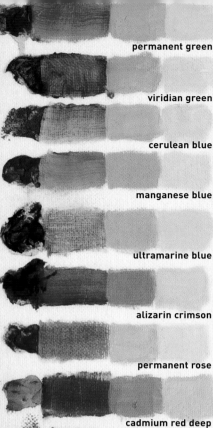

permanent green

viridian green

cerulean blue

manganese blue

ultramarine blue

alizarin crimson

permanent rose

cadmium red deep

cadmium red medium

cadmium red light

cadmium orange

cadmium yellow deep

cadmium yellow medium

cadmium yellow pale

cadmium lemon

viridian green &
permanent green

terre verde &
permanent green

cadmium yellow light
& cerulean blue

cerulean blue &
cadmium yellow lig

Mars orange &
ultramarine blue

cerulean blue &
ultramarine blue

cadmium yellow light
& ultramarine blue

cadmium orange &
ultramarine blue

cadmium red medium
& alizarin crimson

permanent rose &
cadmium red medium

ultramarine blue &
cadmium red medium

ultramarine blue &
alizarin crimson

manganese blue
& Venetian red

manganese blue &
broken Venetian red

blue black &
cadmium red medium

blue black &
alizarin crimson

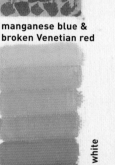

cadmium yellow

burnt sienna

black

earth color scheme with yellow ochre & white

cobalt blue & cadmium orange scale

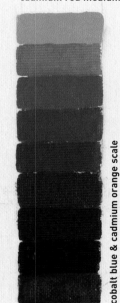

ivory black & broken
cadmium red light

blue black & broken
cadmium red light

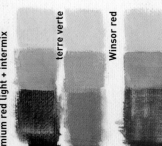

permanent green & broken
cadmium red light + intermix

terre verte

Winsor red

Venetian red

Mars orange

yellow ochre pale

Mars yellow

brown ochre light

raw sienna

burnt sienna

raw umber

burnt umber

ivory black

COLOR IDENTITY

The colors we work with have very specific identities, or "flavors." Each color or color mixture has an associated quality of hue (color family: red, yellow, blue, purple, orange, green, and so on), value (lightness or darkness), and intensity (how bright or neutral the color is). Each tube color has particular properties of brightness to neutrality, warmth to coolness, opacity to transparency. As mentioned earlier, these qualities vary from manufacturer to manufacturer.

While the theories of color interaction can give us a framework for understanding our palettes, the application of color must be understood in a more practical way. A direct method of understanding these "flavors" can come from the following exercise.

Lay out all the colors in your paint box on a palette. A dab about the size of a nickel will suffice. Mix white with each one to make a light tint of the same value—say, a 3 on a value scale of 1 to 10, with 1 being white and 10 being black. The tint mixture should be thick and opaque, like a small "chip" of paint. Make sure to thoroughly clean your brush between each mixture. Lay out these tints next to one another as you mix them. You will begin to notice that some tube colors need more or less white to make the tint. This is a clue as to the tinting strength of the tube color.

This is a color chart with value gradations, tint tests, and color interaction samples. As an exercise, each color should be mixed with white or a darker color or black to match a 1–10 scale of gray. This teaches the matching of colors in nature to their proper value. Using white or lighter colors to lighten above a 5 value is a practical method, as is adding darker colors or blacks and umbers to darken the value below a 5 level.

The color used to adjust the value of the tube color has a tremendous effect on the resulting mixture. For example, burnt sienna lightened by gradations of white makes one set of tints, while using yellow makes another set.

Using a blue to darken the burnt sienna results in half tones and darks different from those generated by adding black. Note that the tones remain steady gradations while the colors may vary.

Additionally, the great colorist Josef Albers created tone variations by juxtaposing colors to illustrate how they affect one another. While the theories he drew from have been known and used for centuries, Albers clarified them in an abstract form that has become the basis of Modernist color theory. If you look at the color squares here, you can get an idea of just how strong an effect color can have on what surrounds it.

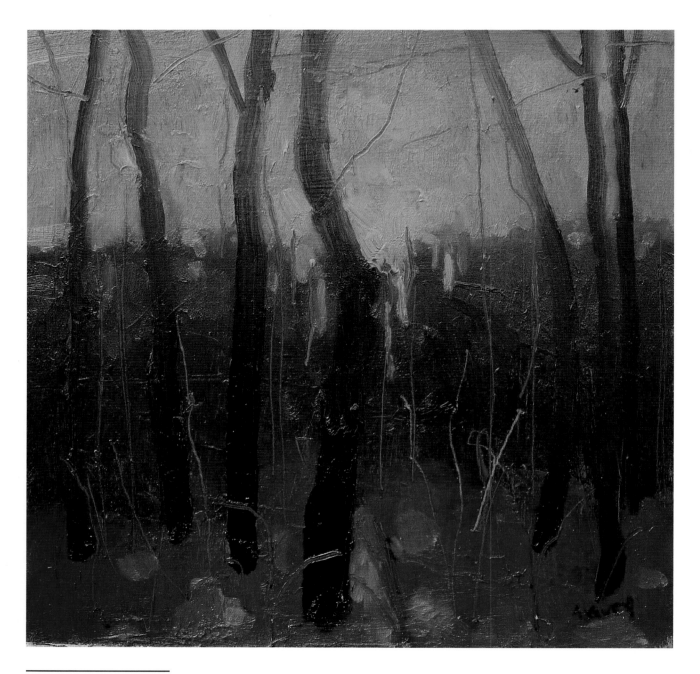

Al Gury, 2007, oil on panel,
10 x 10 inches (25.4 x 25.4 cm).
Permission of the artist

It was very important in this painting to establish the intensity of the sky color and the dark value of the woods very directly. Pure cadmium yellow, orange, and red create the highly saturated "glow" of the sky.

I added a touch of white but not enough to weaken the high chromatic intensity of the cadmiums. The woods are pure greenish umber, while the tall trees are a mixture of greenish umber and ultramarine blue. The dark colors needed little or no mixing to match the right color/value of the trees and woods.

When all the tints are mixed and laid out, begin to compare the qualities of each to the others. For example, look at the red mixtures, both those made with earth colors and those made with prismatic hues. Note how the earth color tints are pinkish, while others are beige-orange pinks, as in the case of burnt sienna. Venetian red and other reds are in the middle in terms of warmth (toward yellow/orange) or coolness (toward blue/purple). When you compare the prismatic tints with the earth tints, there is a decided difference in intensity of brightness between the two groups. The prismatic tints do, however, have the same variations as the earth colors. They range from an orange pink in the case of cadmium red light to lavender pink in the case of cadmium red deep.

Once the whole array is laid out, begin to verbally name and describe the character of each tint. For example, the Venetian red tint has a clear but dull baby pink quality; Indian red (not on the palette on page 44 but a common addition to the classic palette) tint is a dusty lavender; the burnt sienna tint is a beige-brown pink. The raw umber tint is a greenish gray, while the burnt umber tint is a dull pinkish-brown gray. The cadmium red light tint is an orange-peach pink; the cadmium red medium tint is a cherry pink; the cadmium red deep tint is a purple pink. Tints of blues, yellows, greens, umbers, and so forth all have these different and distinct "flavors."

By following this exercise, very quickly you will begin to gain a practical awareness of each color's properties, which will lead you to eventually develop strong instincts about how to create correct color mixtures.

Here is a case in point: A student was trying to make a rich orange tint by mixing a cadmium red and cadmium yellow together with white. Instead, he arrived at a dull brownish mixture. When he checked the paint tube for the name of the red he was using, he discovered that it was cadmium red deep, which is essentially a maroon or purple red. In effect, he had been mixing yellow, purple, and red together, which makes brown rather than orange. He then chose cadmium red light—a yellow-based pigment—for the mixture and achieved a brilliant hot orange.

Another example involved trying to cool or "neutralize" a cadmium red medium while painting a brownish red fabric in a still life. The student was using blue to do the job, which wasn't working well. A change to an earth color like burnt sienna or burnt umber matched the color he needed exactly, as these two pigments are both red based and duller, or more neutral, than cadmium red. The blue he had been using was muddying the color.

In both cases, the student finally made the right choice by thinking through the "flavors" or properties of each color for the desired results. This becomes instinctual with time and practice. In many ways, color usage is like cooking. We begin with the recipes, but eventually we cook through imagination, instinct, and experience.

A similar test can be used to determine the transparency of each color. Some colors are transparent by nature, some are translucent, and some are very opaque. With a brush, drag out a little tube color (no white this time) with some linseed oil on the mixing surface. This will show the relative properties of each tube color's density; compare their intensities. Note that the transparency of a color is by nature brighter and more vibrant that its opaque counterpart.

Learning to understand the nature and mixing properties of colors is within our grasp. Testing, practice, and visual memory are the best solutions to understanding one's palette.

WHITE

White pigments vary as to density and tinting strength. Titanium white is the "whitest" white; it has the strongest tinting strength and the greatest opacity. The lead whites, flake and Cremnitz, are slightly warmer than titanium. Although they are very dense and opaque in impasto mixtures, when scumbled out (that is, applied with a rough, dry stroke of the brush), the lead whites take on a translucency. These two unique properties of the lead whites have made them highly prized over the centuries. Zinc white is the thinnest of the white pigments. It also has the least tinting strength. For this reason it is sometimes recommended to students who use too much white. To truly understand how each white behaves, you must practice with them until you master their various properties.

White can be both a help and a hindrance. The more white we add to a mixture, the lighter it gets. Add too much white and a vibrant light tint begins to lose chromatic intensity. It may even now seem dull next to other colors. Each hue has an upward limit where it loses chroma—that is, saturation—through the addition of too much white.

If a color is already very neutral or dull, adding too much white will make what we call "chalky" color. Muddy colors—those overmixed with too many opposing hues, creating a lack of a clear hue identity—become even worse with the addition of white. By keeping the color mixture simple and adding only so much white as is needed to match the value of the subject, we avoid these risks.

For example, a student painting an autumn still life of yellow pears found that adding more and more white to the mixture for the light mass only made it chalky and dull. The light mass was primarily yellow ochre. The solution was to add a bit of cadmium lemon to the ochre to maintain intensity as the value of the light was raised. Adding a more intense color along with the white negated the chalkiness.

Light is often associated with the use of white. We think that by adding more white to our color mixtures, we capture the quality of light in the still life or portrait. But in fact, it is more important to match the intensity and temperature of the color than it is to add white. For example, a still life of a brightly spotlighted red apple on a table suggests adding white to the red to capture the brightness of the apple. However, this approach would lead to a red that is too light and possibly chalky and pink. Matching the bright red light-mass color to an appropriately intense red pigment would be a better choice; because the apple is under a warm yellow spotlight, starting with cadmium red light or medium is a wiser decision. Add only so much white as is needed to create a match to the intensity and value of the apple's red color.

In summary, white should be used only as needed to match the value and chroma of a subject. Creating the effects of illumination involves other factors besides just adding white.

Cecilia Beaux, *New England Woman*, 1895, oil on canvas, 43 x 24¼ inches (109.2 x 61.6 cm). Courtesy of the Pennsylvania Academy of the Fine Arts, Philadelphia. Joseph E. Temple Fund

Artists such as Cecilia Beaux are masters of nuance in white tints. In this painting, the dress and other fabrics are rendered through the modulation of close warm and cool pale, tinted white mixtures. Beaux winds the whole structure together with subtle touches of mid tones and darks. Her academic drawing skills are adapted and balanced with her color harmonies.

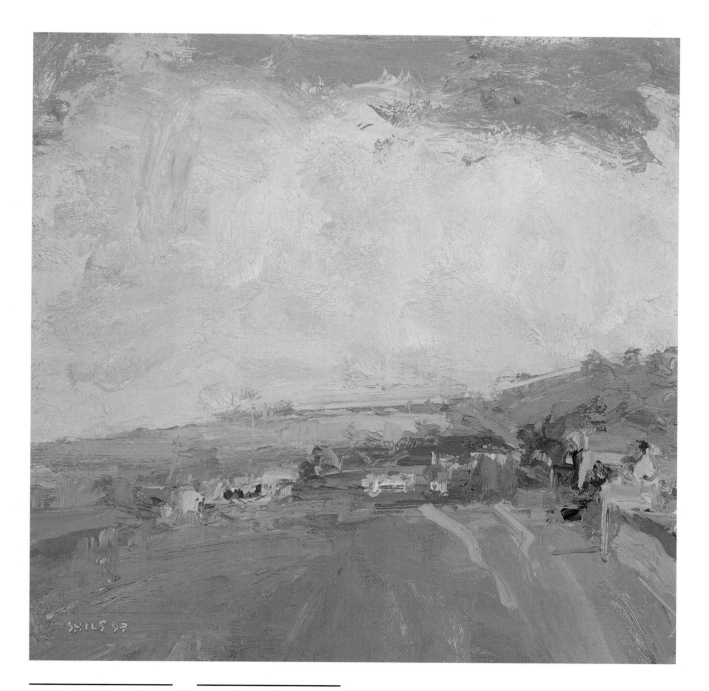

Here, a similar scheme to Beaux's New England Woman is employed. A great variety of subtly tinted white mixtures are combined with hints of structural and tonal drawing.

Use of white in the landscape has developed in much the same way as its use in other subjects. Historically, the underlying practices and theories of color,

temperature, light source, and so on were extended by each artist or period to all subjects. For example, strong warm/cool temperature changes would occur in a William Merritt Chase landscape, portrait, or still life.

Artists working more in the studio tend to be more consistent in these choices. Artists working with observations of changes

of light outdoors in nature tend to be more variable in their warm/cool harmonies and use of white. The light and sky in this Shils painting, however, provided the perfect occasion for an exploration of the use of white in the landscape. Not only was white used in the sky, but it was mixed with the hues that make up the suggestions of the buildings, as well.

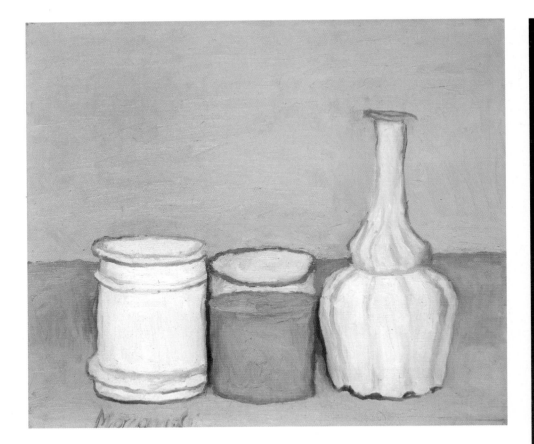

ABOVE: Giorgio Morandi, *Still Life with Flask*, 1953, oil on canvas, 14⅛ x 15⅞ inches (35.8 x 40.3 cm). Hirshhorn Museum and Sculpture Garden, Washington, DC. Gift of the Joseph H. Hirshhorn Foundation, 1966

A master of shape and tonal harmonies, Morandi employs a limited palette of earth colors and white, extended occasionally by a bright or prismatic color. His directly drawn objects are massed (that is, given mass) by scumbled opaque color and then redrawn and formed by simple darks.

RIGHT: Arthur DeCosta, *Yellow Apple*, c. 1970, oil on canvas, 9 x 12 inches (22.8 x 30.4 cm). Courtesy of the Pennsylvania Academy of the Fine Arts, Philadelphia. School collection

DeCosta, rather then relying just on white to create the light values in this still life, balanced the lightening with white by adding warmer colors or by choosing other, higher-chroma colors altogether (rather than white). Excessive use of white has the effect of cooling the colors, rather than maintaining their intensity. However, white is still a prominent pigment important to the final look of this image.

COLOR ANALYSIS

Color analysis is the practical process by which we identify the colors, and thus the paint mixtures, of a subject. The human eye is capable of picking up so many subtleties in color that often we see too much in the subject or become confused as to what the colors really are. Organizing the experience of the colors and tones is the goal.

What we see in most master paintings is a conceptualized and reorganized color structure that presents to the viewer the effect or illusion of what the artist saw. This is especially true of alla prima painting and its processes. In alla prima painting, the description of the subject must be "restructured residually" through planes, color masses, and tonalities to create a strong, directly painted effect. This "simplification" or "conceptualization" is one of the underlying strengths of alla prima painting.

To better understand this, as an exercise set up a small, simple still life. Instead of looking at the details, focus on the large mass of basic shapes and the simple color and tone of each shape. Verbally describe the color of each shape, including the background. Then verbally describe the basic color of the subject's light mass and shadow mass and their relative values rated on a scale of 1 to 10 (1 = white, 10 = black). Finally, verbally describe or name the colors of individual highlights and reflected lights. This process will help you organize the basic color components of the subject and lay them out in an orderly way. Subtleties, details, blending, and so on will follow well if the base is sound.

In other words, identify the base of color blocks and their tones first. Use the previously described experience from color tests and value matching to help you identify these blocks.

The apple photographs on these two pages are meant to help provide an understanding of basic tonality, color, and color blocks. This is the first step in color analysis. In this image, the light and shadow masses (in other words, the areas of light and shadow) have been polarized to convey the tonal foundations of the still life.

This photograph displays the tonal masses simplified into tonal blocks.

Here, more color in the shadows is described as a secondary addition to the base colors. Keep in mind that no matter how simple or varied the colors of the subject or how shaded or illuminated the subject, simplifying the underlying large blocks is the first step to color analysis.

Fairfield Porter, *Jimmy and Liz*, c. 1963, oil on canvas, 45 x 40⅛ inches (114.3 x 101.9 cm). Courtesy of the Pennsylvania Academy of the Fine Arts, Philadelphia. Henry D. Gilpin Fund

In Jimmy and Liz, *Fairfield Porter uses a mixture of tonal harmonies and pure colors to create a sense of light. The late-afternoon light is highly saturated by warm yellows playing off neutrals in the shadows and on the walls. Porter draws from traditional alla prima practices as well as Modernist ones in his design and use of color.*

John Henry Twachtman, **Snow**, c. 1895–1896, oil on canvas, 30 x 30 inches (76.2 x 76.2 cm). Courtesy of the Pennsylvania Academy of the Fine Arts, Philadelphia. The Vivian O. and Meyer P. Potamkin Collection. Bequest of Vivian O. Potamkin

Twachtman makes use of a limited color palette and range of tonality and value here. This, along with the brushwork, effectively conveys the feeling of the scene and the experience of being outdoors in the country on a snowy day.

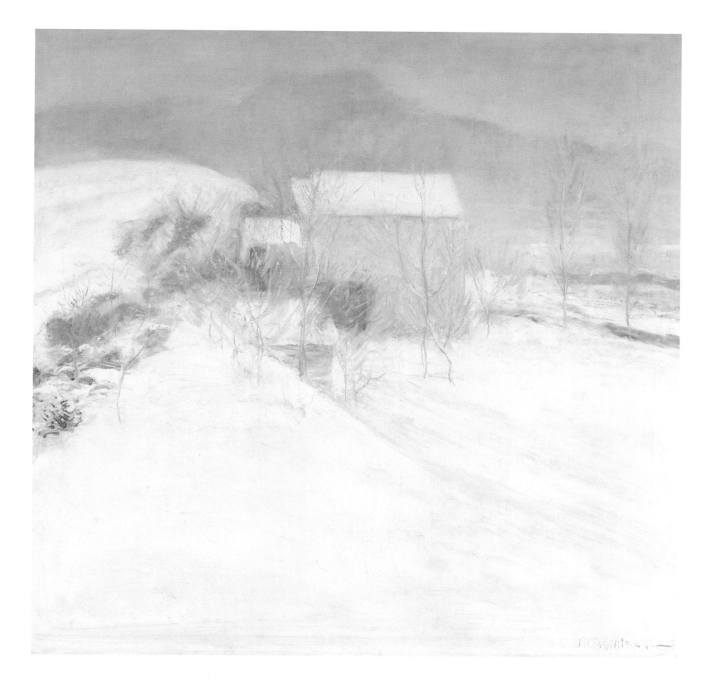

COLOR VALUE

Each color in nature has a value, or relative lightness or darkness, associated with it. Along with its intensity and hue, each color mixture in a painting is also a value. To become familiar with the values of color mixtures, practice gauging a mixture against a ten-value gray scale that ranges from white (1) to black (10). Commercially made gray scales can be purchased, but the experience of making one yourself is more valuable.

The easiest way to make a gray scale is to mark off ten blank squares. Place a block of white oil paint in the square at one end and a block of black oil paint in the square at the opposite end. Mix equal amounts of white and black and place the resulting gray exactly in the middle of the scale. Fill in the other blocks until you have an even spread of grays from white to black. Mix swatches of colors and match them to this scale on your tint test chart. Gradually, test yourself by naming the values of colors you see in nature and your painting subjects. This simple process takes visual memory and practice but will become instinctive eventually.

In summary, remember to visually match the colors of your subject to a simple generalized value scale. Keep it simple and clear in the first layers of a painting and then add subtleties.

As with the examples on pages 54–55, the simple apple still life also illustrates colors broken down tonally. It is important to match each color block to its corresponding tone and mix the color to match that tone. With this solid base of correct tone matching in the color mixing, additional color subtleties, reflections, and so on can also be matched to the correct tone and laid on top to finish the painting.

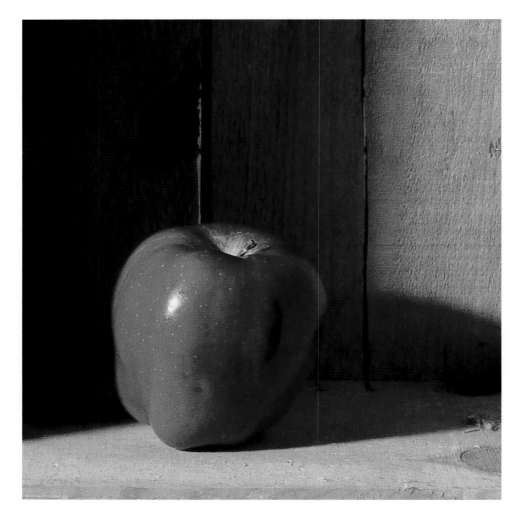

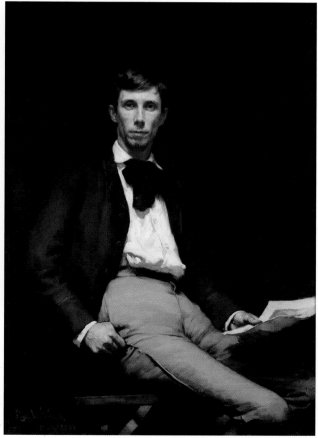

BELOW: Robert W. Vonnoh, **Companion of the Studio**, 1888, oil on canvas, 51¼ x 36¼ inches (130.2 x 92.1 cm). Courtesy of the Pennsylvania Academy of the Fine Arts, Philadelphia. Joseph E. Temple Fund

These subtle yet powerful images by Beaux and Vonnoh are good examples of a limited palette used in a purely tonal manner. In the Beaux, close tonalities create a soft sense of atmosphere. In the Vonnoh, strong dark and light linked by half tones create a bold sense of form.

ABOVE: Cecilia Beaux, **Seated Girl in a Long Black Dress**, c. 1885, oil on cardboard, 19⅝ x 12¼ inches (49.8 x 31.1 cm). Courtesy of the Pennsylvania Academy of the Fine Arts, Philadelphia. Gift of Henry Sandwith Drinker

OPPOSITE: Jon Redmond, *Stairway*, 2007, oil on canvas, 10 x 8 inches (25.4 x 20.3 cm). Courtesy of the artist

ABOVE: Jon Redmond, **Red Wall**, 2000, oil on canvas, 10 x 10 inches (25.4 x 25.4 cm). Courtesy of the artist

In Jon Redmond's work, light falling on architectural forms creates a rich sense of mass, planes, and tonalities. In the above image in particular, the red wall is a color equal in both value and chromatic strength. The high chroma color—not any use of white—creates the illusion of light.

Dwight W. Tryon, *Evening*,
1886, oil on canvas, 16 x 24¹⁄₁₆
inches (40.6 x 61.1 cm).
Courtesy of the Pennsylvania
Academy of the Fine Arts,
Philadelphia. Henry D.
Gilpin Fund

This softly atmospheric land-
scape relies on rich mid tones
punctuated by dark touches in
the trees for its form.

THE COLOR OF LIGHT

Light sources, the color of the particular source, and the effect of ambient, or environmental, light on a subject are the three most important factors in structuring the color of a painting.

Historically, especially when painting was almost entirely a studio activity, lighting was most often viewed conceptually, first as a means for revealing the forms of a subject in a simple dynamic way and thus facilitating composition, and then as providing a sense of warmth or coolness (or neutrality) between the colors of the light and shadow masses. The primary goal was to tell the story of the subject at hand, to create meaning, through a clear structure the viewer could understand. To achieve this end, painters used a variety of lamps and studio windows to illuminate their subjects, directing those light sources in ways that would establish the perception of three-dimensional depth and degrees of warmth or coolness in color.

Light sources are crucial in defining form. The direction and intensity of the light either reinforces form or flattens it. For example, a strong warm light source from above and the side (at a 45-degree angle) creates a strong effect not only of form but also of temperature, which reinforces form. Renaissance painters like Leonardo da Vinci realized light source and direction maximize form. Frontal lighting can flatten form. Cool light can either flatten or strengthen form depending on its direction.

Obviously, lighting aesthetics have varied over the centuries. Compare, for instance, the deep tonal qualities of paintings from the Baroque period, as seen in the work of such seventeenth-century contemporaries as Dutch painter Rembrandt and Spanish painter Diego Velázquez, with the lighter-key effects seen in paintings by such eighteenth-century masters as France's François Boucher and the English portraitist Henry Raeburn. The deeper Baroque tones convey a powerful sense of mass, form, and movement, while the lighter tones preferred by Enlightenment-period artists project a sense of openness, intellect, and poetry.

In the nineteenth century, a variety of artists' movements began to emphasize working with available natural light rather than traditional studio lighting effects to capture, in painting, time of day, atmosphere, and ambient, or environmental, light. Among these movements were the Hague school in Holland, the Naturalists and Impressionists in France, and the Luminists in America, all of whom focused on the qualities of light found in nature and its effects on color.

It is very important to become familiar with the properties of various forms of lighting and their relationship to painting your subject. Directional spotlights and window light can create a strong sense of chiaroscuro. Ambient daylight and fluorescent light will surround the form with light and diminish tonal differences. Incandescent lights and direct sunlight are a warm yellowish or pinkish yellow in quality. Ambient daylight is bluish or grayish, while light from many fluorescent sources is greenish or lavender in color. Color-corrected fluorescents can come close to producing light that is the color of daylight.

Each type of lighting creates a very different effect in the setup of the subject and the outcome of the painting. Become familiar with the various types and the painting processes that relate to them.

ABOVE: Walter Elmer Schofield, *Winter*, 1899, oil on canvas, 29½ x 36 inches (74.9 x 91.4 cm). Courtesy of the Pennsylvania Academy of the Fine Arts, Philadelphia. Henry D. Gilpin Fund

This painting is an example of cool ambient light flattening the form and reinforcing the flat shapes of the landscape.

OPPOSITE: Jon Redmond, 2000–2005, oil on panel, 10 x 10 inches (25.4 x 25.4 cm). Courtesy of the artist

Light, or luminosity, is intimately tied to the concepts of color intensity and value. Here Redmond creates an overall "warm" atmosphere by use of the middle-tone brown-reds and brown-greens. The tub is described not with white but with more intense versions of the atmospheric colors. By doing this, Redmond maintains the color mood—as well as the atmosphere—of the scene. The light (cool daylight) seen in the hallway behind is balanced by a cool highlight on the left edge of the tub.

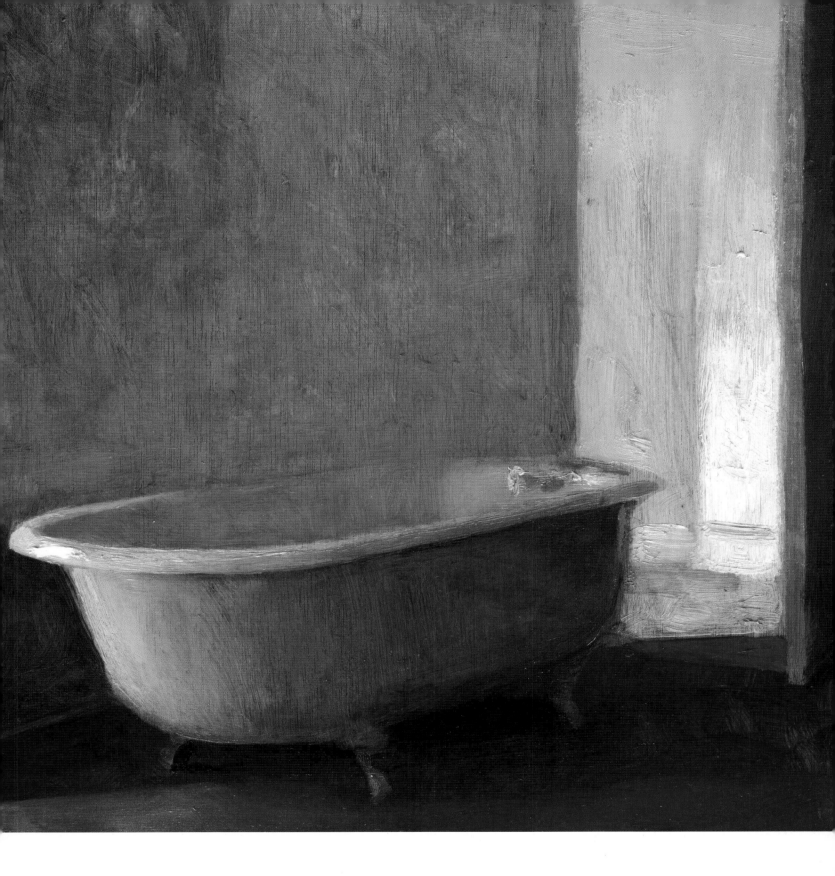

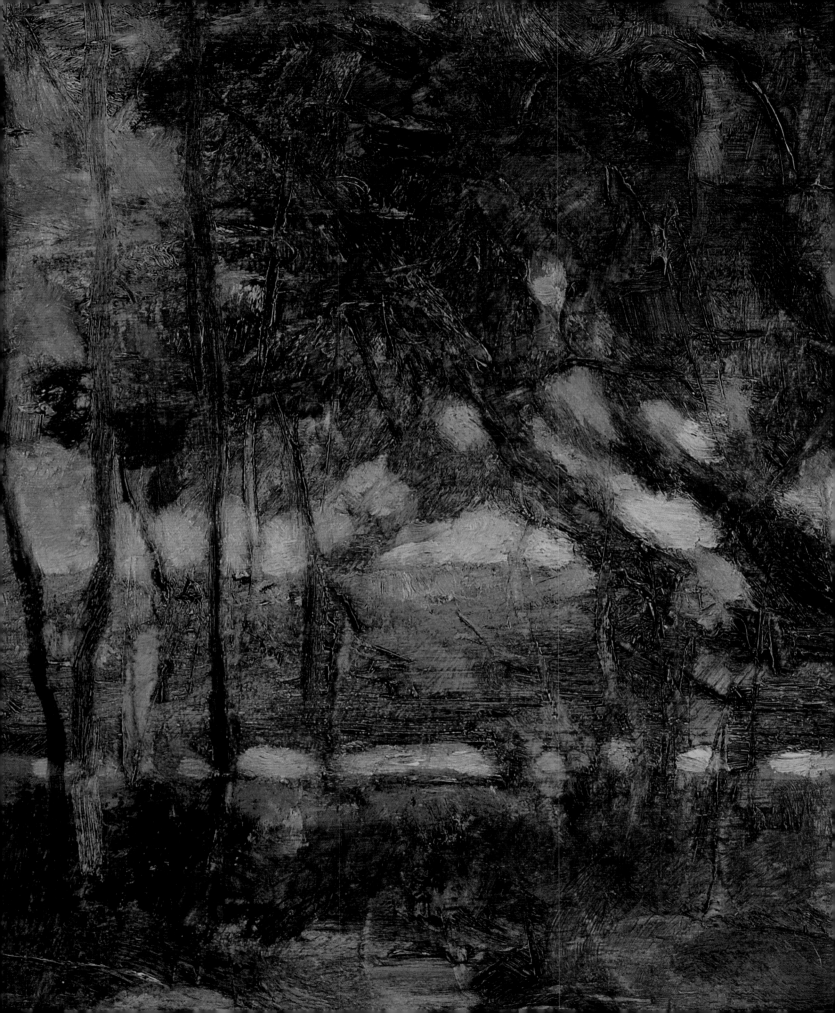

3

Techniques

Alla prima painting relies on a variety of principles relating to optics, paint layering, and brushwork and is often very complex in its construction. While at first glance an alla prima painting may seem very simple and done with a minimum of technical variety, most make use of a range of layers and additions to create the final effect. The concept of an alla prima work being a one-shot effort has its place in the history of direct painting, but there is a broader and more complex reality to the history and practice of this major aesthetic approach to painting.

For example, many great Italian, Spanish, and Flemish Baroque masters known for their rich, direct brushwork, in reality, present a complex construction of blocked masses, scumbles, impasto, descriptive brushwork, and final unifying glazes.

UNDERPAINTING

Ways of starting the alla prima painting vary historically but fall into a few simple categories: the direct placement, wipe-out, and direct color blocking methods. Whichever underpainting method you use, it should be simple and economical in describing the major masses, values, and composition of the subject. The choice of method has a direct relationship to the development and layering of the painting.

Thomas Eakins, *Figure Study: Masked Nude Woman*, c. 1875–1885, oil on cardboard, 14 x 8 inches (35.6 x 20.3 cm). Courtesy of the Pennsylvania Academy of the Fine Arts, Philadelphia. Charles Bregler's Thomas Eakins Collection. Purchased with the partial support of the Pew Memorial Trust and the Henry S. McNeil Fund

This Eakins work presents three important concepts: First, it is a quick sketch or study done in a short period of time, probably no more than an hour. Second, it captures the core qualities of strong tonal contrast, simple temperature changes between warm and cool, and quick rich brush calligraphy. Third, it represents Eakins's aesthetic approaches as an open-form painter and a "realist," departing from the classicizing of the figure.

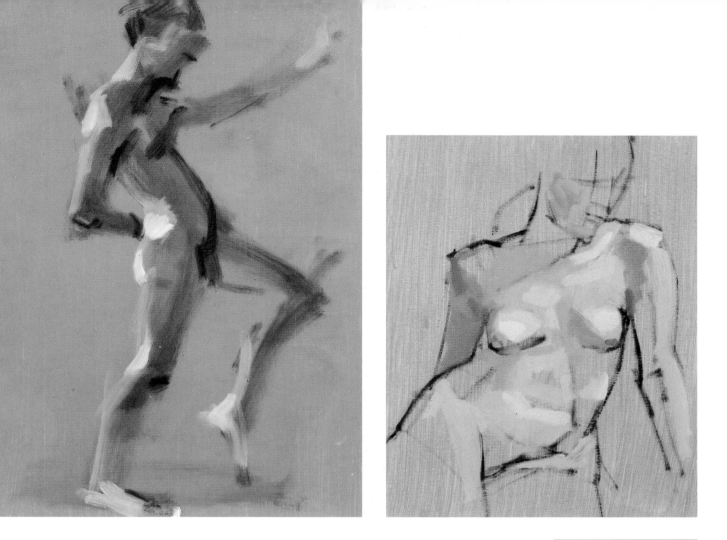

Direct Placement

Direct placement is done with the brush to provide an underpainting for the colors and brush layering to follow. Varying from clear linear brush angles, planes, and lines to bold, loose calligraphic arabesques and scumbled tones, the underpainting and its placement should be simple and indicative of the general elements of shape, structure, and composition. Little or no medium is used. Layers of direct paint are then added to block in the colors and tones. Most often these placements are done with an umber or other neutral colors so as to disappear under the upper layers of paint. Painters from Velázquez to Eakins and Sargent used this simple, bold approach.

LEFT: Al Gury, oil on gessoed Masonite, 14 x 11 inches (35.5 x 27.9 cm)

RIGHT: Al Gury, oil on gessoed Masonite

For both these images, a loose set of shapes and masses are described with the brush as the first "placement" of the subject. This general beginning, with large areas of color tones "massed in," is typical of direct painting.

Wipe-Out

The wipe-out method involves coating a white or off-white canvas with a wet imprimatura, or first layer, made of a neutral transparent color. Umbers or mixtures of burnt sienna and black or burnt sienna and ultramarine blue are common. The imprimatura requires enough medium, oil, and thinner to be wet, but not runny or too oily. A brush drawing of the subject is placed directly into the wet surface of the canvas. The light masses and other intermediate tones are "wiped away" with a soft, absorbent rag or brush. The overall effect is one of a generalized—though clear and strong—drawing of the subject, focusing on its tonality and mass. Color is then blocked in to the underpainting to further develop the subject. This technique became very popular in the nineteenth century for academic studies of the model, for the portrait, and for still life.

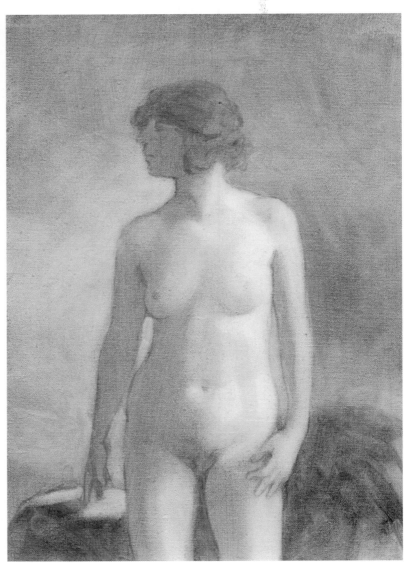

Arthur DeCosta, wipe-out underpainting, oil on canvas, 16 x 12 inches (40.6 x 30.4 cm). Pennsylvania Academy of the Fine Arts, Philadelphia. School collection

An example of the wipe-out method, this DeCosta underpainting uses burnt sienna and ivory black oil paint over a red chalk drawing on a "chamois," or pale tan, ground. A detail is above.

ABOVE: Arthur DeCosta, wipe-out underpainting, oil on gessoed canvas, 12 x 10 inches (30.4 x 25.4 cm). Pennsylvania Academy of the Fine Arts, Philadelphia. School collection

In this wipe-out underpainting for a still life, DeCosta loosely placed the tonal masses into a wet imprimatura and then wiped out the light areas of the subject with a rag to create a chiaroscuro effect. This provides the setting for the placement of tonal color and descriptive brushwork. The imprimatura is the transparent, usually brown layer used to begin an alla prima or direct painting; it can be wet or dry.

RIGHT: Arthur DeCosta, wipe-out underpainting, oil on canvas, 12 x 10 inches (30.4 x 25.4 cm). Courtesy of the Pennsylvania Academy of the Fine Arts, Philadelphia. School collection

This wipe-out portrait underpainting uses burnt sienna and ivory black oil paint on a tan ground.

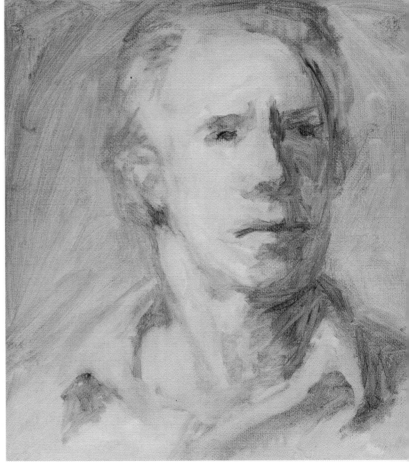

Color Blocking

While the direct placement and wipe-out methods rely on drawing in the broad sense of the term, the color-blocking approach masses in color blocks directly and uses little or no underdrawing. It has been popular with painters who are concerned primarily with color shapes and harmonies, rather than drawn or tonal structures. The French Impressionists, Postimpressionists, and many early Modern painters used this method to beautiful effect.

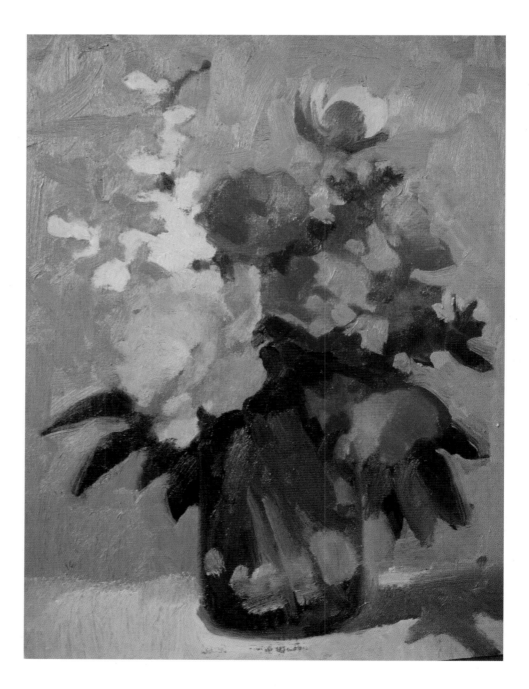

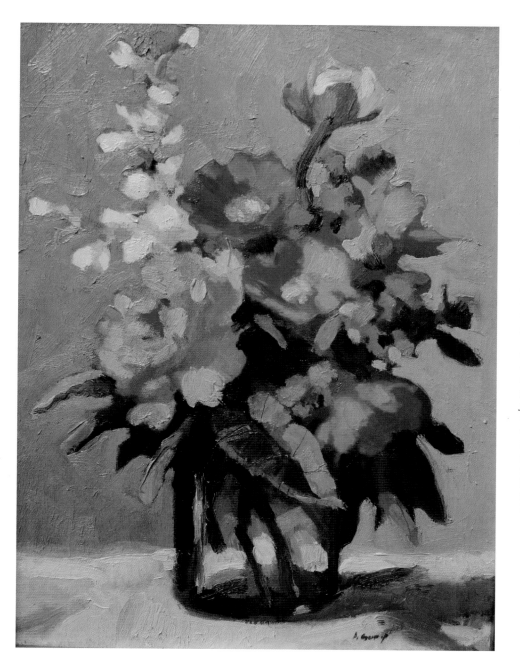

Al Gury, *Poppies and Peonies*, oil. Permission of the artist

In the color-blocking underpainting opposite, I analyzed the flowers for their primary mass, tone, and shape—devoid of any details. I rendered the brilliant colors in the light (nonshadow) areas mainly with bright prismatic hues to achieve the chromatic intensity of the actual flower colors and the warmth of the incandescent light falling on them. For the shadow areas of these masses, I used cool versions of each of those base colors. For example, dioxazine purple and ultramarine blue make the cool version of the warm pink purples that I had made from permanent rose and ultramarine blue. If these colors are not cool enough, I also add cool earth tones. This is true for each color mass.

To finish the still life (left), I add details in the brightest, warmest colors and make adjustments of edges (sharpening or softening them as needed). Top-layer brush calligraphy is very specific to the textures and edges of each flower. I also lay down the final background color over the neutral background of the underpainting.

In the end, you can see the relationship between the finished image and its color-block underpainting. The underpainting establishes the basic forms using simple blocks of color that don't have too much variety in them. Once I get the basic values and placement down, I then define the forms more thoroughly, using the broader range of colors to indicate more fully the highlight and shadow areas.

LAYERING

Alla prima painting can range from quick brushy paintings done in a single layer in one shot to complex works of multiple layers done over many days. The "lean to fat" (thinner to thicker/less oily to more so) model is generally accepted as both practical and conservationally sound. The terms *lean* and *thinner* describe paint with less oil medium added to it, while *fat* or *thicker* paint has more medium added to it. *Leaner* can also refer to paint that has had some thinner added to it. Relative to that, *thicker* can mean paint that is just as it is, with nothing added. Layers should develop from thinner paint with less oil added that is generally applied with less aggressive brushstrokes to upper layers that are thicker, brushier in application, and richer in oil or medium. Paintings that are unstable in their layers often develop cracks, shiny spots, and even flaking. This is

Frans Hals, *Portrait of a Member of the Haarlem Civic Guard*, c. 1636/1638, oil on canvas, 33¾ x 27 inches (85.7 x 68.5 cm). Andrew W. Mellon Collection. Image courtesy of the Board of Trustees, National Gallery of Art, Washington

A superb example of the whole layering process, following the lean-to-fat model, is Dutch painter Frans Hals's portrait of a civic guard. Loose placement is followed by a general blocking in of forms, lights, and darks. Next come thicker directional strokes to finish the modeling of the form, and the darkest darks, lightest lights, and details come at the end. Final, single skins of glaze colors were applied over the sash and sky to complete the rich effect.

Also note that this image is a good example of a tonal approach to color. It shows the use of warmer, brighter color in the lit portions of the subject and more neutral and darker tones in the receding shadow areas of both the figure and the background.

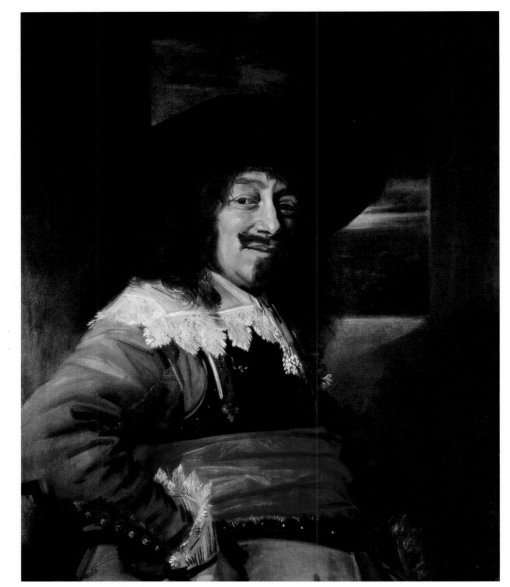

because the drying times of the different oils and mixtures vary to such a degree that the layers become fragile and unstable.

The placement, or underpainting, of an alla prima painting is often made with loose, thin strokes that capture the general shape and structure of the subject. If the paint is too thick or dry, a small amount of thinner or medium is often added. Direct, more specific, and heavily loaded strokes follow to develop form and structure. Surface layers usually exhibit the most dramatic and often medium-rich loaded brushstrokes and details. When a surface glaze is employed, it is a full oil- or medium-rich mixture that is applied thinly over the dried underlayer.

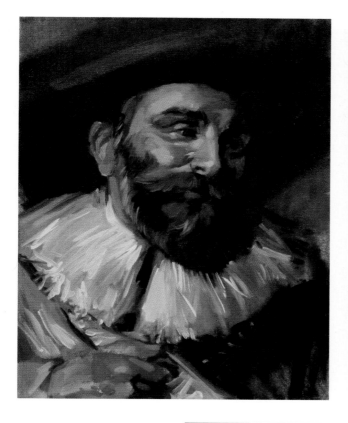

Al Gury, after Frans Hals, oil on canvas, 14 x 11 inches (35.5 x 27.9 cm). Collection of the artist

Sketch copies of masterworks can be used to learn the basic elements of construction. For this copy of a Hals work, I focused on strong tonality, expressive brushwork, quick finishing accents of both lights and darks, and unifying final glazes. It is an ideal practice piece for understanding the process of direct painting. A loose general brush placement defines the basic shapes on a middle-tone ground and is followed by general massing in of large blocks of color and tone. Upper layers are built through brush calligraphy that describes specific textures and color changes. They are then adjusted by a finishing glaze. Remember that the history of alla prima painting includes many degrees of complexity.

BLENDING

Blending is an element of painting that is often misunderstood and shrouded in myth. Simply put, basic blending allows for strength of structures and planes to remain, while making appropriate transitions from one form or area to another. Even in the most polished and enameled-looking of classical closed-form (line-oriented) paintings, the blending never destroys the sense of structure.

As brushstrokes are placed to describe form or texture, often they are too strong or harsh initially. To adjust them to the right degree of clarity or softness, you can smooth or even blend the edges of the strokes that need softening by dragging a clean, dry brush over them. This is a process that is only done either at the end of a painting session to prepare for the next session or at the end of the painting—but when it is still wet, to get the desired finish to the brushwork. This light "dusting" will integrate the planes

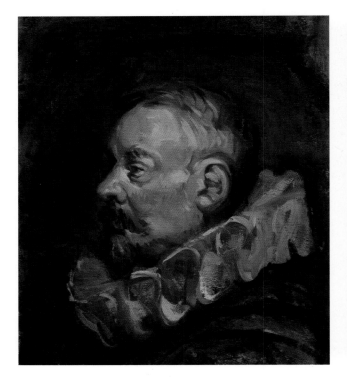

Al Gury, **Portrait of a Gentleman** after Peter Paul Rubens, oil on gessoed watercolor paper with gray ground, 14 x 12 inches (35.5 x 30.4 cm). Collection of the artist

Blending in alla prima painting can be a confusing concept. Blending, or modulation of "paint edges" and surface textures, is done sparingly and only as needed. On the other hand, it can be essential to the outcome of the desired effects in the painting. Here, the first paint layer is composed of transparent brown shadow mass

and opaque light mass. To draw together the edge between the two, I used a clean, dry brush to create a transition that is both clear and subtle. I added more specific brushwork to modulate facial anatomy, reflections in shadows, and details. And finally, I checked the whole painting for edges and stray marks that needed blending or

light "dusting" to create a harmonious whole.

It is very important to note that blending is not done for its own sake and must be done only at the end of each stage or session to maintain textures and variety. Otherwise, the result will be bland, flat, and rubbery, and the colors may become muddy.

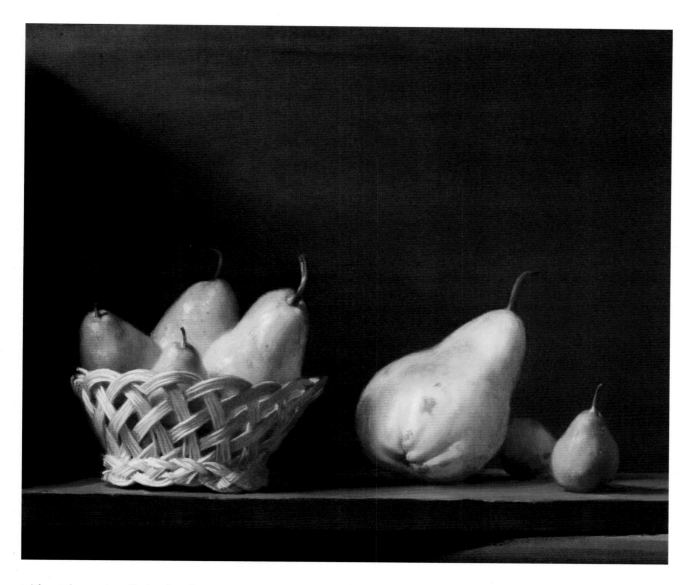

without destroying distinctions between structures. The degree to which this integrating is done depends on the degree of smoothness or "brushiness" (visible brushstroke texture) desired in the painting. A bristle or sable brush can be used. It is very important to refrain from anxiously blending away the structures, planes, and brushwork that gives the painting its strength.

In general, a good time to blend is at the end of the painting session when finishing the work or preparing for the next day's painting session. Remember, from a distance, only a minimal amount of blending is needed to make most alla prima paintings show up well. Do not overblend. Blending is used to enhance optical transitions in the paint. Overblending flattens the form and destroys light/dark contrast.

Arthur DeCosta, *Seven Pears*, 1960, oil on canvas, 9¹⁵/₁₆ x 12¹/₁₆ inches (25.2 x 30.6 cm). Courtesy of the Pennsylvania Academy of the Fine Arts, Philadelphia. John Lambert Fund

In DeCosta's Seven Pears, *blending is used to integrate the surfaces of the pears to create the rich mixture of velvety skin enlivened by highlights, planes, and the darks seen on the shadow sides of the fruit. However, at no time are the textural differences of any of the surfaces in the painting blended away.*

BRUSHWORK

Alla prima painting is characterized by rich and varied brushwork. Ranging from subtle scumbles (see page 88) to bold, heavily paint-loaded impasto brushstrokes, the work of each painter is often characterized by a signature use of the brush. An example is American painter John Singer Sargent, whose dramatic and skillful brush calligraphy informs all of his work.

Brush calligraphy refers to the way in which the brush is used to load, drag, scumble, stroke, or draw with the paint. Masters of direct painting often develop very unique personal forms of brush calligraphy that characterize their personal style. This calligraphy is usually very much a part of a direct painting, while in indirect painting, the brush marks are submerged or polished away into the overall drawing and illusion of refinement.

RIGHT: John Singer Sargent, *The Breakfast Table,* 1883–1884, oil on canvas, 21¼ x 17¾ inches (53.98 x 45.09 cm). Harvard University Art Museums, Fogg Art Museum. Bequest of Grenville L. Winthrop, 1943.150

Imaging Department © President and Fellows of Harvard College

John Singer Sargent is a master of brush calligraphy and one of the great role models of direct painting. In any given painting, he used a loose brush drawing massed over with thicker or thinner scumbled paint. He then developed particular surfaces with strong brush calligraphy keyed to the texture and special effect of each area. He finished with touches of darks and lights to give the painting clarity and to reaffirm drawing structures.

OPPOSITE: Jon Redmond, 2000–2007, oil on panel, 10 x 10 inches (25.4 x 25.4 cm). Courtesy of the artist

Directional brushwork is especially important in Redmond's paintings of architectural subjects. Each surface is described by a loaded brush moving in the direction of the flat surfaces of wood and stone. A sense of perspective and depth is further enhanced by bolder brushwork in the foreground and arch and by smaller strokes in the rooms and window beyond.

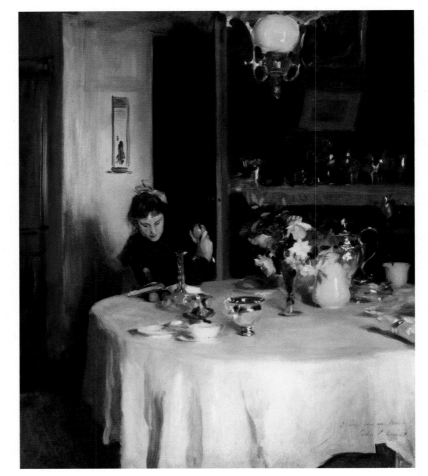

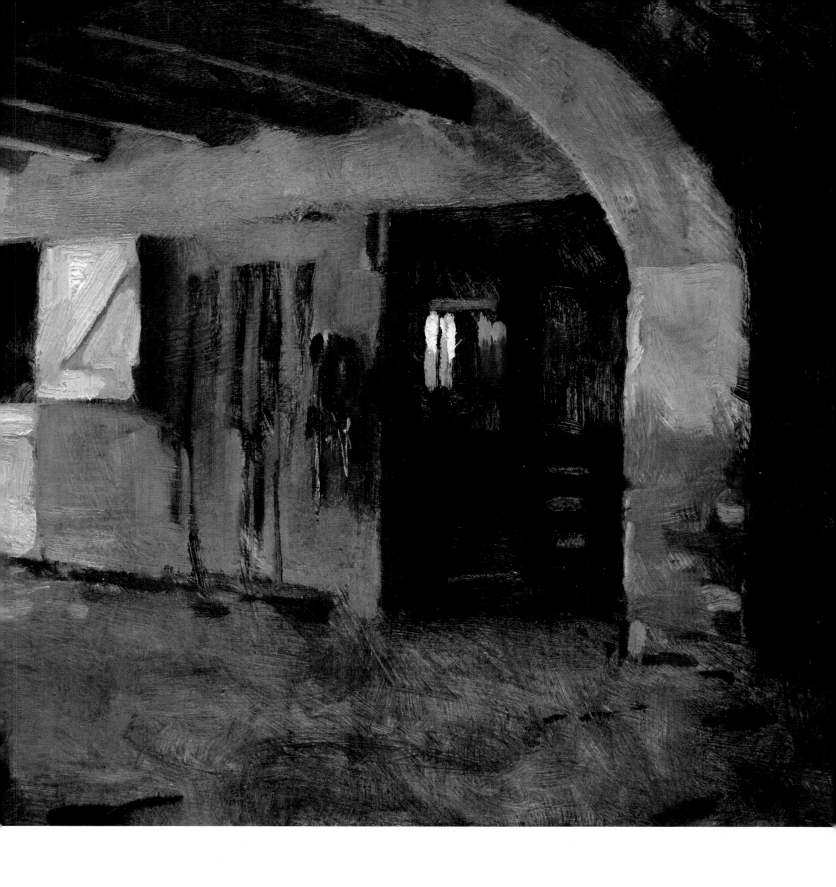

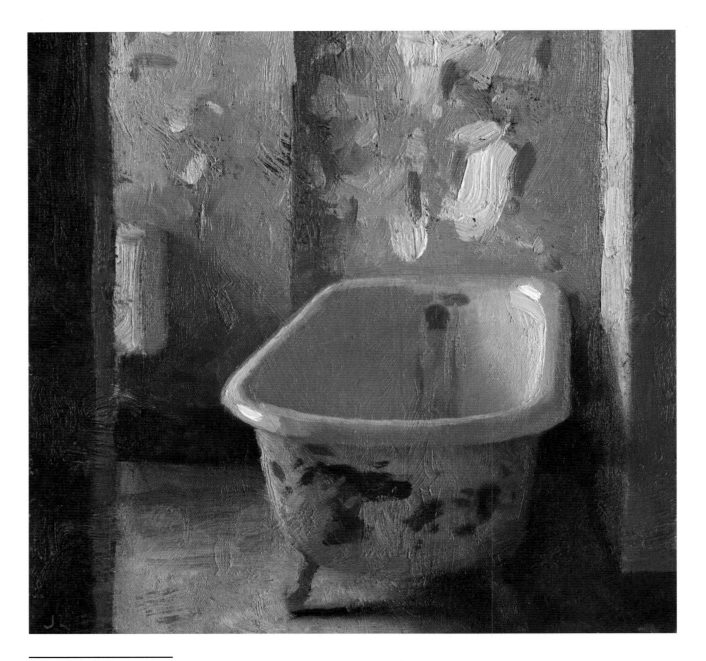

ABOVE: Jon Redmond, ***Rm. 614 Tub***, 2007, oil on panel, 10 x 10 inches (25.4 x 25.4 cm). Courtesy of the artist

OPPOSITE: Diego Velázquez, ***The Needlewoman***, c. 1640/1650, oil on canvas, 29⅛ x 23⅝ inches (73.9 x 60 cm). Andrew W. Mellon Collection. Image courtesy of the Board of Trustees, National Gallery of Art, Washington

Texture in a direct painting is an important function of brush calligraphy. In Jon Redmond's painting of the tub, an overall scumbled first layer is finished with bold, thick touches of pigment to create the illusion of the flaking paint and wallpaper in the room. Each stroke is applied with great economy to create this rough texture when the viewer stands away from the painting. Smoother surfaces, such as the floor, are, upon examination, painted fairly roughly but appear smoother relative to the wall textures. The masterful touch of highlight on the tub completes the poetry of this small painting.

By contrast, Velázquez's image makes use of a broader range of paint surfaces to create the illusion of the more subtle textures of the skin and hair. Nevertheless, scumbled areas, layered over with thicker impasto in this masterwork, have a strong relationship to the basic character and tradition of the Redmond painting. Details of the hair, shawl, and so forth show the variety of density, fluidity, and sharpness or softness of brush calligraphy typical of direct painting. It's all a matter of degree.

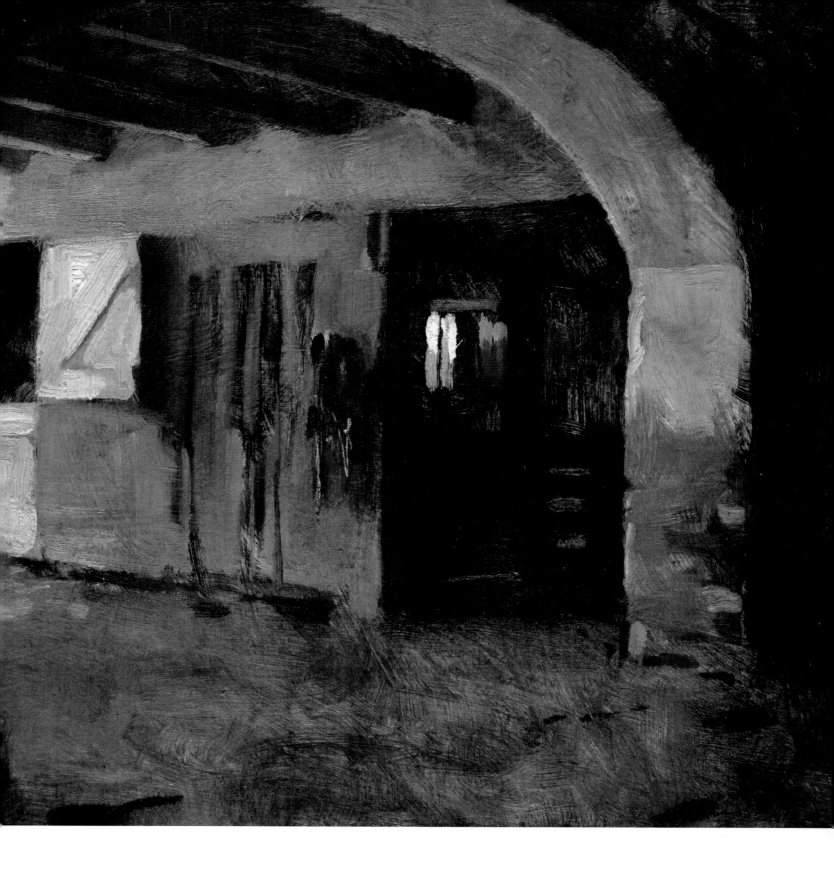

Drawing with the Brush

One of the most important characteristics of alla prima, direct, or "painterly" painting is drawing with the brush. The structure of a direct painting is built, or drawn, with the brush from general elements at the beginning to particular details at the end. In open-form, or direct, painting, the mass and drawing continues to be developed up to the top layers, where the details of the drawing are rendered. Placements, scumbles, impastos, and glazes all build up to a finish with final strokes completing the drawing and form at the end.

This distinguishes direct painting from closed-form, or indirect, painting (that is, painting that depends on a refined linear underpainting and layers of paint creating optical effects). Typically, closed-form paintings are virtually completed by the drawing of the underpainting. The layers that follow serve to enhance the form already established in the underpainting.

In alla prima painting, the direction of the brushstroke creates angles and curves, which develop the drawing (form) of the subject. Planes (strokes of the brush, which show where a surface changes direction) are very important to developing the mass of the subject. In a portrait, for example, planes describe the changes in underlying anatomy, as well as the outside contours of the sitter's head. Drawing with the brush is an important characteristic of alla prima or direct painting. Learning to construct form and indicate planes with varieties of brushstrokes is very important.

OPPOSITE, LEFT: Al Gury, *Student*, c. 1990, oil on canvas, 16 x 12 inches (40.6 x 30.4 cm). Collection of the artist

OPPOSITE, RIGHT: Al Gury, *Portrait of Jen*, c. 1990, oil on linen canvas, 14 x 11 inches (35.5 x 27.9 cm). Collection of the artist

LEFT: Al Gury, 2001, oil drawing, imprimatura on gessoed panel, 14 x 11 inches (35.5 x 27.9 cm). Collection of the artist

The layering of brushwork in all three of these paintings is similar in concept to that of alla prima painting methods in general. One layer provides a structural setting for the next, from basic masses to intermediate structuring to finishing touches of darks and lights. Final glazes may then be applied—and often are by direct painters. Large simple structural shapes, such as the oval of the face, and the generalized massing of light and shade provide organizing guides for the layers of the painting. These large elements must be maintained—and periodically reaffirmed—as the painting develops. Basic large planes define a first layer of form and anatomical or surface structure. Some of these original plane strokes will remain visible to the end of the painting, providing a sense of structural unity and visual interest. If these important underlying elements get lost, smeared away or confused, reset or redraw them very directly and boldly. In this way, a painting will never be lost. Intrinsic to all direct painting is the ability to readjust or redraw as you go. It is very flexible.

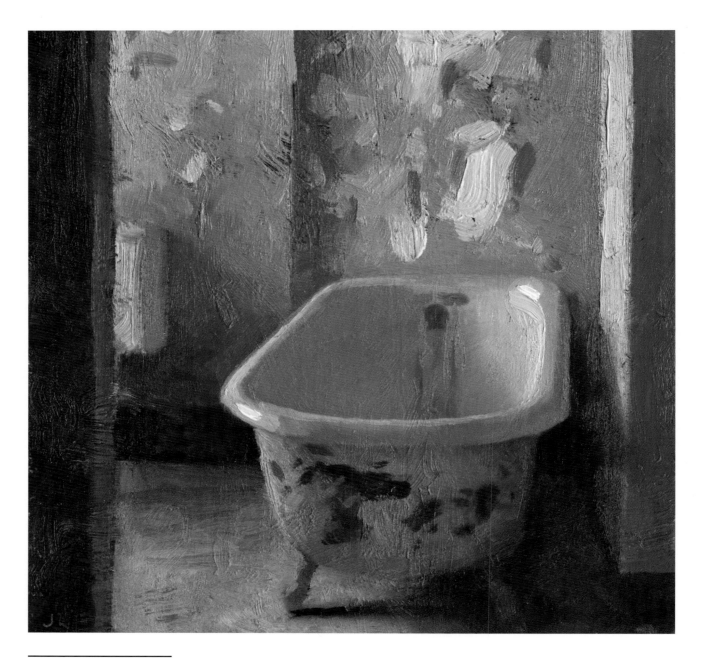

Texture in a direct painting is an important function of brush calligraphy. In Jon Redmond's painting of the tub, an overall scumbled first layer is finished with bold, thick touches of pigment to create the illusion of the flaking paint and wallpaper in the room. Each stroke is applied with great economy to create this rough texture when the viewer stands away from the painting. Smoother surfaces, such as the floor, are, upon examination, painted fairly roughly but appear smoother relative to the wall textures. The masterful touch of highlight on the tub completes the poetry of this small painting.

By contrast, Velázquez's image makes use of a broader range of paint surfaces to create the illusion of the more subtle textures of the skin and hair. Nevertheless, scumbled areas, layered over with thicker impasto in this masterwork, have a strong relationship to the basic character and tradition of the Redmond painting. Details of the hair, shawl, and so forth show the variety of density, fluidity, and sharpness or softness of brush calligraphy typical of direct painting. It's all a matter of degree.

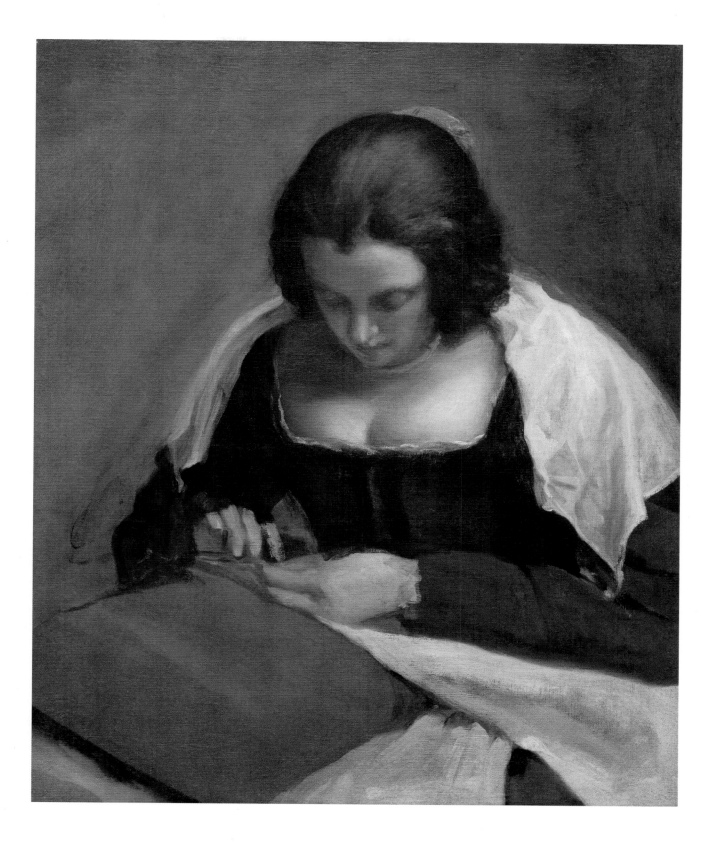

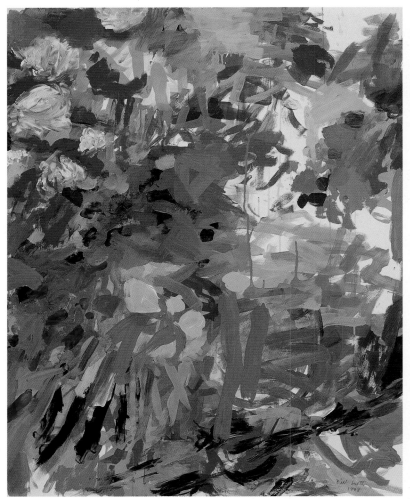

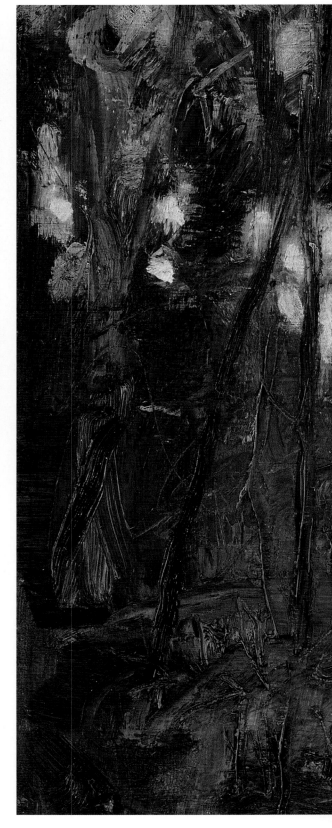

ABOVE: Bill Scott, *Hydrangea from Françoise*, 1998, acrylic on paper, 40 x 32 inches (101.6 x 81.2 cm). Courtesy of Hollis Taggart Galleries, New York. Private collection

Photo: Joseph Painter

In this Bill Scott painting, layering of brushwork and the touch and feel of brush calligraphy are of the utmost importance. This image creates an overall illusion of atmosphere, color, light, and movement, while offering numerous instances of subtle interactions that can be enjoyed in their own right. Alla prima brushwork in this painting is similar to that described in previous works. The semiabstract nature of the final work is a larger vision of the concept that every square inch of a great direct painting, when examined independently, should be very interesting visually.

RIGHT: Al Gury, *Deep Woods*, 2006, oil on panel, 11 x 14 inches (27.9 x 35.5 cm). Private collection

"Drawing" with the brush is especially important in alla prima painting. For this composition, I created the effects of trees and foliage by dragging, scumbling, and stroking the paint to suggest nature. A unifying, transparent dark blue-green glaze ties things together and intensifies ridges and marks in the paint.

LEFT: Louis B. Sloan, *Gathering Storm over Philadelphia*, c. 1961, oil on canvas, 38 x 46¼ inches (96.5 x 117.4 cm). Courtesy of the Pennsylvania Academy of the Fine Arts, Philadelphia. John Lambert Fund

Sloan built up layers of washes, scumbled paint to mass in forms and tones, and followed this with dense, loaded paint strokes, which created not only local textures but the emotional effect of the approaching storm. The houses and their relatively smooth strokes are set off against the rough, almost expressionistic impasto of the sky. The composition is unified not only by the rich patina of brush calligraphy but by the close tonalities of the sky and buildings.

ABOVE: Stuart Shils, *Apartment House on 33rd Street*, 1998, oil on panel, 10¾ x 8¾ inches (27.3 x 22.2 cm). Courtesy of Tibor de Nagy Gallery, New York

Shils employs a rapid yet precise brushwork in the best traditions of alla prima painting. Broad, generalized masses of tone and color provide settings for specific color accents. His surface brush calligraphy moves the viewer's eye easily through the composition from one area to another. Top-layer touches of the brush create textures and spots of light that also unify the painting's surface.

SCUMBLING, VELATURAS, AND GLAZES

Scumbling, velaturas, and glazing are paint application methods that are a bit more specific than general brushwork, so it's helpful to break them out here for a clearer understanding. The important things about all three methods are that they be layered properly and that they have only so much medium in them as is really needed.

Scumbling is a dry-brush effect used to add subtlety to paint layers. A velatura is a type of translucent milky glaze that can create optical grays and illusions of layers glowing through one another. A traditional transparent glaze most often is used to adjust the color or value of an area of a painting as a final layer.

Painters considered to be working in the direct, painterly, or alla prima tradition have, since the sixteenth century, employed a great variety of technical effects in their work. As mentioned previously, while the quick, one-shot alla prima painting is the simplest type of direct work, most more-developed alla prima works are not only done in a variety of layers but are developed over a number of painting sessions. Artists working in this tradition, such as Velázquez, Hals, Manet, Monet, Eakins, and Freud for example, built paintings through a number of sessions and layers, often incorporating washes, scumbles, impasto, and a final glaze to complete the piece.

Each direct master varies in the number and type of technical effects used, but all draw from a pool of historical and practical methods available to them. The use of a final glaze in a Hals painting does not classify him as an indirect painter. It is the overall final "effect" and unifying structures of the painting that qualify it as either direct or indirect. In a study of alla prima painting methods, the whole range of technical processes used by such painters must be examined to understand what has really been created through the history of painting. This more complete examination of alla prima or direct painting will offer modern painters a range of options rather than the narrow academic definitions presented and often misunderstood in the last hundred years.

Scumbling

A scumble is sometimes called a dry brushstroke. Using a dry brush, semi-opaque color is roughed over a passage of a painting to integrate two areas or to create added luminosity and depth. The translucency of the scumbles may vary. Scumbling can also be used to rough in the first layer of color in an alla prima painting, to be followed by more purposeful strokes and even a finishing glaze.

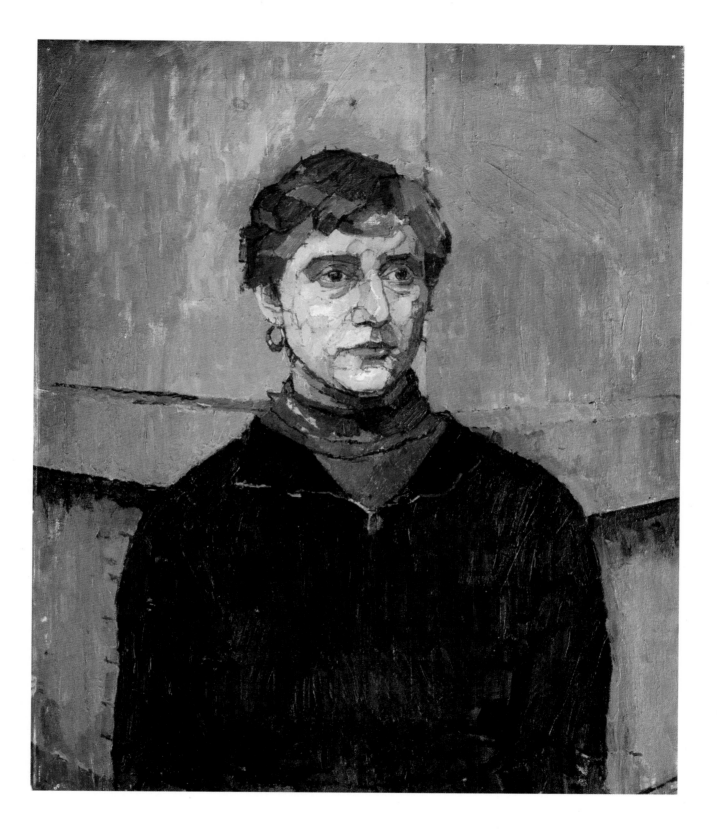

BELOW: Jon Redmond, *View*, 2000–2007, oil on panel, 10 x 10 inches (25.4 x 25.4 cm). Courtesy of the artist

OPPOSITE: Carolyn Pyfrom, *Jenny by the Door*, 2006, oil on canvas, 24 x 28 inches (60.9 x 71.1 cm). Courtesy of the artist

Throughout the simple expanse of the wall, floor, and sky in this rich interior below, Redmond applies scumbled paint to build up the texture and tonality. Only in the buildings seen from the window does he use directional, planar strokes.

In the image opposite, the subtle tones of neutral grays, whites, and yellows are built up as scumbles over the large architectural areas. Directional strokes in the figure finish off the painting surface. The scumbled effect creates subtlety; if more direct strokes had been used throughout, the painting would have seemed busy and expressionistic rather than quiet.

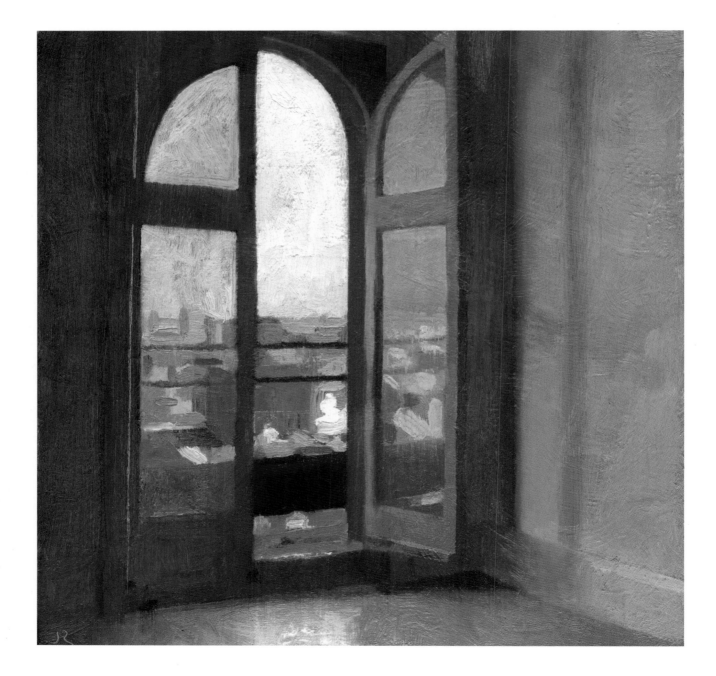

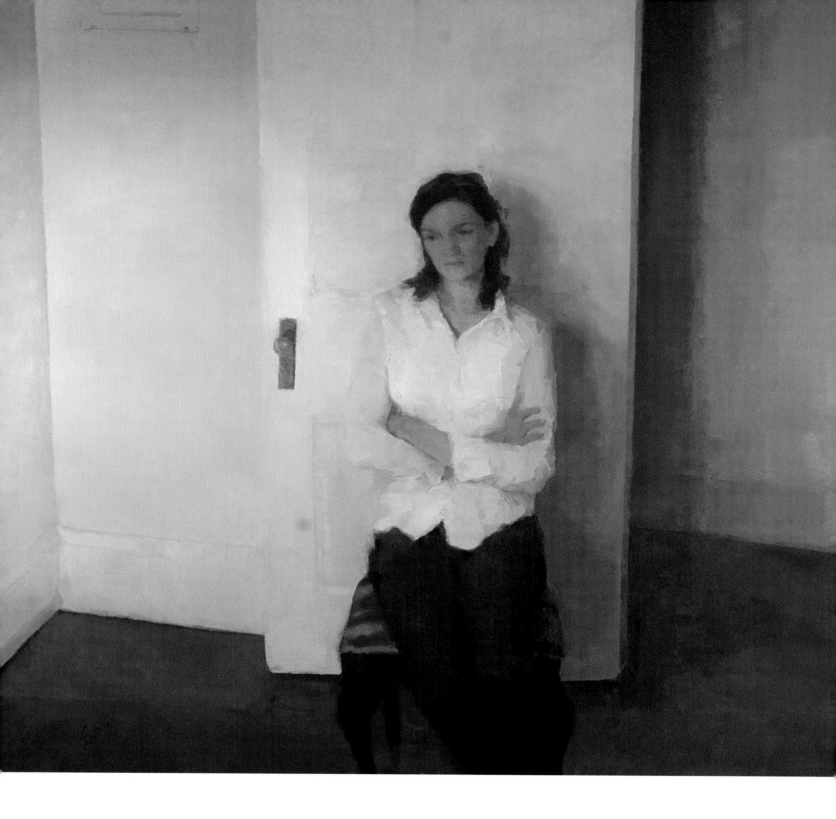

Velaturas

A velatura is a milky or translucent form of a glaze that, along with scumbling, is often used to integrate or modify layers of paint. Both velaturas and scumbling can be used either as intermediate layers or as topmost finishing elements. For example, velaturas are most often seen in indirect painting such as fifteenth- and sixteenth-century Italian and northern European works. Early Flemish portraits would be developed first with a complete closed-form underpainting. A translucent velatura tinted to the appropriate flesh color would be spread over the face, creating an opaque, light mass and optical grays or cools in the shadows as the underpainting showed through the velatura. Details and local adjustments would be added to the top layer of the face in the eyes, nose, and mouth with a drawing color and a fine brush. Velaturas are often used to modify or adjust layers of what is otherwise a direct painting.

RIGHT: Arthur DeCosta, portrait underpainting, oil on canvas, 12 x 10 inches (30.4 x 25.4 cm). Courtesy of the Pennsylvania Academy of the Fine Arts. School collection

This underpainting for a portrait makes use of a velatura. First, a red chalk drawing was executed over a mid-tone tan. Then, a translucent, flesh-toned velatura was laid down over the drawing. The modeling of the form, achieved by the chalk drawing, shows through the velatura, providing three-dimensional structure.

OPPOSITE: Alex Kanevsky, *Waterlady*, 2007, oil on Mylar mounted on board, 36 x 36 inches (91.4 x 91.4 cm). Courtesy of the artist

Waterlady *is constructed using thin, translucent paint (in the tradition of a velatura), with final opaque touches to complete the form and detail. The light tan ground and cooler touches show through the translucencies, creating optical illusions of space and richness. The techniques of this direct painting also contribute to the lovely poetic feel of Kanevsky's work.*

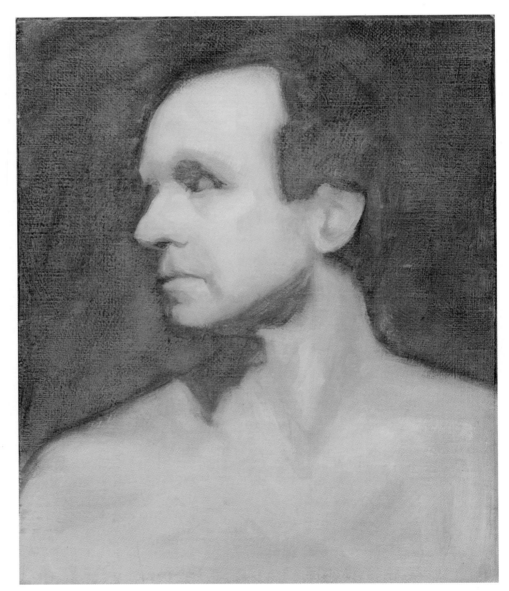

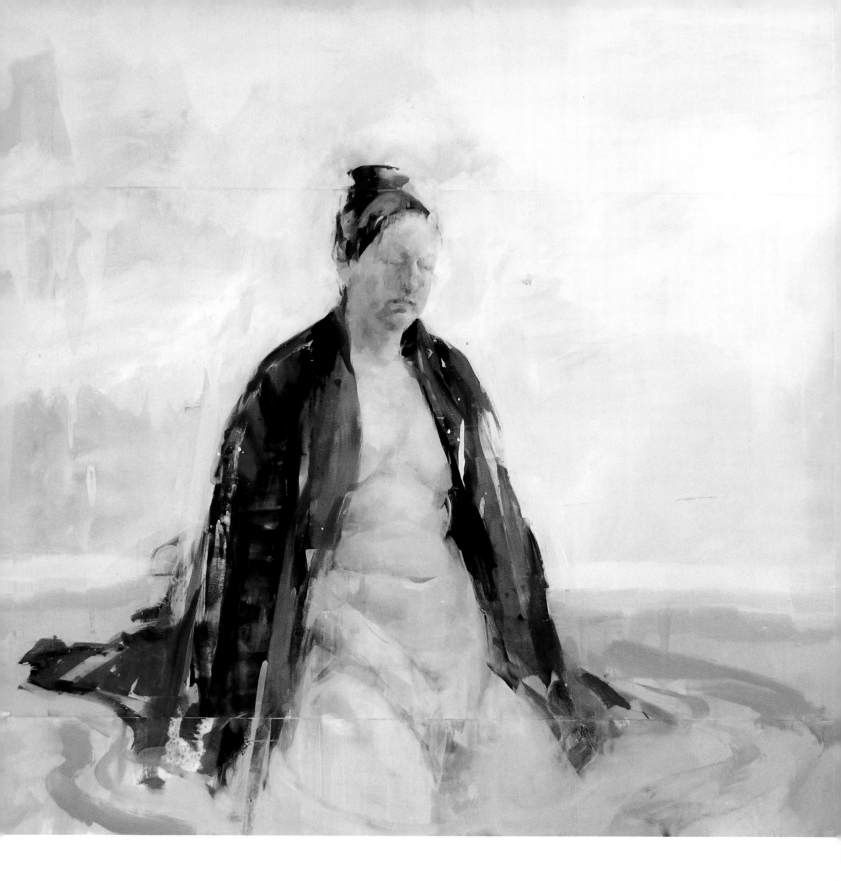

Glazes

Of all the oil painting techniques, glazing is the one that is the most misunderstood and shrouded in myth and mystery. Late-nineteenth-century painters and writers speculated on the "secrets of the old masters." With the gradual demise of the workshop system over the centuries and the advent of state-sponsored academies, many of the practices of the studio were indeed lost or left unclear in the minds of later generations. Glazing practices began to take on an aura not unlike that of the Holy Grail in the minds of romantic nineteenth-century painters.

Some of these attitudes center on the idea that fine old-master paintings were created with many layers of subtle glazes placed one over another to create luminosity and depth. Most early oil paintings, however, were actually extremely practical and economical in their methods, because while such paintings often made use of several layers to create the finished effect, the old masters knew that multiple glazes would only darken one another and create an unstable structure. Late-nineteenth-century paintings created in an unstable manner often are conservation nightmares, exhibiting cracking and flaking. So, while a painting by the Italian painter Titian (1488–1576) is very stable in its structure, works by the American Symbolist painter Albert Pinkham Ryder (1847–1917), although very beautiful, are highly unstable due to his unorthodox layering.

Arthur DeCosta, *The Burial of Count Orgaz (after El Greco)*, oil and acrylic on watercolor paper, 20 x 16 inches (50.8 x 40.6 cm). Courtesy of the Pennsylvania Academy of the Fine Arts. School collection

This work by Arthur DeCosta makes use of glazing to impart color to the underpainting. First, burnt sienna, ivory black, and white acrylic paints were placed over a red-chalk drawing that was transferred to gessoed watercolor paper (above). Then, finishing glazes of oil color were applied to tint the grisaille underpainting. This reflects the alla prima methods of El Greco—directly painted grisaille colored by single skins of local glazes.

The most basic type of glazing technique is the most common: a single, medium-rich transparent top layer to finish and adjust the tone or color of an otherwise directly layered painting. This is the final layer applied over a dry painting. Commonly, a transparent finishing glaze may be added to tint lips, clothing, and backgrounds. Also, a glaze may serve to help bring the subject forward spatially.

As discussed in the scumbling section, it is important to reiterate here that alla prima artists employ a range of techniques, not always rigidly adhering to the one-shot output. Direct painters have often used a final thin glaze to adjust or finish an area. Very common in paintings from the seventeenth through the nineteenth centuries, this concept—rather than invalidating the direct nature of these works—enhances their vigor and drama. And again, the overall effect of a painting must be considered when deciding its classification. Thomas Eakins, heavily influenced by the Spanish Baroque masters, is one of the most important modern, open-form alla prima painters. His works often include a finishing glaze to unify his masterful brushwork and tonalities.

Arthur DeCosta, copy of a sixteenth-century painting, c. 1970, oil on canvas, 18 x 24 inches (45.7 x 60.9 cm). Courtesy of the Pennsylvania Academy of the Fine Arts. School collection

In DeCosta's copy of a sixteenth-century painting, the figure and landscape were developed in earth colors. The sky and robe were built up from a grisaille underpainting, and then an ultramarine blue glaze was placed over the sky and a rose madder glaze was placed over the robe.

As in other copies by DeCosta, the final glazes over the fabric and sky areas in this painting illustrate their use in finishing an otherwise direct painting. This simple type of layering common to direct painting should not be confused with that found in more complexly layered closed-form paintings.

DEPTH PERCEPTION

There is an old optical rule: Sharper, darker, clearer, brighter comes forward; softer, fuzzier, grayer goes back. This is basically how we perceive depth, both physically and atmospherically. Layering of brushwork also creates a sense of depth in a painting, and the layering of brush effects from background to foreground depends on the aforementioned rule.

For example, in a portrait, to get the nose to come forward, you need to render its planes and edges clearer and sharper to create the illusion of the structure coming forward off the head. In a landscape, the foreground areas need to be more vigorous in their brushwork, while the background needs to be softer or less distinct by comparison so that it appears to recede into the distance. This is achieved by the combination of elements mentioned in the optical rule. However, such rules are meant to be adjusted as needed and shouldn't be used as a rigid set of solutions at all times.

Al Gury, *Portrait of Sarah*, 1998, oil on canvas, 14 x 11 (35.5 x 27.9 cm). Collection of the artist

Depth is achieved in this portrait by the application of general rules of optics in brush-work and color temperature. Clearer edges in the brushwork advance, while the softer edges here and there around the form link the figure to the softer, atmospheric background. Warmer and brighter colors in the skin move forward because they are also sharper and clearer in their brush calligraphy. Sharp highlights on the nose and earrings bring those elements forward relative to the broader and slightly less sharp brushwork in the clothes and other areas of skin. The soft purplish color of the background forces the warmer, sharper colors of the body forward. Keep in mind that the relativity of sharp to soft, warm to cool, and so forth can be manipulated in a myriad of ways to create depth and interesting visual effects.

Arthur DeCosta, *Portrait of Al Gury,* c. 1970, oil on canvas, 16 x 12 inches (40.6 x 30.4 cm). Collection of Al Gury

DeCosta uses almost the whole range of alla prima brush effects in this portrait. An imprimatura (the transparent beginning layer) over a tan ground sets the effect of atmosphere on the canvas. Over loose brush placement made of burnt sienna and ivory black, the first denser layers are brushed into the face and scumbled in the clothes. The background has a translucent brown brushed into the transparent imprimatura. Brushstrokes in the face and body are lightly "dusted" with a clean, dry brush to blend away edges that are too sharp and to prepare for the final touches of lightest lights and darkest darks. Brush calligraphy is strongest in the forward-moving surfaces: the hair at the forehead, the nose, and the collar. Subtle brush accents clarify the features and integrate them into a harmonious special whole.

Color is a good example of this. Logically, a bright red in a still life should optically zoom forward. Yet, it will do this only if its edges, brushstrokes, and values are also strong and clear. The same red can recede into and be kept in the background if it is rendered with softer edges and brushwork. In addition, how it is perceived is relative to other, stronger effects in the foreground. Neutral darks can come forward, while bright and light areas can be kept back by the adjusting of the rules relative to each other. Values, edges, intensities, strokes, scumbles, and so on all work together in concert relative to one another to create depth in a direct painting.

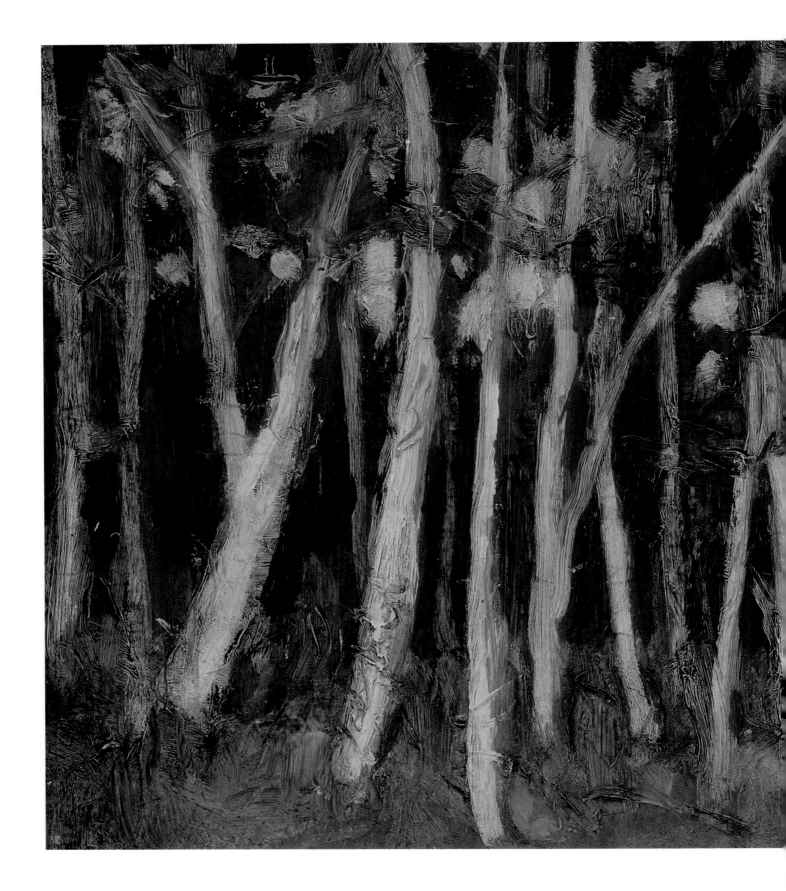

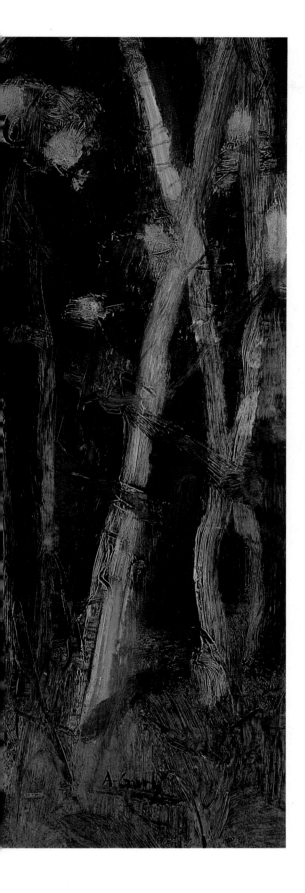

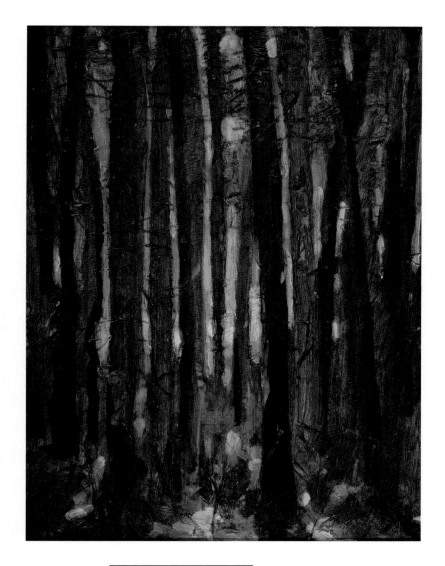

LEFT: Al Gury, **Birch Grove,** 2007, oil on panel, 11 x 14 inches (27.9 x 35.5 cm). Private collection

ABOVE: Al Gury, **Pinewoods at Sunset,** 2006, oil on panel, 16 x 12 (40.6 x 30.4 cm). Private collection

In both of these paintings, the formal optical rules that create depth are manipulated and stretched. In the image opposite, the light trees advance by virtue of the clarity of their brush-strokes and edges. The dark pigments, by contrast, are soft and diffuse, so they recede. In the image above, the reverse happens: the dark trees advance because they have stronger, sharper edges, while the light hues, though intense, are soft and, therefore, recede. The rules for rendering depth are meant to be manipulated and varied for the good of the painting.

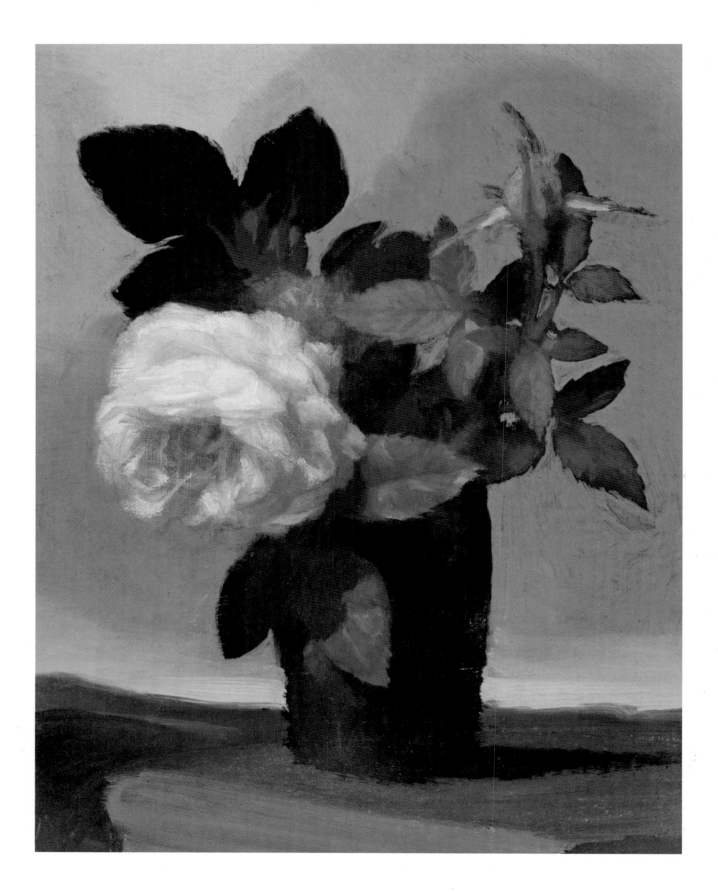

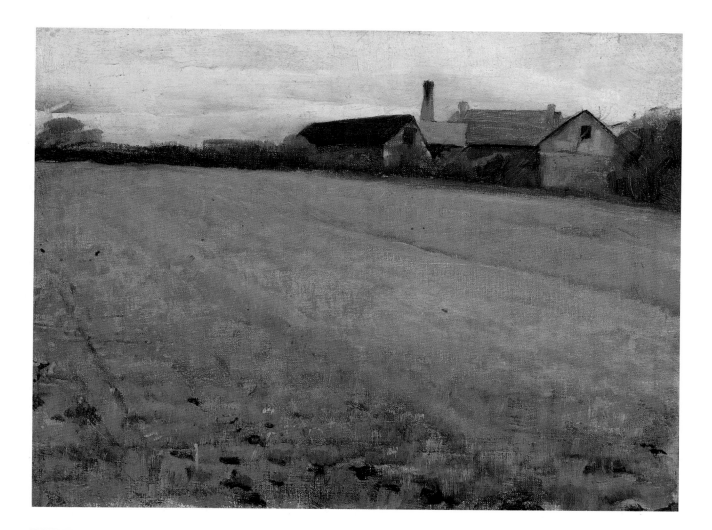

OPPOSITE: Arthur DeCosta, **Roses in a Jar,** c. 1970, oil on canvas mounted on panel, 10 x 8 inches (25.4 x 20.3 cm). Courtesy of the Pennsylvania Academy of the Fine Arts, Philadelphia. School collection

In this simple yet elegant still life, DeCosta creates illusions of atmosphere and depth through the use of optical rules and relationships. The rose is clearest in its detail and brushwork, particularly the *leading edge of the nearest petals, as is the edge of the shelf on which the vase sits. The bud and bright green leaves are next in their spatial position relative to the viewer. They are a little softer in their clarity. The background leaves are less detailed and of a more neutral set of colors, which places them farther from the viewer optically. The sky, while bright, has no detail or edge of any kind and stays in the distance.*

ABOVE: Cecilia Beaux, **Landscape with a Farm Building, Concarneau, France,** 1888, oil on canvas, 11¹⁄₁₆ x 14⁹⁄₁₆ inches (28.1 x 36 cm). Courtesy of the Pennsylvania Academy of the Fine Arts, Philadelphia. Gift of Henry Sandwith Drinker

Cecilia Beaux is a master of illusions and relationships, which creates a sense of depth and perspective in her paintings. Aerial and atmospheric perspective can be defined as an illusion of depth created by the relationships of edges, sizes, *colors, and values, rather than of lines and vanishing points. In this landscape, the foreground is brushier, which brings it forward optically relative to the building, which is more neutral in color and less vigorous in its brushwork. By establishing this relationship between background and foreground, Beaux avoids the difficulty of putting too much emphasis on the buildings and not enough on the field, thus creating a landscape that flattens out or seems to "drop off" at the bottom.*

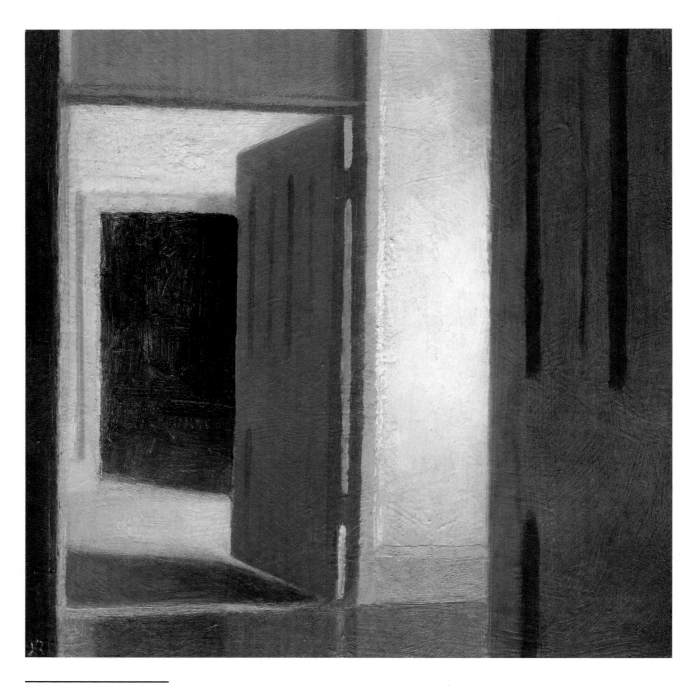

Jon Redmond, *Interior*,
2000–2007, oil on panel,
10 x 10 inches (25.4 x 25.4 cm).
Courtesy of the artist

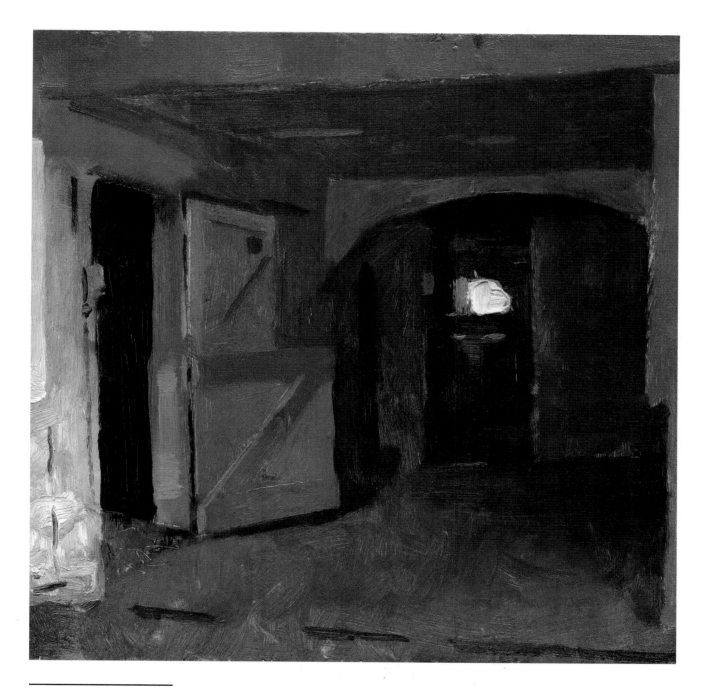

Jon Redmond, **Barn,**
2000–2007, oil on panel,
10 x 10 inches (25.4 x 25.4 cm).
Courtesy of the artist

Optical rules are meant to be manipulated and tinkered with for the good of the painting. There is an infinite variety of relationships and adjustments that can be created to provide a sense of depth and space in a painting. Things must be flexible. For example, darks can come forward if they are also brushier and have stronger edges than the background, but darks can be kept in the background by virtue of being softer in definition relative to the foreground. Brights can advance if they have stronger definition but can also remain in the background if they are softer in definition relative to the foreground forms. In these Jon Redmond paintings, the rules are manipulated in interesting ways. Planes, architectural forms, and foreground darks move the viewer's eye through the scene and the space. Redmond uses, bends, and breaks the rules to create these striking spatial descriptions.

Peter Van Dyck, *Cast Hall, PAFA*, 2006, oil on canvas, 24 x 18 inches (60.9 x 45.7 cm). Courtesy of the artist

In this painting, the large, softly defined forms of the cast figures come forward by virtue of their large mass, not their clarity or detail. Light and mass—rather than strict rigid rules of optics—unify and organize this composition. The almost playful use of light and form in this painting is yet another example of the optical rules working in service of the painting and the artist's vision—not the other way around.

Alex Kanevsky, *Annunciation*,
2007, oil on linen, 66 x 66
inches (167.6 x 167.6 cm).
Courtesy of Alex Kanevsky.
Private collection

*This mysterious painting by
Alex Kanevsky combines the best
elements of traditional alla
prima painting with dramatic
compositional elements that*
*recall the great modern Abstract
Expressionist painters Franz
Kline and Richard Diebenkorn.
Intensely dark transparent
masses frame an atmospheric
transition into deep space.
Those larger, warm foreground
masses come forward while
progressively cooler and smaller
masses and brush touches
recede into the distance of the*
*room. The luminous ceiling
mass provides a counterpoint
to the anchoring dark masses.
The figure of a woman provides
an intensely psychological
element while at the same time
helping to define the space.
This work is a beautiful exam-
ple of the blending of modern
painting aesthetics with time-
honored concepts.*

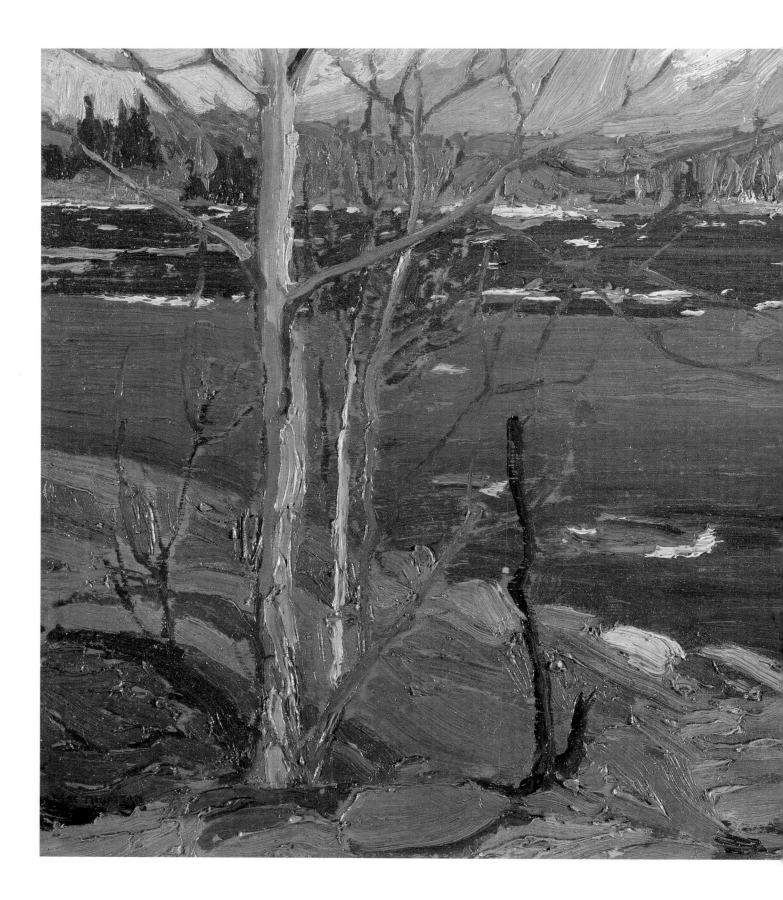

SKETCHES VS. FINISHED PIECES

The practice of making an oil sketch or oil study stands alone in the alla prima tradition. The simplest form of alla prima or direct painting is, in fact, the one-shot sketch, usually on a small scale. This is done fairly quickly in one sitting and not intended as preliminary work for a more finished piece. Oil sketches are also used by both direct and indirect painters as preparatory studies and are at the core of academic training. The 8 x10-inch pochade size (see page 29) is typical. For many painters, this form of direct painting is the most attractive. Canadian landscape painter Tom Thomson (1877–1917) is highly respected for his powerful, small-scale oil sketches.

Preliminary oil sketches or studies for larger paintings are done to analyze and study the overall characteristics and general effect of a subject prior to starting the more developed work. This is an excellent study practice and often produces small alla prima paintings of great beauty. The oil sketches by eighteenth-century English landscape painter John Constable (1776–1837) set the tone for this tradition. His sketches are often more well liked than his elaborate finished works.

Tom Thomson, *The Opening of the Rivers: Sketch for "Spring Ice,"* 1915, oil on wood-pulp board, 8½ x 10½ inches (21.6 x 26.6 cm). National Gallery of Canada, Ottawa. Bequest of Dr. J. M. MacCallum, Toronto, 1944

Photo © National Gallery of Canada

The oil sketch can be both a painting that stands alone and a way of preparing and envisioning the elements of a more complex work. Tom Thomson used his quick, on-site landscapes in both ways. The majority of his paintings of the woodlands and rivers of Canada, particularly Ontario, are masterful examples of the oil sketch that is complete in and of itself. Each stroke is calculated to capture the mass, shape, and texture of the elements of the scene quickly and concisely. The small scale of these paintings facilitates the strength of the overall composition and effect.

A preliminary sketch should focus on the essential elements of tone, color, shape, and composition that will organize the larger finished work. In this sense, they often have a brushy and almost abstract quality. Preliminary oil sketches for portraits also can clarify the likeness of the sitter. The oil studies of John Singer Sargent and Thomas Eakins are very powerful in their simplicity.

The oil sketch can be both a finished aesthetic statement in its own right and a preparatory study for a larger work. These small studies exhibit directness of brushwork and intensity in the formal qualities of shape, tone, mass, and expression. The finished work ideally embodies the strong qualities defined in the sketch.

Tom Kohlmann, portrait study, 2007, oil on canvas, 14 x 11 inches (35.5 x 27.9 cm). Courtesy of the artist

The bold brushwork in this painting not only captures the "character" of the subject but also describes his anatomy and the structure of the form. Quick direction changes in Kohlmann's brushwork literally "draw" the portrait.

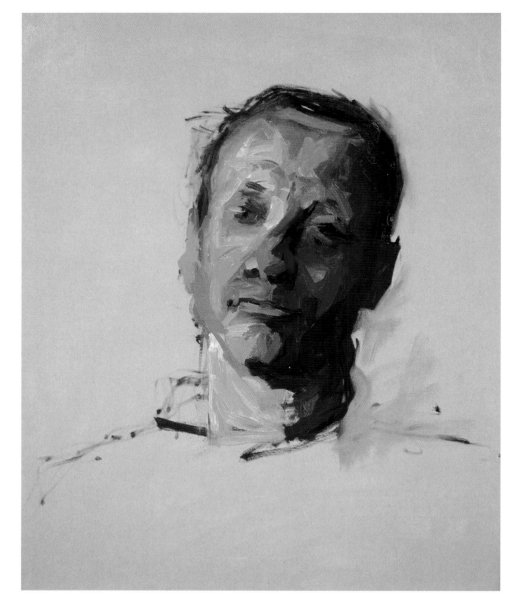

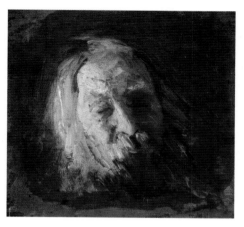

Thomas Eakins, *Walt Whitman*, c. 1887, oil on panel, 5½ x 5¼ inches (13.9 x 13.3 cm). Museum of Fine Arts, Boston. Helen and Alice Colburn Fund

Photograph © 2008 Museum of Fine Arts, Boston

Thomas Eakins, *Walt Whitman (1819–1892)*, 1887, oil on canvas, 30⅛ x 24¼ inches (76.5 x 61.6 cm). Courtesy of the Pennsylvania Academy of the Fine Arts, Philadelphia. General Fund

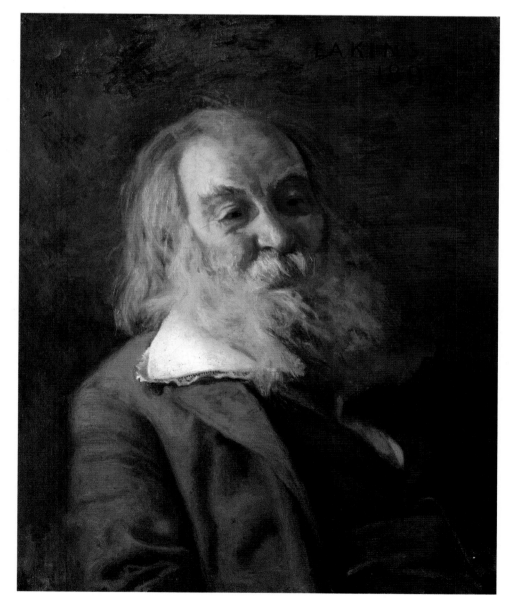

There is much debate among painters concerning the merits and aesthetic strength of the portrait sketch versus the finished portrait. Since the seventeenth century, the execution of the direct oil sketch as a preparation for a major work has been a common practice in both portrait studios and the classrooms of the academies. Classic academic training, even that currently practiced at the Pennsylvania Academy of the Fine Arts, includes learning how to develop a painting through the process of drawings, preparatory oil sketches, and the painting stages of the final work. This is true for both direct and indirect methods.

Thomas Eakins made many oil sketches, as well as photographs, in preparation for portraits he considered to be major projects. His oil study for the portrait of Walt Whitman is considered by many painters to be a magnificent work in its own right that satisfies many ideas of what a good portrait is. The bold, almost abstract qualities of the sketch capture the formal qualities of the portrait in color, mass, shape, tone, and intensity. The finished work adds the human element of his sense of humor and complexity of personality.

COPYING THE WORK OF OTHERS

Students have been copying the works of recognized masters for as long as art training has existed. The Romans studied and copied famous Greek works, medieval masters emulated the works of the Greco-Roman world, students during the Renaissance copied classical works and the works of their workshop masters, and the academic systems of the eighteenth and nineteenth centuries included the execution of museum copies as a regular part of their curriculums. It was common for students in the nineteenth century to augment their incomes by painting and selling copies.

The twentieth century saw philosophical changes and additions to the canons of art education in this area. One approach suggested that if the education of a young artist was primarily through experimentation, and the work of an artist was an autonomous and personal developmental process, outside influences such as copying would have a negative influence on the unique creative growth of the artist. Art was less about skill and craft and more about exploration and invention, according to this belief.

Theories of human development and learning suggest that art students, like children, will partly find themselves by emulating and experimenting with a variety of adult style models. Appropriate copying of masterworks aids in the synthesizing process of experience, identity, and experiment. This, in turn, leads to the development of a mature artist.

Tips for Copying the Masters

Painting copies that illustrate the historical use of a palette, structure, composition, or style is an excellent way to study. With the advice of your instructor, choose a painting appropriate to your goal, whatever it may be. If you are not under the guidance of an instructor, make an honest assessment of the areas you need to strengthen in your work. Choose a master whose work has strength in those areas, and do a sketch copy to get a feel for how to improve those elements. Copy them boldly to really get the feel of them and to then be able to apply that experience to your own work. You may have to do many copies along the way as self-study.

Very experienced painters routinely do copies, both to explore and learn the aesthetics of an artist they admire and to refresh themselves when they are tired or flat. In addition, keep the following things in mind when you make a sketch copy:

A masterwork can be copied with a limited palette, with a full classic palette, or with the exact palette the master used.

Copies can either focus on very specific elements (such as flesh mixtures, individual body structures, or specific brushwork) or large issues (such as layering, composition, and light and shade).

You can choose masters from different time periods who use different methods, or you can copy one master extensively.

ABOVE, LEFT: Al Gury, *St. Jerome and the Angel (after Jusepe de Ribera)*, 2002, oil on canvas, 14 x 11 inches (35.5 x 27.9 cm). Collection of the artist

ABOVE, RIGHT: Al Gury, *St. Peter (after El Greco)*, 1991, oil on panel, 14 x 11 inches (35.5 x 27.9 cm). Collection of the artist

LEFT: Al Gury, after Thomas Eakins, 2000, oil on panel, 12 x 9 inches (30.4 x 22.8 cm). Collection of the artist

These copies are explorations of three different technical elements of direct painting. The Ribera copy employs a limited earth palette and focuses on the strength of tonality in Ribera's paintings. *The palette was flake white, yellow ochre, burnt umber, burnt sienna, and ivory black. The El Greco copy focuses on that artist's use of direct grisaille underpainting finished with thin local glazes to tint each area. The palette here was ivory black and titanium white for the underpainting and ultramarine blue, permanent rose, and chrome yellow for the glazes. The Eakins copy is a study of planes and brush structure. The palette was yellow ochre, raw umber, burnt sienna, red oxide, ivory black, cadmium yellow light, cadmium orange, vermilion, permanent rose, ultramarine blue, and Prussian blue. These are examples of using the sketch copy to study particular elements of a painting about which one wishes to learn more.*

Types of Copies

There are two basic kinds of copies: a sketch copy, which can be done casually and for a variety of goals, and an exact copy, which requires close supervision and planning. Certainly, the copying tips outlined on page 110 apply to a sketch copy, which can be done from a good, clear, large reproduction of a master's work.

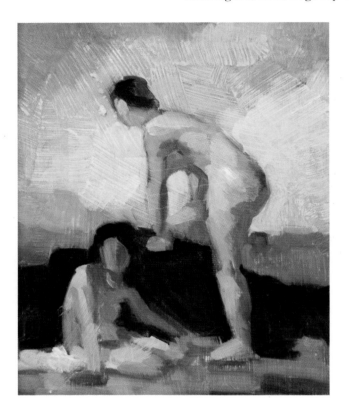

Student copy after William Bouguereau, c. 1990, oil on gessoed panel, 10 x 8 inches (25.4 x 20.3 cm). Collection of the author

This lovely sketch copy is successful because the student analyzed the basic structure of the original and translated it into its essential masses, planes, and colors. The original painting is an indirect work with a high classical polish to the finish, but this sketch stands on its own as a fine example of direct figural and compositional painting. It also mirrors the appearance and goals of Bouguereau's own preparatory studies, as well as those of most other indirect painters of the nineteenth century.

Sketch copies usually show strong evidence of the "hand" of the person doing it, rather than a close simulation of the original master's hand. For example, many of Rubens's copies of Titian and Caravaggio look as much like a Rubens as they do a work by one of those Italian masters. However, sketch copies can look very close to the original in final effect.

Additionally, the tradition of the sketch copy makes use of quickly done alla prima painting for the purpose of learning or practicing various elements of craft: brushwork, color, composition, blending, planes, expression, or overall process. Palettes and methods may vary, but general research on the original should be done first. Sketch copies are typically small but can be of any size as long as they suit the goals of the exercise and depart from the size of the original or are a fragment of the original.

Exact copies intend to simulate most of the "effects" of the original. These copies re-create the process used by the original artist and stay very close to the details in the original painting. Prior to beginning a good "exact copy," you should research extensively the original methods and materials employed, including the ground, layering, brushwork, original palette, and surface finish. Working from a fine reproduction is acceptable, though the original is, of course, better. Familiarity with a range of works by the master is important regardless of whether a reproduction or an original is to be used.

The supervision of the instructor is important in the execution of this kind of copy. An exact copy should be undertaken only after the painter has experience doing sketch copies, especially of the master they wish copy more exactly. Consulting an instructor who has experience in these matters can help set guidelines, research goals, and critiques of progress. The instructor should be consulted for the appropriate methods, goals, and so on. If you don't have access to an instructor, you should do extensive research on the master's aesthetic goals, style, working methods, and materials, and make comparisons of a number of the artist's paintings to assess commonalities. Research the palette colors, supports, ground color, layering and brushwork methods, and finishing effects.

The execution of an exact copy can be a frustrating process if there is not enough preparation. Time must be taken to do the research and set aside for the whole process; depending on the artist chosen, this can be anywhere from one to three months. If you are not in a formal class, make sure you plan with care. Note that you can use a reproduction

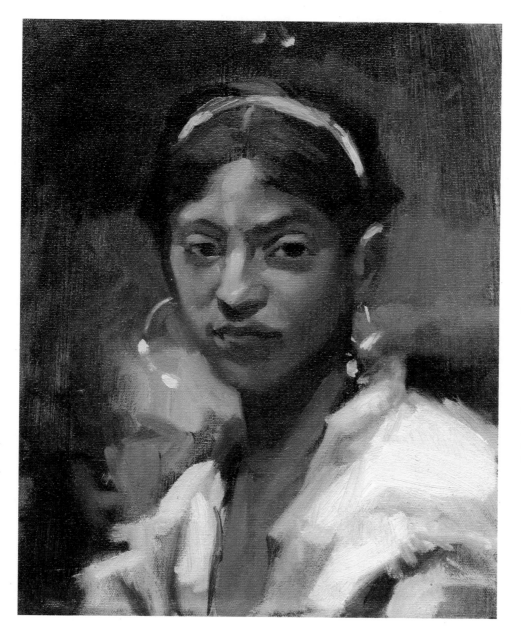

Al Gury, *Head of a Capri Girl (after Sargent)*, 2001, oil on canvas, 14 x 11 inches (35.5 x 27.9 cm). Collection of the artist

This copy focuses on Sargent's use of closely related neutral colors and simple value structures. I used a small finishing glaze of rose over the hair ribbon, for example, which seems true to the original.

One important factor in copies in general and sketch copies in particular is that the "hand" of the artist making the copy is usually visible. The way artists make brushstrokes and drawing touches is a function of their own hand movements and personality. So, there is always a bit of the "copier" in each copy, no matter the original artist. Rubens's copies of Titian and Caravaggio all have a feeling of Rubens in them. This is a good thing and helps the painter eventually develop his or her own sensibilities and aesthetics. Rather than being an exercise in "merely copying," this helps painters move toward their true selves as artists.

of a piece, as opposed to the original in a museum. Make sure to refer to the reproduction often, and do a number of preliminary drawings to work out the composition, structure, values, and anatomy. Be very patient. The underdrawing (done with the brush as you begin) is essential to keeping the whole structure of the painting intact. If the drawing structure seems to get lost, simply redraw it with the brush and move forward.

In either case, whether you are making a sketch copy or exact copy, re-creating masterworks is an excellent way to study all the topics discussed in this book. While sketch copies are, in general, closely related to alla prima methods, exact copies can be done of any master, including direct painters.

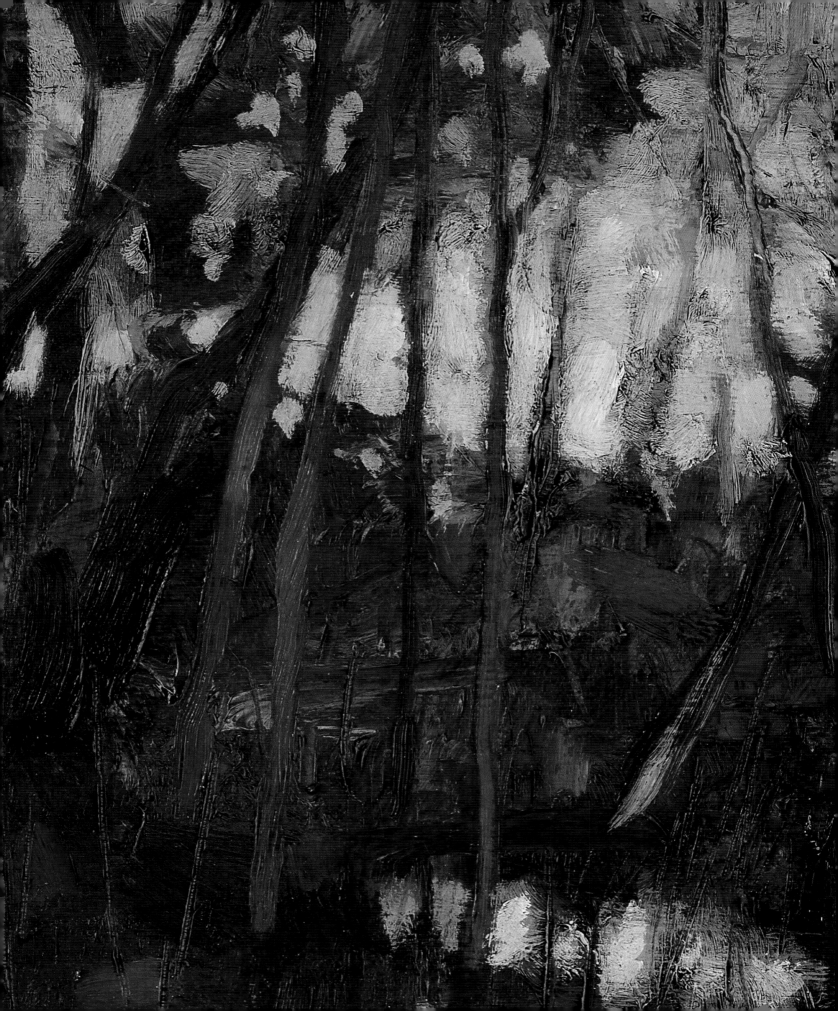

4

The Genres Explored

———

The following demonstrations describe basic direct painting methods as might be applied to the four major genres of portrait, figure, still life, and landscape. They do not illustrate the great variety of approaches possible but rather focus on the ones essential to a good understanding of alla prima painting.

The step-by-step sequences provide visual examples of placement, blocking in, and types of brushstrokes, layering, and finishing; all follow the "lean to fat" concept described in the text. In other words, preliminary paint layers are thin or scumbled on, while successive layers are thicker and more heavily loaded. Details at the end are established with a small amount of refined linseed oil added to facilitate the flow of the brush over wet paint. Otherwise, these paintings are done with little or no medium.

PORTRAIT

The familiar likeness of a friend or family member is one of the most common types of painting in Western art. Portraits of ancestors and heroes were common in the classical world, and by the seventeenth century, the portrait was not only a commemoration of an individual but also a sign of wealth. In colonial America, portraits quickly became symbols of the security and stability of a family in the New World.

Leonardo da Vinci (1452–1519) is credited with introducing the "psychological" portrait into the canon. Rembrandt (1606–1669) created portraits of tremendous poetry and pathos. In the nineteenth century, portraits were a subject of complex artistic exploration at the hands of the Impressionists, Realists such as John Singer Sargent and Thomas Eakins, and early modern painters. Today, portraiture is done for commemorative reasons as well as for aesthetic ones.

John Singer Sargent, *Mr. and Mrs. John White Field*, 1882, oil on canvas, 44⅞ x 32 inches (114 x 81.2 cm). Courtesy of the Pennsylvania Academy of the Fine Arts, Philadelphia. Gift of Mr. and Mrs. John White Field

Sargent's early portraits are characterized by their rich dark tonalities and the strength of the personalities portrayed. This portrait of Mr. and Mrs. John White Field shows a masterful use of a fairly limited palette and the elegant use of light and shade that characterizes his early works. Also, this double portrait is very touching emotionally in the use of the hands touching and the physical closeness of the Fields in the composition.

Diego Velázquez, *Juan de Pareja (born about 1610, died 1670)*, 1650, oil on canvas, 32 x 27½ inches (81.2 x 69.8 cm). The Metropolitan Museum of Art, Purchase, Fletcher and Rogers Funds, and Bequest of Miss Adelaide Milton de Groot (1876–1967), by exchange, supplemented by gifts from friends of the Museum, 1971

Image © The Metropolitan Museum of Art

One of the masterpieces of Western painting, as well as of portraiture, Juan de Pareja *shows Velázquez at the height of his powers in his late work. Having been influenced by Titian and other Italian atmospheric tonal colorists, Velázquez brings a painterly lightness of touch to his brush layering and a luminosity to the color. A full range of alla prima brush effects and layering is employed, including a blocking in of masses followed by local plane development. A variety of brush touches creates texture in hair, lace, and jacket. The additions of final dark touches in the features and highest lights on the forehead, nose, and cheeks are followed by the application of dark glazes to unify the shadows.*

A number of considerations are important to the outcome of the portrait: lighting, background, composition, and overall process. In my demonstration that follows, for example, the overall lighting arrangement created a warm and brilliant light mass and a cool though colorful shadow mass. Portrait compositions traditionally range from a head and neck to the upper torso, or a half, three-quarter, or full-length pose. It's very important not to crop the portrait at a major landmark or joint of the body; doing so will make the figure seem cut off and truncated. Cropping just above a joint or major landmark will tell the viewer that the body continues on outside the cropped area. Also see page 132 for guidelines on posing a model; many of the issues involved with posing the figure apply when having someone sit for a portrait.

Along with the issues of painting process and color, one needs a reasonable visual awareness of the anatomical structure of the head. This not only impacts the likeness of the model, but also the planes and the layering of the paint. A number of good books on anatomy and head structure exist for you to consult.

Peter Van Dyke, *Rachel*, 2006,
oil, 24 x 18 inches (60.9 x 45.7
cm). Courtesy of the artist

*Classic palettes acquire that
categorization or status
because they have been so
practical and usable over the
centuries. This portrait by
Peter Van Dyke uses a palette
similar to that of Velázquez,
Sargent, Eakins, and many
Impressionist modernist
painters. The colors that have
become part of classic palettes
are well balanced relative to
one another and can be used to
capture most color, atmospheric,
and tonal effects in nature.
They are extremely practical
and easily adapted to varia-
tions in subject or observed
conditions.*

Tom Kohlmann, *Portrait*, oil,
20 x 16 inches (50.8 x 40.6
cm). Courtesy of the artist

*In this masterful piece of brush
construction by Tom Kohlmann,
a classic palette and structural
brush calligraphy create a very
modern portrait. The modern
portrait is often characterized
by psychological insights into
the sitter, emotional expression,
a lack of flattery, and a strong
sense of personal vision.
Whether the more modulated
surfaces and mood of the Peter
Van Dyke portrait (above) or
the emotionally edgy portrayals
of Tom Kohlmann, classic alla
prima methods become a solid
foundation for personal aes-
thetic statements.*

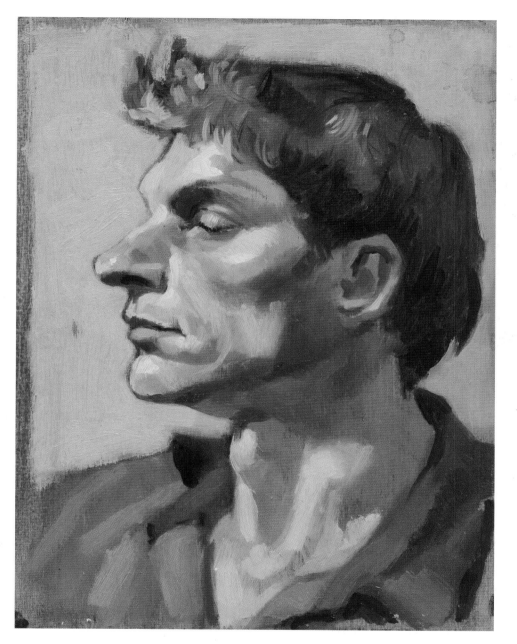

Al Gury, *Tom*, 1995, oil on Masonite, 10 x 8 inches (25.4 x 20.3 cm). Courtesy of the artist

Portraits in profile were extremely common from the time of the classical Greeks to the early Renaissance. Always elegant, these full profiles often suffer, however, from seeming flat and pattern oriented. Leonardo da Vinci's innovations in atmospheric oil painting and his preference for the more psychologically evocative three-quarter profile resulted in pure profiles becoming less common from the sixteenth century on. Even so, beautiful profile portraits have remained a focus in both direct and indirect painting for their elegance and exploration of line and silhouette.

While focusing on this sitter's strong features in profiles, robust brush calligraphy and color maintain the three-dimensionality of the model's form and negate flatness.

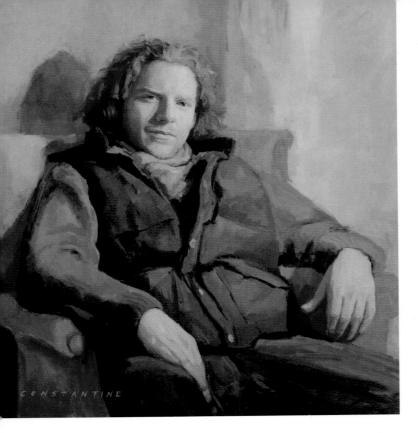

Lennart Anderson, *Portrait of Barbara S.*, 1976–1977, oil on canvas, 72⅛ x 60¼ inches (183.2 x 153 cm). Courtesy of the Pennsylvania Academy of the Fine Arts, Philadelphia. Gift of the Pennsylvania Academy Women's Committee, Balis and Co., Mrs. E. R. Detchon, Jr., Mrs. Kenneth W. Gemmill, J. Welles Henderson, The Blanche P. Levi Foundation, L'Oreal Corp., Dr. Charles W. Nichols, David N. Pincus, Marion B. Stroud, Mr. and Mrs. Stanley C. Tuttleman, Mrs. Bernice McIlhenny Wintersteen, and public subscription

Rachel Constantine, *The Sculptor*, 2005, oil on panel, 25 x 23 inches (63.5 x 58.4 cm). Courtesy of Artist's House Gallery, Philadelphia

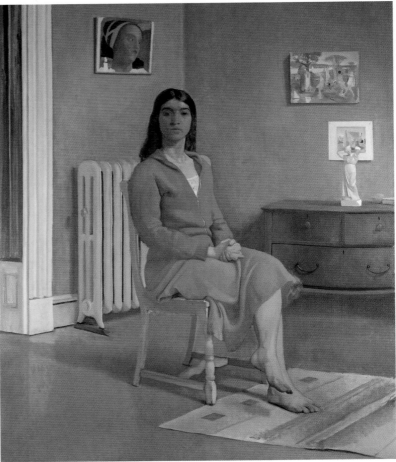

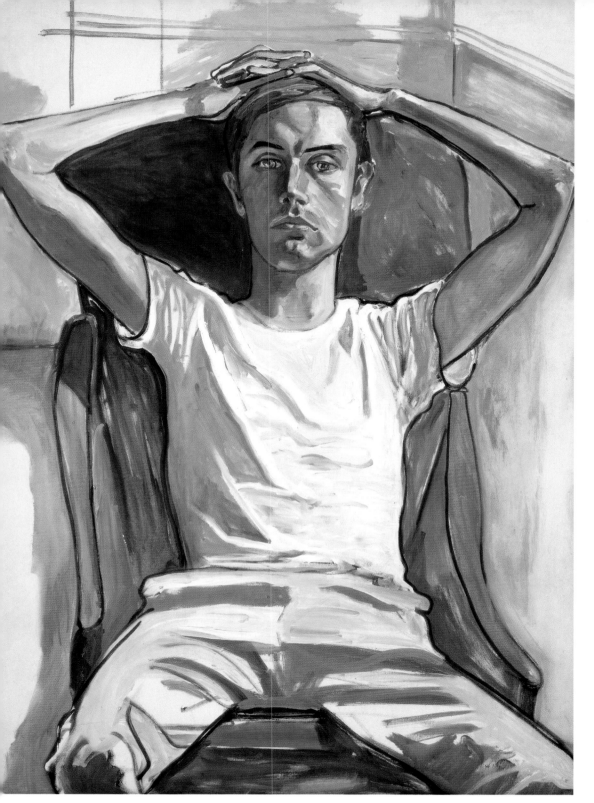

Alice Neel, *Hartley*, 1966, oil on canvas, 50 x 36 inches (127 x 91.4 cm). Gift of Arthur M. Bullowa, in honor of the 50th Anniversary of the National Gallery of Art. Image courtesy of the Board of Trustees, National Gallery of Art, Washington

Portrait compositions are as varied and complex as other figural paintings in the history of Western painting. The more the composition focuses on the sitter (showing only the head and shoulders), the more it is just about that person. The more the figure is included, the more the painter tells the viewer about the life around that sitter.

In the three paintings seen here, we get three very distinct "narratives" about not only the sitters but the attitudes and aesthetics of the painters. The Constantine portrait is casual and intimate, showing a young man with a bit of attitude watching us closely. It is all about him, and the design is compact and focused. The Neel portrait confronts us with a disarming, open pose designed to tell us that the subject is a very modern young man. The pose leads us into exploring the geometry of the whole canvas through its angles and shapes. Rather than focusing on just the sitter, it introduces the viewer to a broader abstract composition in the rectangle. And finally, the Anderson composition is a complex, formal design focusing as much on the space and other visual elements around the sitter as on the figure itself. The young woman is one element among many in the painting. The viewer is provided with a portrait that is also an interior and a still life and that can be enjoyed as a painting on many levels.

The Self-Portrait

A time-honored tradition of study and practice is the self-portrait. Self-portraits provide valuable documents of artist's methods, materials, and styles. They have been a common practice of most artists from the fifteenth century to the present and have crossed all stylistic boundaries. Self-portraits are a favorite subject of alla prima painters and an important source of artistic exploration.

The logistics of painting oneself take time and care for the self-portrait to be successful. To begin, choose a mirror large enough to view your face, neck, and shoulders. Set your easel and canvas back far enough from the mirror so that you can view your whole image in one glance; so, if you're including your torso in the composition, for example, make sure you can see not just your head but your torso, as well.

Place your easel and canvas on a slight diagonal to the mirror so that you can look as straight as possible back and forth from the canvas to the mirror. The image you paint is the one seen when you look comfortably toward the mirror. Try to move only your eyes as you go from your image in the mirror to the one on the canvas. Try not to move your head. This is difficult, but it can be done.

If using window light, set up the easel and mirror in a way that gives you the fall of light over the features that suits your study and goals for form. In addition, make sure

Violet Oakley, *Self-Portrait: The Artist in Mourning for Her Father*, c. 1900, oil on canvas, 25 x 20¹⁄₁₆ inches (63.5 x 51 cm). Courtesy of the Pennsylvania Academy of the Fine Arts, Philadelphia. Gift of the Violet Oakley Memorial Foundation

An important document of American art history is the legacy of self-portraits by our women painters. This somber and dignified painting by the young Violet Oakley is a fine example not only of psychological presence but also of simplified masses, planes, and tones. Adding more detail to this direct painting would not have enhanced the mood Oakley is presenting to us.

The painting is also a classic example of the self-portrait genre. The painter observes us, and herself, from a short distance as if to ask, Who am I at this moment? Her clothing and pose add the notes of seriousness that the title conveys.

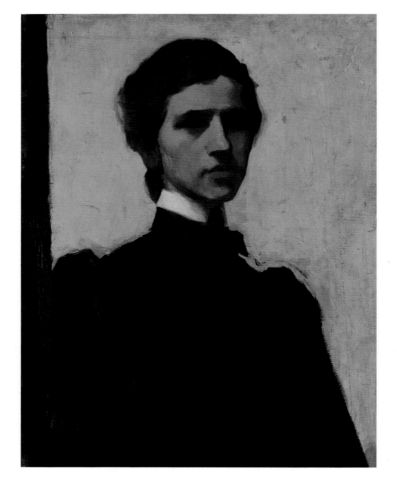

Al Gury, *Self-Portrait*, 2000, oil on panel, 14 x 12 inches (35.5 x 30.4 cm). Collection of the artist

Self-portraits have been used as a vehicle by artists to convey many things about themselves. An old joke among painters is that most self-portraits show the painter looking angry, depressed, or outright crazy. This actually results from the long periods of staring into the mirror, rather than anything else. Self-portraits also often are more an indication of how we see ourselves than how others see us.

For the beginner, the first self-portrait attempt will be frustrating. It may be a mess. The second one may look like a wild person. The third attempt may look more like a relative. Later attempts, with hard work, will result in a somber likeness.

you have enough window light falling on your canvas to give you adequate painting and mixing light. If using artificial light, you will need a spotlight to light your face at the angle you have chosen for the portrait. And again, you will need sufficient light on the palette for mixing your paints. Some painters try to have one light source for the whole; others set up two light sources. Pay special attention to the color and direction of the light and whether or not it is reflected light.

Try to do several quick paintings. Making quick alla prima sketches of yourself expedites the learning of methods and the familiarization with materials. Self-portraits offer an excellent way to study. They encourage an examination of the structure of the head for portraiture in general, as well as being a vehicle for self-expression. They are also among the most common alla prima paintings, but they take the most time to master. The first attempt may be a failure. In the second attempt, you may look like a relative of yours. In the third, you may look like yourself, but a very grim version of you. With persistence, you will achieve strong self-portraits.

Portrait Demonstration

To achieve the warm light mass and the cool shadow mass in this composition, I lit the model's head and upper body with a strong directional spotlight. The ambient light in the studio came from a northern skylight, supplying cool, diffuse light that filtered into the shadow mass, making it closer to middle tone and tinting the shadow colors with blues, grays, and lavenders.

In setting up for a portrait, several factors are important. One is the position of the sitter relative to yourself in height: Looking down on the model creates a very distinct psychological effect, being level with the model follows traditional Renaissance posing, and looking up at the model creates an unusual perspective. Also consider the angle of the sitter's head relative to you: Having the model face you directly, turn in a three-quarter view, or sit in profile all have interesting

effects on the painting both structurally and psychologically. And yet another important factor is lighting, both its type and direction: Incandescent light creates strong differences in temperature between light and shadow areas. Daylight results in strong form as well but presents a very different range of colors. Fluorescent light tends to flatten forms and create very unusual colors. Sidelight (or diagonal lighting) from above strengthens form and cast shadows.

The easel should be placed at a slight diagonal to the model. The distance to the model depends on the type of portrait and amount of detail desired. The more focused on the head, the closer the easel should be to the model. Placing the easel farther away allows more opportunities for half-length and full-length portraits, as well as for the inclusion of the surrounding environment. An important point is to be able to see your whole composition in one glance.

Painting a portrait that can be considered a likeness demands that you understand the bone structures and proportions of the human head. To that end, studying anatomical models is very helpful.

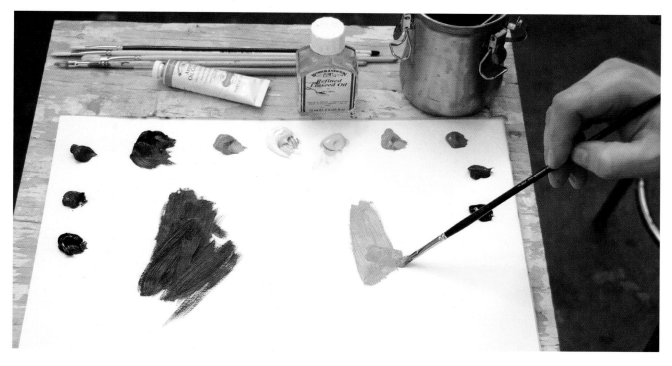

To lay out my palette, I place the darks used for my initial drawing to the left and the first colors for establishing my lights to the right. Each person's complexion has an overall "flavor"; this model's general complexion is pinkish. This simple analysis provides the key for all the color mixing. What I'm using in this case are white, cadmium orange, and permanent rose.

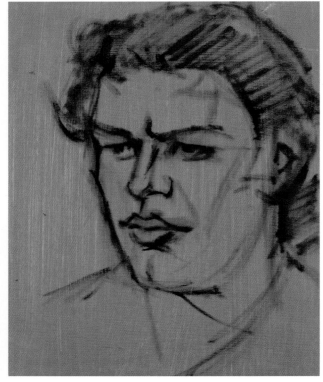

1. *To establish the structure of the portrait, first I analyze the shapes and proportions of my model so that I can assemble a likeness and, at the same time, try to capture something of his personality. I begin by drawing with raw umber on a middle-tone gray ground to establish the relationships of the tilts, angles, curves, and spaces of his face.*

2. *I continue adding detail, creating, in essence, an oil drawing.*

3. *Shadow mass and angles are defined.*

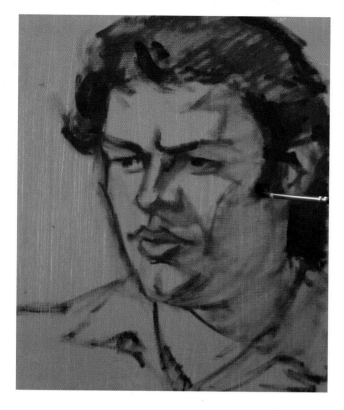

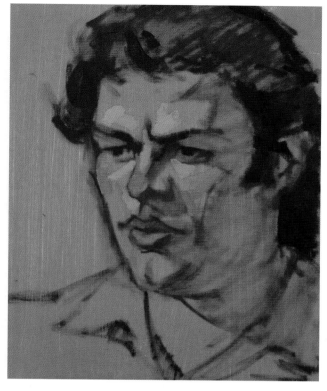

4. *Here, I've described the shadow mass by scumbling into the drawing with raw umber to complete the placement.*

5. *At this point, I start to lay down the first light-mass (non-shadow-area) colors I need to build the "planes" of the face following the angles indicated in the underpainting.*

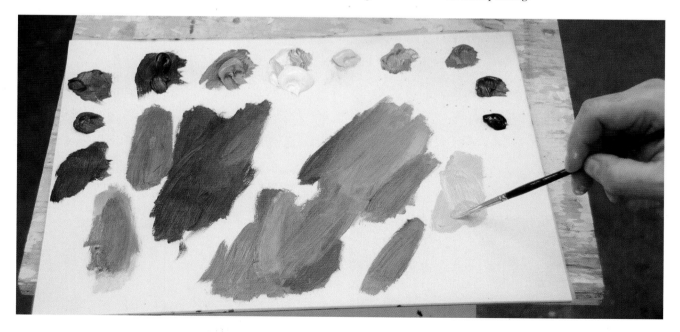

After completing the underpainting, I will being establishing the skin tones, so I begin mixing them in earnest on the palette.

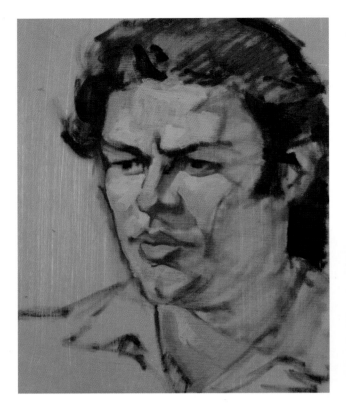

6. *I continue establishing the light areas, leaving the shadow areas untouched.*

7. *Now I establish the first shadow-mass colors of the face and neck (these are the areas where the form is in shadow). As mentioned prior, the ambient studio light comes from north windows, and the model's pinkish complexion is cooled by this light. Colors used here, including white, are raw umber, permanent rose, and ivory black.*

8. *At this point, I move to the shirt and background. I've chosen the background color to set off the model's color and values.*

9. The white shirt reflects the color of the light source: a pinkish yellow. Colors used at this point are white, cadmium yellow, permanent rose, raw umber, and, in the background, white, ivory black, and yellow ochre.

10. Middle-tone colors are laid in hollows and transitional areas. Neutral versions of the shadow colors are used to describe variations in the anatomy, for example in the hollow of the cheek and around the edges of the jaw, and lighter middle tones describe variations in the anatomy of the light masses. Darker middle tones vary the contours and anatomy of the shadow masses.

11. Note that reflected lights in the shadow masses are not so much lighter as they are brighter in color. Remember that too much white destroys the value of the shadow mass.

12. Final highlights and darkest darks and details are placed. Highlights are lighter yellow-pink tints. They are placed on the topmost planes. The darks, placed in the hair and eyes, are deep umbers and black. These final additions reaffirm the drawing and structure, and they add texture and reality to the model's face. A small amount of linseed oil has been added to these final mixtures, following the "lean to fat" model of paint layering. Colors used at this and the last stage (opposite) include white, cadmium orange, cadmium yellow, permanent rose, burnt sienna, and ivory black.

FIGURE

Considered the pinnacle of art subjects for thousands of years, the nude figure remains one of the most difficult and controversial of painting topics. In Western culture, paintings of the figure have represented both eroticism and the soul naked before God. Classical nude figures adorned the walls of Pompeian villas, and Renaissance figures became vehicles for teaching theology and moral lessons. Botticelli (1445–1510) and Titian (1488–1576) elevated the nude figure to the highest levels of poetry and taste.

The classic alla prima or direct study of the figure was at the core of academic training in the nineteenth century. It represented the triumph of intellectual classicism and study over more mundane artistic pursuits. The figure became a favorite topic of any number of Impressionists and early Modern painters. Thomas Eakins and the German Expressionists raised troubling and complex questions about the human condition through the use of the nude. Today, it remains essential to the learning of drawing and painting as well as to understanding the progress of Western culture.

The figure is often considered the most difficult of painting subjects. Not only is the color and brushwork used of great importance, but so too are the structure, anatomy, and likeness of the model's body. A study of basic figure anatomy and drawing is essential to understanding the model.

One of the most productive ways to begin to paint the human figure is to do an alla prima brush drawing of the model, capturing the gesture, proportions, and general form of the body. This can be done with an underpainting color on a white or toned canvas. Adding highlights with white to this simple oil drawing will identify the most important light-mass planes. This exercise can be done as a direct drawing in oil or using the wipe-out method (see page 70). These simple oil drawings can then easily become the "placement" for a more developed painting and can be adapted to any subject. A full-color oil study of the model can be built up on top of an oil drawing.

Posing the Model

The figure should be posed in such a way that clarifies its structure. Simple, classical standing and seated poses work best at first. These poses minimize the compositional complexities of foreshortening the limbs. Convoluted, curled-up, or foreshortened poses can make it very difficult for beginners who don't yet know a lot of anatomy or drawing solutions to make sense of the model.

"Interesting" poses are better handled by painters with more drawing experience. In my classes, we begin with standing classical poses, add seated poses, and finally study foreshortening in its various degrees of complexity. This helps the student learn to organize the experience of what they are seeing.

The model should be lit in a manner that maximizes the clarity of the color and tonal masses. The lighting described in the portrait demonstration is what I used for the figure demonstration that follows on page 136. Composition and cropping follow the same rules as for portraiture.

In addition, care for and respect of the model are paramount. The artist/model relationship has a wonderful and long history. Keep in mind that an interesting pose that can be held for five minutes might be impossible to hold for ten. Discuss what's acceptable with the model, and provide whatever the model needs (for example, breaks, heaters, cushions, privacy, a changing room, and so on) to be comfortable and ensure a successful painting session.

Al Gury, *Life Study*, 2005, oil on gessoed Masonite. Collection of the artist

Making a quick oil sketch of the figure reinforces one's ability to capture structure, planes, gesture, and color swiftly and with confidence. This time-honored practice is at the core of academic training in painting and is also a refreshing exercise for accomplished artists. These small works can stand alone or be a means to an end in the development of a larger piece. Here, the strong difference between the light and shadow planes creates a solid sculptural form.

Arthur DeCosta, wipe-out underpainting, c. 1970, oil, 16 x 12 inches (40.6 x 30.4 cm). Courtesy of the Pennsylvania Academy of the Fine Arts, Philadelphia. School collection

The wipe-out underpainting provides one of the quickest descriptions of structure. It starts with an imprimatura, a transparent mixture, placed over the canvas. This is usually a mixture of oil, thinner, and a transparent color mixture (such as burnt sienna and black or burnt sienna and ultramarine blue). The imprimatura is scumbled over the canvas, creating a cloudy atmospheric effect into which the figure is then wiped away with a soft, absorbent rag. The result is a strong sense of light and shade masses with, generally, no details—although the outcome can be made sketchier or more refined depending on the goals of the artist. Commonly done on white canvases with the imprimatura creating a middle-tone surface, wipe-out under-paintings are also often done on already toned canvases.

FIGURE 133

ABOVE: Sidney Goodman, *Nude on a Red Table*, 1977–1980, oil on canvas, 53½ x 77¾ inches (135.8 x 197.4 cm). Courtesy of the Pennsylvania Academy of the Fine Arts, Philadelphia. Funds provided by the National Endowment for the Arts, the Contemporary Arts Fund, and Mrs. H. Gates Lloyd

This dramatic nude exhibits most of the direct painting methods described in this book. A transparent imprimatura and broad, scumbled drawing made the base, and opaque colors were laid in, both on the wet surface and later on the dry surface. There are areas of both scumbled and stroked planes of color.

It's interesting to note that as the painting developed, the artist found it aesthetically interesting to only hint at the head and other elements, leaving their original rough placement visible. This enhances a sense of mystery as well as a feeling

of this being a sketch on a grand scale. As this piece shows, mature artists use direct paint-ing methods and concepts in very inventive ways to suit their aesthetic goals.

RIGHT: Tom Kohlmann, 2000–2005, oil on canvas, 30 x 24 inches (76.2 x 60.9 cm). Courtesy of the artist

This powerful image is meant to be a crucifixion but can stand alone as a masterful figure study. As seen in Kohlmann's other images (see pages 108 and 118), the brushwork is very vigorous, with a mini-mum of blending and detail. The broad, curving strokes carve the form in a very sculp-tural manner. Bold darks punctuate the anatomy, creating clarity. Only a suggestion of the head adds to a sense of mystery and brings the focus onto the nude body.

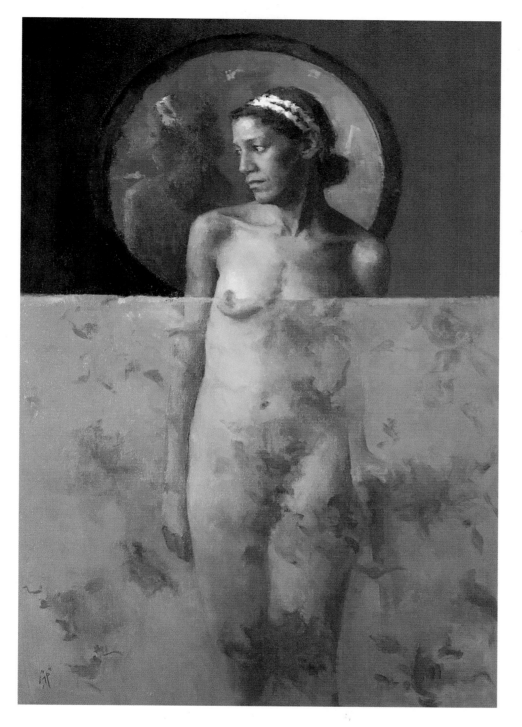

Carolyn Pyfrom, *Persephone*, 2000–2005, oil on canvas, 25 x 18 inches (63.5 x 45.7 cm). Courtesy of the artist

Carolyn Pyfrom's work is informed by many sources of direct painting. The American Tonalist tradition, French and Italian atmospheric painting, poetic classical figure traditions, and contemporary images and moods give great strength to this modern painter. Including a hint of a reflection of the figure in the mirror continues a practice common from Titian to Pearlstein. And the lyrical composition offers a strong nod to Bonnard's mysterious nudes in interiors with mirrors. The slightly draped or veiled figure is a theme both traditional and provocative.

FIGURE 135

Figure Demonstration

This graceful pose provided many opportunities to illustrate direct methods in figure painting. The strong diagonal light revealed large masses of form and color. The incandescent spot on the model in a studio lit by a northern skylight created a rich variety of warm and cool color changes. The shapes in both the model and the background offered a chance to explore composition as well as textural brushwork. Overall, the painting took an hour and a half to execute.

The setup in the studio, with a closer view of the pose below.

1. I begin with the first placement of the general figure structure using a brush and raw umber. The dark drawing shows up well on the middle-tone gray ground. At this point, major planes, proportions, shapes, anatomy, and composition are very simply described in the brush drawing. Details are unnecessary because I will develop them in the upper layers of the painting.

2. Development of the shadow-mass shapes begins by "mapping" them with the brush.

3. I finish the placement with tone scumbled into the shadows. The finished placement drawing becomes the "map" for the color and form development.

FIGURE 137

4. As evident in the close-up image of the model on page 136, the light mass is bright and intense under the spotlight. With the first description of color in these light-mass areas, the warm strokes of color show up strongly on the gray ground. The brush follows the simple surface directions, or planes, of the model's form. This describes the structure very quickly. Colors used at this point are white, yellow ochre, and cadmium red.

5. Development of general color continues with the leg and lower body. Note that the upper half of the figure is described with warm, mostly prismatic colors where the light is focused; by contrast, the temperature of the lower half of the figure is cooler or more neutral and is best described using the earth colors. I've used white, Indian red, yellow ochre, and ivory black.

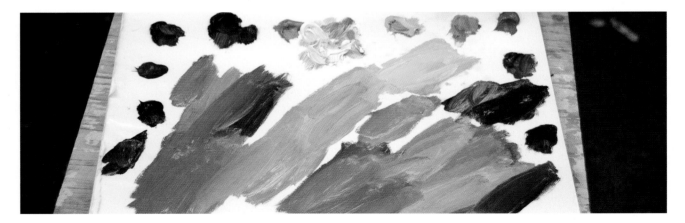

As the painting develops, the palette shows pools of color mixtures relating to different areas of the composition. Some are distinct and clearly separate; others merge into one another to create useful "combination" mixtures and neutrals.

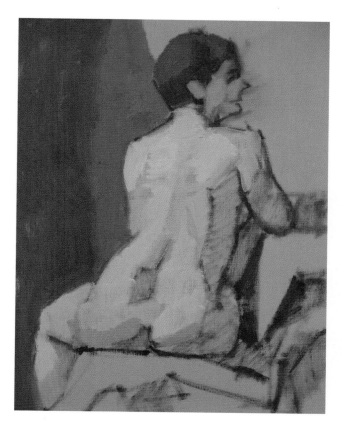

6. I start to develop the background at the same time that I build up the figure. The background colors are chosen to complement those of the figure in temperature, value, and hue contrast. I start with white, permanent rose, and ivory black. You can put the background in at any time. However, it is important to relate the background colors, tones, and textures to the figure and the painting as a whole at some point. A good time to do this might be when the model takes a break.

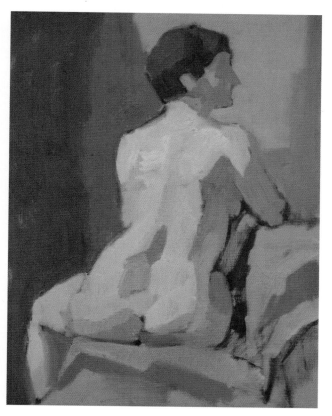

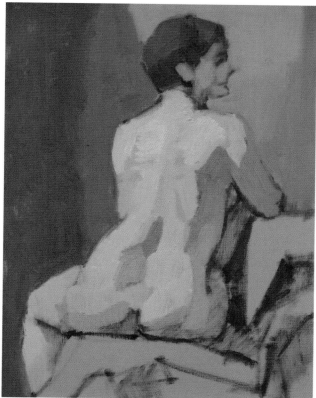

7. At this stage, I start development of the basic shadow-mass colors. They should be a simple basic mixture that can be modified later; in this case, it's a neutral lavender-blue, with a little beige-brown mixed into it. This color mixture provides a unifying base for the shadow. Often, we see so many colors in shadows that we end up mixing mud. Simplifying the base mixture, and laying down local touches and reflected light tones later, will create the effect that is seen on the model. Colors used here: white, burnt sienna, and ivory black.

8. Only after establishing the basic shadow masses do I start adding reflected colors in the shadow mass. Reflected lights are rarely lighter than the surrounding shadow. Rather than being "light," they are usually more intense colors close to the shadow mass in value. Too much white will destroy the value of the shadow mass.

On the right side of the figure, a higher chroma rose pink creates the illusion of reflected light in that shadow area. Colors used are white, permanent rose, ivory black, and ultramarine blue.

FIGURE 139

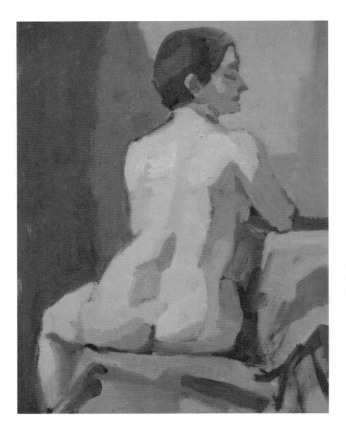

9. *It is important to clarify simply and boldly the block form of the chair. Details of folds will come later, once the form of the chair and its fabric covering are laid in. White, permanent rose, ultramarine blue, and raw umber are used at this stage.*

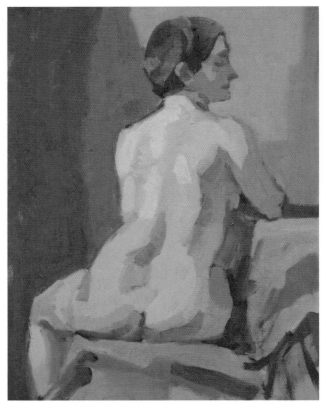

10. *At this point, I lay in the half-tone colors and transitions between the light mass and the shadow mass. Half tones (middle values between black and white) are essential to form. To establish them here I use neutral versions of the light-mass and shadow-mass colors that are made by the addition of earth colors to the bright mixtures.*

11. *Light half tones render the variations of anatomy in the light areas. See the upper back and shoulders particularly at this point.*

12. *Darker half tones describe form changes in the shadow areas. These color values also create bridges between areas, especially between light and shade. The drapery under the model is first set by half tones, followed by touches of darks to anchor the figure, create creases in the fabric, and show the direction of cast shadows.*

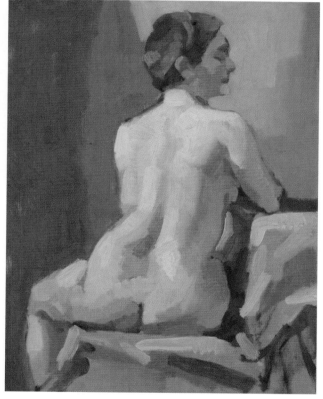

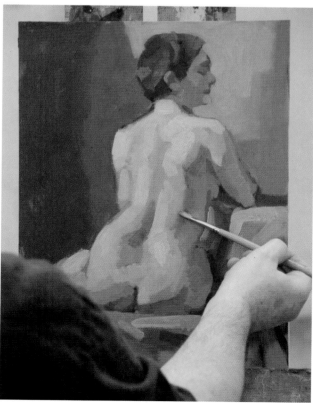

13. *Adding in some half-tone colors.*

14. *The face of the model (who has a rich pink and cream complexion) requires brighter versions of the overall figure color. For example, permanent rose is added to intensify the pink quality of the face. Generalizing the skin color and tone earlier on provided a solid base for these later color strokes. Colors here: white, permanent rose, burnt sienna, raw umber, with burnt sienna, cadmium orange, and raw umber for the hair.*

FIGURE 141

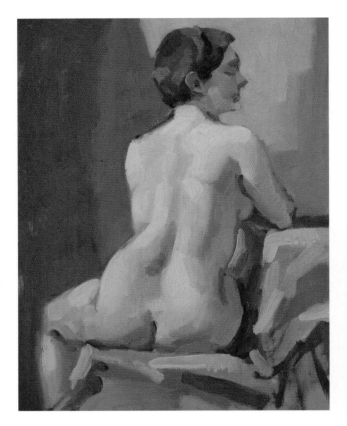

15. *I finish with adding the lightest highlights and darkest darks and then blending. The highlights, or "hot spots," on the figure are a little lighter that the rest of the light mass and have a touch of cadmium yellow light in them rather than yellow ochre.*

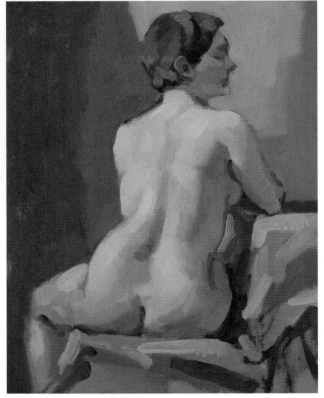

16. *The darkest darks occur in the folds and creases, reaffirming the drawing and giving strength to the structure. Blending is done sparingly with a clean dry brush to soften any harsh edges.*

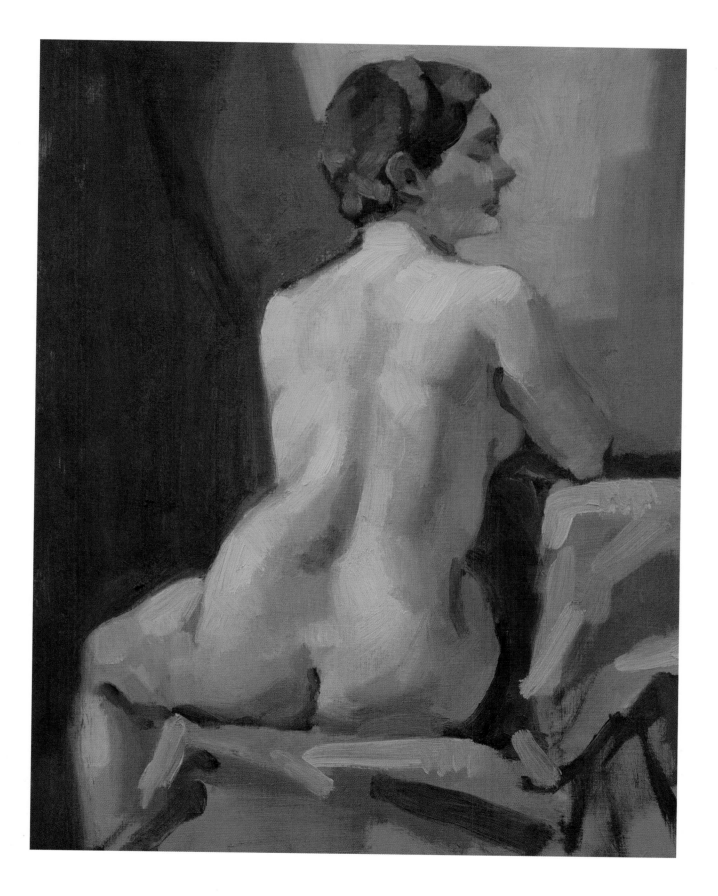

FIGURE 143

STILL LIFE

Beautifully realized, simple still lifes have been common in painting since the ancient Egyptians. Minoan, Greek, and Roman still lifes give us insight into the daily lives of ancient peoples and civilizations. By the seventeenth century in Europe, still life painting was one of the most highly regarded and lucrative businesses in which an artist could engage. Still life was used to highlight wealth and abundance on the one hand and the fragility of life on the other.

Nature morte (the French term for *still life*) was a major vehicle for teaching moral lessons. The eighteenth-century French painter Chardin (1699–1779) elevated the simple still life to a new level of elegance, seriousness, and simplicity. Nineteenth- and early-twentieth-century painters such as Manet, Cézanne, and Matisse guaranteed the still life as a subject of not only study but also of serious artistic exploration.

Al Gury, *Poppies*, 2007, oil on panel, 12 x 9 (30.4 x 22.8 cm). Private collection

The intimacy of this small still life is created by the simplified, bold color and brushwork of the flowers, the close cropping within the compositional rectangle, and the broad scumbled and brushed strokes of the background. In this case, less is more.

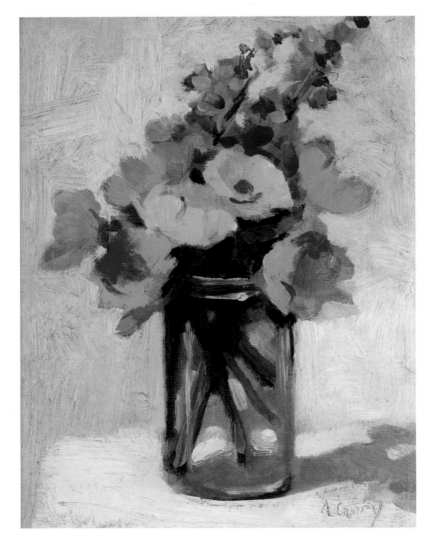

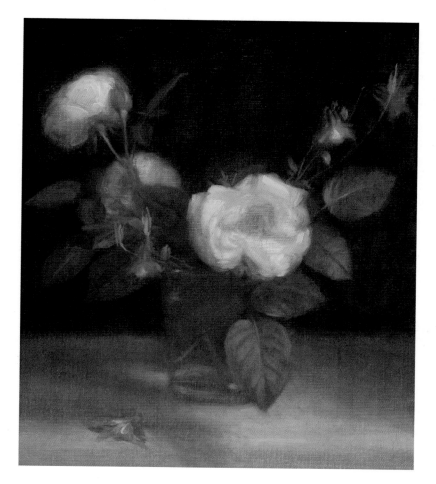

Arthur DeCosta, *Roses*, c. 1970, oil on canvas, 14 x 11 inches (35.5 x 27.9 cm). Collection of Al Gury

This poetic DeCosta still life of roses is informed by a number of important influences that continue to inspire modern still life painting: the still lifes of the eighteenth-century French painter Jean-Baptiste-Siméon Chardin, the nineteenth-century French painter Henri Fantin-Latour, and the nineteenth-century American painter Charles Willson Peale. These artists have been touchstones for DeCosta, who combines a modern interest in analysis of form, texture, and composition with his own very personal sensibilities of drama and poetry. His flowers are actors on a stage, with all the presence of a portrait of the nude figure.

Rachel Constantine, *Monument*, 2006, oil on linen, 14 x 12 inches (35.5 x 30.4 cm). Courtesy of Artist's House Gallery, Philadelphia

Rachel Constantine explores themes that are at once personal and timeless. This composition alludes both to the symbolic nature morte of the Baroque era and to the still lifes of Chardin. Her own sensibility adds poetry as well as an edge of modern anxiety and sadness.

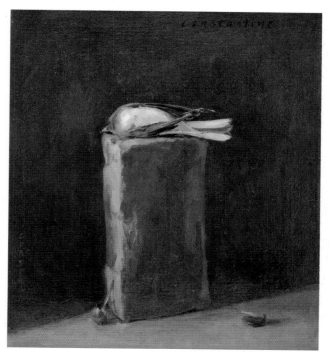

FIGURE 145

RIGHT: Scott Noel, *Della Robia*, 2006, oil on linen, 42 x 46 inches (106.6 x 116.8 cm). Courtesy of the artist

This Scott Noel still life is a rich harmony of subtle opaque tints and neutrals. Unified by the light and the lush surface of layered paint, created by both brush and painting knife, the composition is a powerful statement of both abstract design and time-honored observational perspective. The subject adds a current of lyric poetry to the whole work.

BELOW: Jane Piper, *Red and Pink with Green Leaves #2*, 1987, oil on canvas, 36 x 46 inches (91.4 x 116.8 cm). Private collection. Courtesy of Hollis Taggart Galleries, New York

Jane Piper drew upon many sources of inspiration. Her academic training in drawing, art history, and methodology at the Pennsylvania Academy of the Fine Arts and in France, prepared her to become a masterful painter who created a synthesis of observation, Modernism, and tradition. This rich, painterly work exhibits her love of still life and flowers.

OPPOSITE: Arthur Beecher Carles, *The Turkey*, 1927, oil on canvas, 57½ x 45 inches (146 x 114.3 cm). Courtesy of the Pennsylvania Academy of the Fine Arts, Philadelphia. Gift of the Board of Directors

Arthur Beecher Carles, a great representative of the Philadelphia colorist tradition, took nature as a point of departure for expression through alla prima painting. Influenced by Postimpressionist painters and Henri Matisse, Carles's work organizes and translates complex observations of the subject into harmonies of color, form, drawing, and composition.

FIGURE 147

Still Life Demonstration

The still life is probably the most accessible of the four genres demonstrated here. It needs no special arrangements with sitters or travel to a location. It is all around us in our homes and studios. Since mastery of painting needs constant practice, the still life offers, in many ways, the perfect study subject.

The methods of placement, analysis, and process described in the previous demonstrations all apply to the still life. Small, quick still lifes are an ideal way to practice color analysis and brushwork. They can be done of a single object on a table or of an elaborate composition. Still lifes are also easy to set up and paint in a small studio space.

1. As with the previous genre demonstrations, the process starts with placement of the general large shapes with a brush and raw umber. It is essential to block out the larger areas that will give shape, structure, and cohesion to the painting as a whole.

2. Further placement details added at this point include some of the various planes of the flower forms and the shadow cast by the flowers onto the table surface.

3. I build on that with the placement of smaller shapes that add to the "map" of the still life.

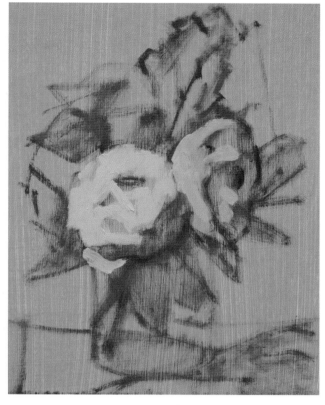

4. When the placement drawing is finished, the shapes and forms are described with simplicity and clarity. There are no major subject details, however, because I will develop those as I apply the color.

5. The color development begins with the light mass of the flowers, using white and cadmium red light. The light source was a warm, incandescent spotlight, and the strong, warm light-mass colors create an immediate sense of form. The gray ground, the placement drawing, and the first "lights" produce form in a direct, economical way.

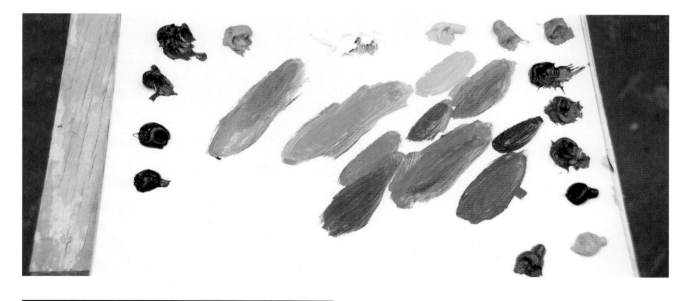

To prepare for the addition of color, I begin mixing colors on the palette.

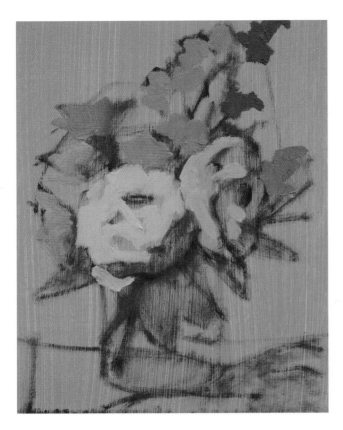

6. *Development of the light-mass colors continues with white, cadmium red light, cobalt violet, cadmium orange, and permanent rose. I matched my paint mixtures to the colors and tones of the light areas of the subject. The ability to match paint mixtures to the color values of the various parts of your subject is an important skill to cultivate.*

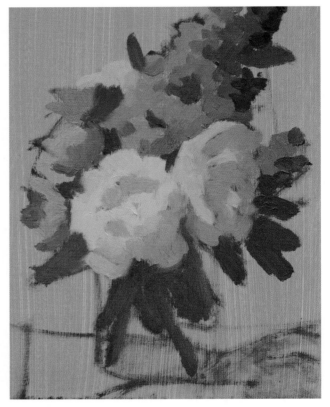

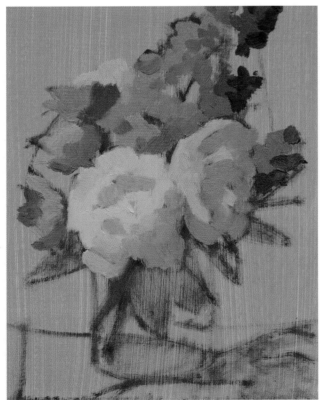

7. *Now I begin to apply some darker-value shadow-mass (shadow-area) colors. The ambient window light of the studio cooled the shadow colors, so I used raw umber to "dull," or neutralize, my cool-color choices. Mixing earth color with prismatic colors creates a softness that is well-suited to the shadow colors.*

8. *As I continue establishing the shadow mass, colors used up to this point are white, raw umber, cadmium red light, cobalt violet, cadmium orange, permanent rose, chromium oxide green, and ultramarine blue.*

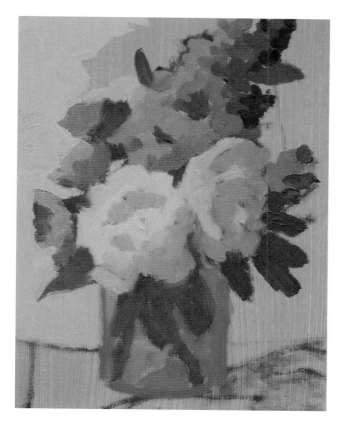

9. *Here I start to develop the background and the vase structure.*

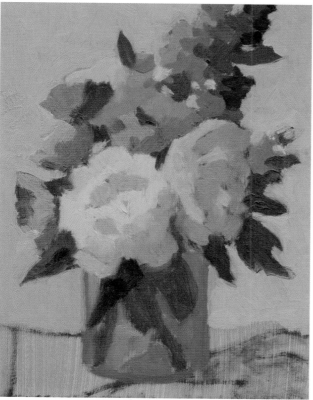

10. *The background color is cooler than anything in the still life. Its temperature, hue, and value show off the flower colors well by contrast. Colors used: white, raw umber, yellow ochre, and ultramarine blue.*

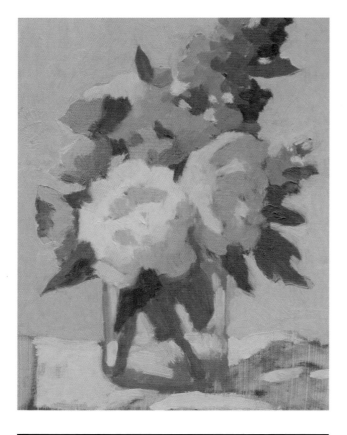

The next step will be begin establishing the lighter areas of the table surface, which are lighter in value than much of the rest of the composition—and the color mixing in the lower left of the palette reflects this.

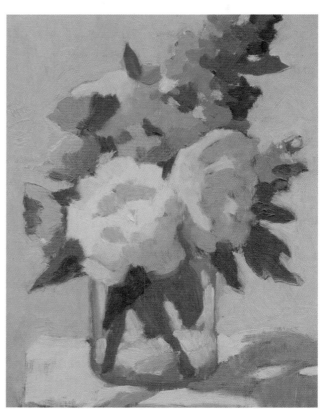

11. Note that the surface of the table is, in parts, seen through the glass vase. Pay attention to these types of optical effects in your still life arrangements. Glass vases and bowls, as well as any water in them, may create reflections and will affect the appearance of any items contained therein.

12. Next I move on to the darker values of the table surface.

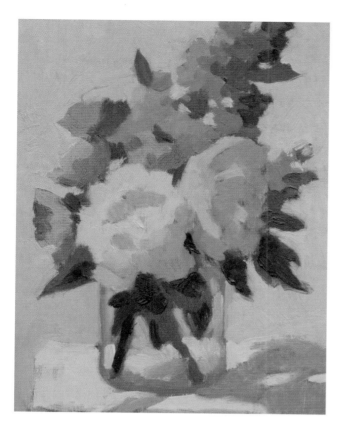

13. *The addition of the darkest value details in the leaves, especially those underneath the two largest flowers, begins to impart some real depth to the subject and brings those two blossoms forward.*

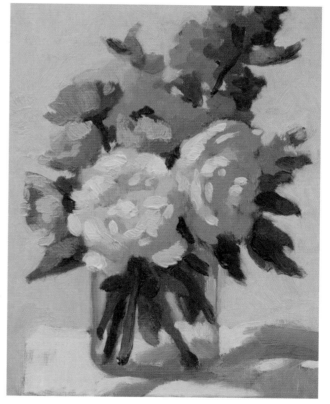

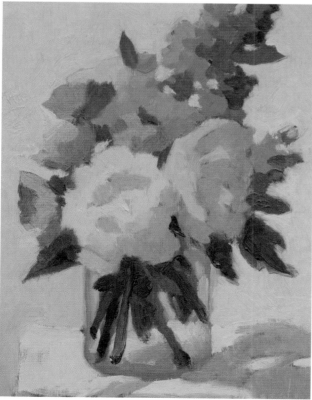

14. *I continue adding details in the stems in the vase.*

15. *Here you see development of the secondary colors and variations in the large blocks of light-mass and shadow-mass colors. This is the most difficult stage in the painting process. Color variations should be kept simple. Usually, they are middle-tone versions of the other colors.*

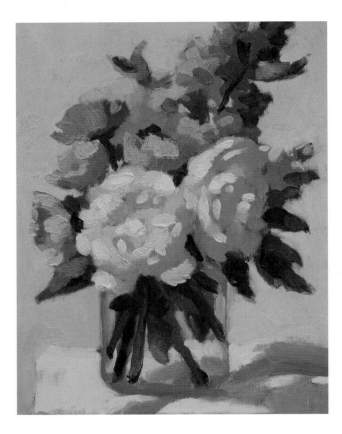

16. I use brush calligraphy—a variety of brushstrokes—that quickly and simply describes textural differences in the flowers, leaves, and glass.

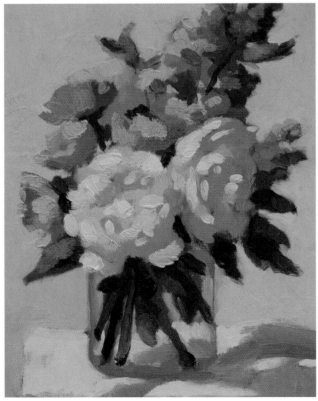

17. I start finishing the details with small strokes of color in some of the flowers.

18. This final phase reaffirms drawing and shapes, as well as textures and details, with the placement of the lightest lights and darkest darks.

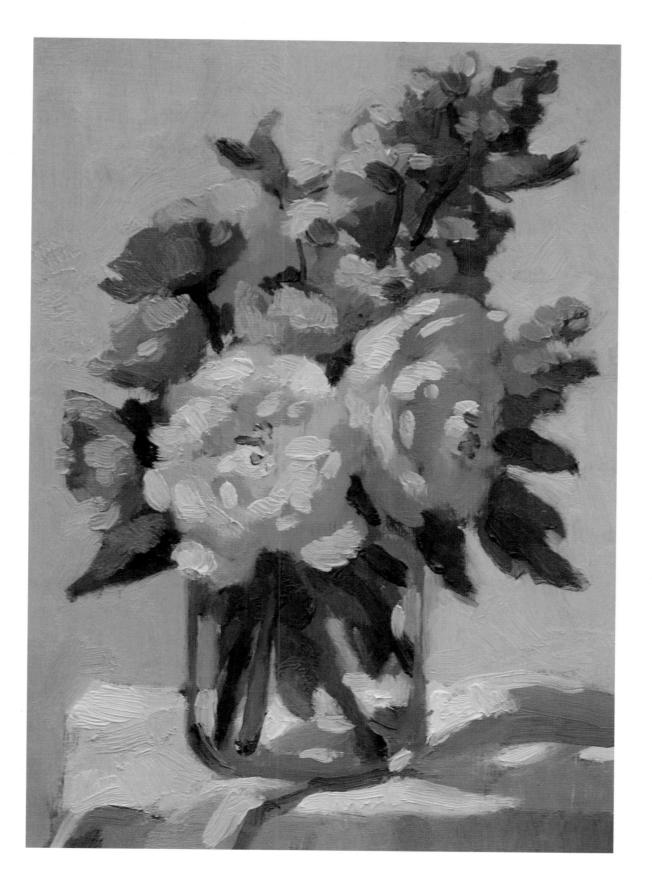

LANDSCAPE

Over the centuries, the landscape—like the figure, still life, and portrait—became a vehicle for exploring many philosophical, religious, and symbolic ideas. The Romans created beautifully poetic landscapes to adorn the walls of patrician homes in Pompeii. In medieval Europe, the landscape became a symbolic backdrop for tableaux of biblical figures. The Italian fresco painter Giotto (c. 1267–1337) is credited with introducing the first naturalistic landscape in painting. In the Renaissance, Leonardo da Vinci (1452–1519) studied naturalistic effects of light and atmosphere on the landscape around him.

Landscapes first began to emerge as observations of a real place in the sixteenth century. It was not until the eighteenth century that the practice of making the on-site landscape sketch became common. The oil studies of English painter John Constable (1776–1837) have had tremendous influence on alla prima painters for over two hundred years. And like still life, landscape painting became a vehicle for aesthetic explorations of all kinds in the twentieth century.

Joe Danciger, *Woods*, c. 1980, oil on linen canvas, 16 x 16 inches (40.6 x 40.6 cm). Courtesy of the artist

Joe Danciger creates an effect that combines the illusion of depth with an overall sense that the picture place is created by patterning. Painting on-site, Danciger lays out the initial shapes and compositional elements on a white canvas. Scumbled paint creates a first layer of color, temperature, value, and pattern upon which to build. Impasto strokes, both of lighter and darker tones, enhance and finish the final effect of the scattering of light and movement in this elegant painting.

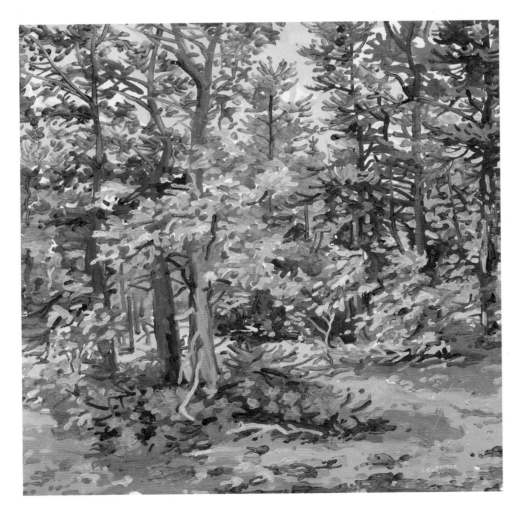

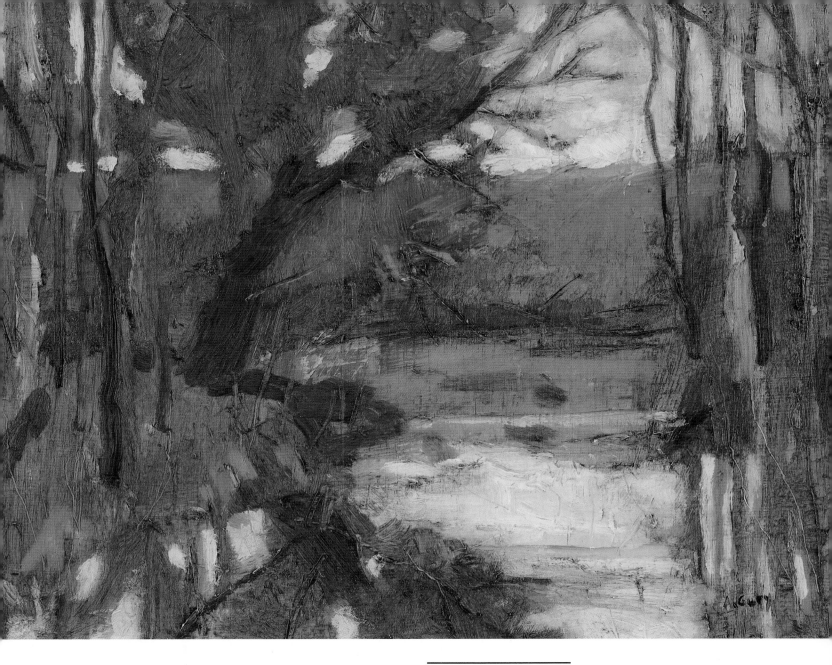

Al Gury, *Quiet Inlet*, 2006, oil on panel, 11 x 14 inches (27.9 x 35.5 cm). Private collection

Some years ago, I asked myself, What do I really see when I look at a scene that interests me? Surprisingly, first were shape *and* tone masses. *Next were* color *and* atmosphere. *Not on the list: details. This honest question led to a love of orchestrating a poetry of shape, tone, and color that borders on the abstract but is always informed by place and observation of nature.*

Using a toned gray or tan ground, I mass in large blocks of tonal color to create a composition that is pleasing to me. With both a brush and a painting knife, I manipulate the surface and add to it until I get the texture I want. I draw details into the composition with a brush or even scrape them in with a knife or the end of a brush handle. A final glaze over everything unifies the composition and creates varieties of illusions of atmosphere. This whole painting was done from sketches and memory.

Seymour Remenick, **Delaware River from Bridge**, 1953, oil on canvas, 19¹⁵⁄₁₆ x 22 inches (50.6 x 55.8 cm). Courtesy of the Pennsylvania Academy of the Fine Arts, Philadelphia. Gift of Benjamin D. Bernstein

Seymour Remenick, another great role model for many young painters in Philadelphia, was known for, among other things, the beauty and economy of the brush calligraphy in his compositions. This very beautiful landscape presents not only subtle illusions of atmosphere and light but also an aesthetic that is powerfully personal and modern. The underlying organization of the spaces of the canvas into horizontal thirds gives a unity and strong abstract underpinning to this masterpiece of atmospheric direct painting.

Jon Redmond, *Composition*,
2000–2007, oil on panel,
10 x 10 inches (25.4 x 25.4 cm).
Courtesy of the artist

A complex painter of light and tone, Jon Redmond uses alla prima painting methods in a layered manner. An initial placement scumbled on the panel establishes composition and tonality. Opaque strokes develop local areas. Some of the initial thin placement is allowed to show through, while other areas are built up in layers of opaque paint. Darkest darks and lightest lights are added last.

Again, the idea that a direct painting is made in a one-shot session is only part of the alla prima tradition. Redmond employs in his compositions the richness of layering that is often used by direct painters.

Al Gury, **Landscape**, oil on panel, 11 x 14 inches (27.9 x 35.5 cm). Courtesy of F.A.N. Gallery, Philadelphia

Techniques, working methods, and training are meant to free painters to do what they want in their work. Heavily trained in observation and technique, I now freely use the rules to create the image I see when looking at a landscape. Summers and weekends always include travels to gather information, including the specifics of types of trees, plants, and colors in nature, as well as compositional and aesthetic ideas for potential paintings.

Some of my landscapes are small moments best seen on 8 x 10-inch panels painted in a direct, quick manner. Others demand layering and a separation from nature to evoke the feeling I had on-site. Consequently, the majority of my landscapes, like this one here, are done in the studio as reflections on nature rather than documents of nature.

Al Gury, **Landscape**, oil on panel, 16 x 12 inches (40.6 x 30.4 cm). Courtesy of F.A.N. Gallery, Philadelphia

Landscapes are often thought of as horizontal compositions. The shape of the canvas must suit the aesthetics of the artist and what he or she is trying to convey. This vertical landscape creates the upward loft of the delicate trees and the bits of light between them.

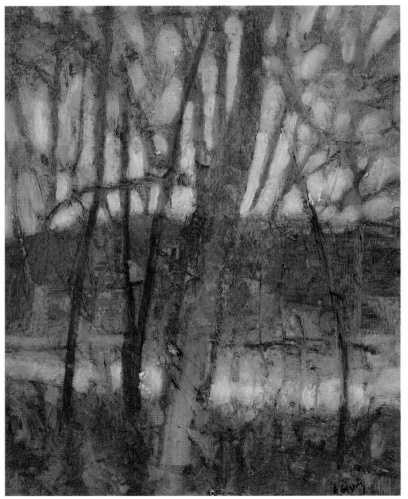

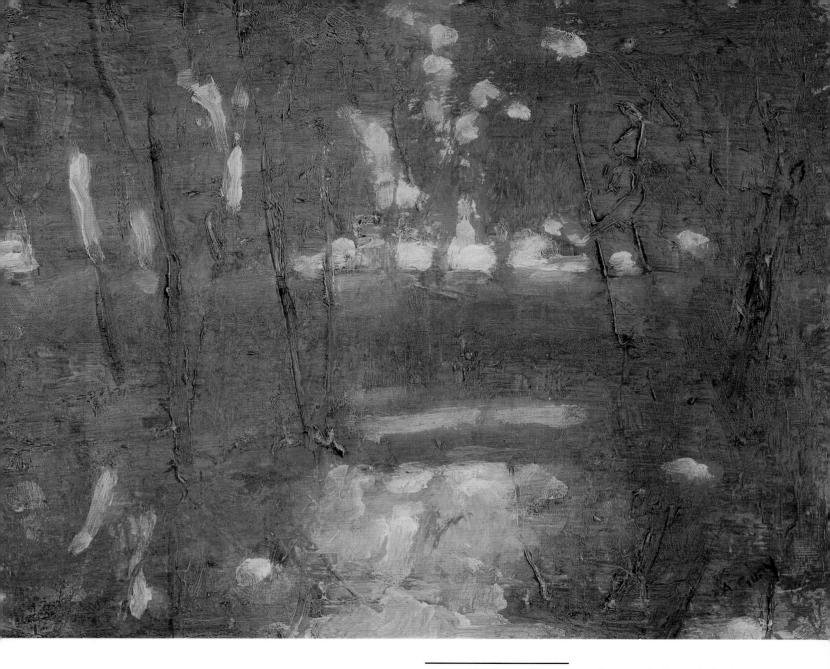

Al Gury, *Landscape*, oil on panel, 11 x 14 inches (27.9 x 35.5 cm). Courtesy of F.A.N. Gallery, Philadelphia

As previously discussed, classic palettes are meant to be adjusted as needed. Here, chromium oxide green and cobalt violet were added to help create the underlying color tones. A unifying glaze organized the masses and colors. Here, for me, American Tonalist painters such as Inness and visionaries like Albert Pinkham Ryder are powerful role models for understanding personal approaches to landscape painting.

Landscape Demonstration

Painting the landscape on-site can be a daunting project. A common myth is that landscapes that appear to be made from observation are necessarily always done on-site. However, many Impressionist landscapes, for example, were either started outside and finished in the studio or done from oil sketches, drawings, and other reference materials also in the studio. Of course, many were—and are—done on-site. The pochade box for outdoor oil sketching is mentioned on page 29. Such portable studio equipment and the invention of the collapsible oil paint tube helped to cause an explosion of on-site painting in the nineteenth century.

When approaching this subject, organizing the visual experience of the landscape is the first task, whether you are painting indoors or outdoors. The small alla prima oil study is the best way to begin. These can be preparations for a more complete work or can stand alone as complete aesthetic statements. A summer spent doing small-scale alla prima landscape studies can vastly improve one's understanding of color and process.

I used this photograph as an aide de memoire, *as nineteenth-century painters often referred to their photo reference. The masses of tone, color, and texture were interpreted from the photo as a basis for purely aesthetic choices and processes. Understanding how and when to use photographs for paintings is of the utmost importance. Knowing what photos can and cannot do is critical to their use. (See page 174 for more on how to use photographs when painting.)*

Color palettes for most of painting history, and up through today, are extensions of classic palettes. To a core palette of ochres, umbers, siennas, black, cadmium yellow and red, rose, and ultramarine blue, painters often add sap green, cadmium greens, veridian, cerulean blue, and violets.

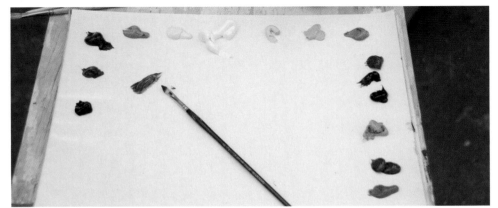

1. *I begin placement of the landscape with a drawing done in raw umber on a gray middle-tone ground.*

2. *At the start of the under-drawing, just the large shapes and the perspective angles are described.*

3. *Note that no details or textures are needed at this stage, because they will be added as the paint layers are developed.*

4. *As in the still life demonstration, smaller shapes are described to gradually create a "map" for the colors and brushstrokes.*

5. Before you begin applying color, analyze the colors of the landscape. While the direct sunlight is a warm yellowish gold, the ambient atmosphere and sky colors are cool lavender blues.

6. After my color analysis, I block in the sky and reflective water colors and start on some of the green middle area of the composition.

7. All the colors of the first layers of this landscape will be cooler or more neutral than the final layers. Touches of bright warm colors to describe sunlight on surfaces will come at the end.

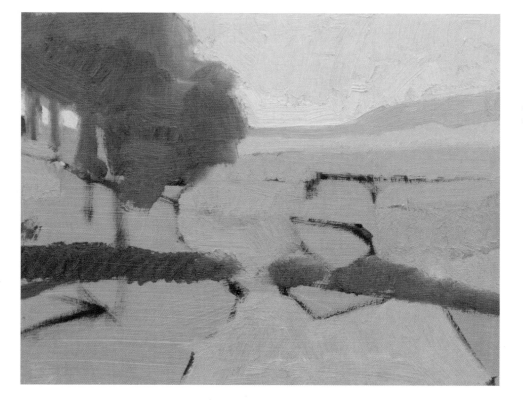

8. I place my color blocks for the distance, middle distance, and foreground. Colors used to this point are white, ultramarine blue, Naples yellow, chromium oxide green, phthalo yellow green, raw umber, and yellow ochre.

9. *I continue placing the greens of the central bush and what will eventually be the reflection in the pond of the trees that appear in the left portion of the composition.*

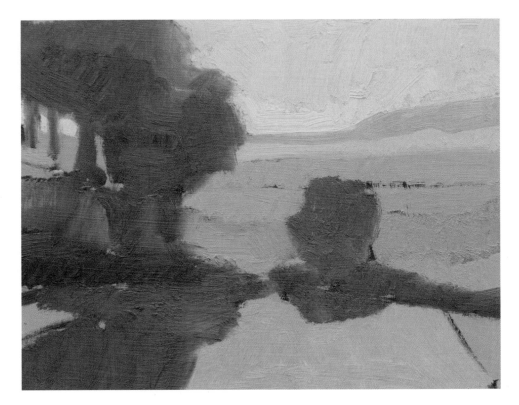

10. *More color blocks are added to the right foreground and I continue building up the details in the middle distance behind and around the bush and trees.*

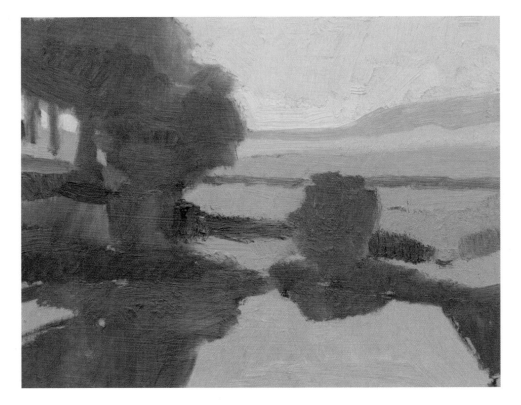

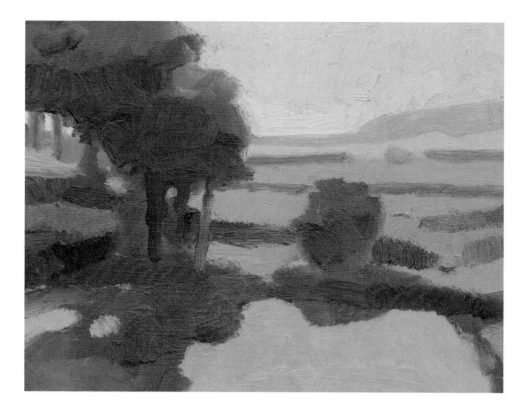

11. *At this stage, the pond and its reflection are fully blocked in. Additional details start to define more of the tree trunks and the areas behind them, and darker tones build up layered details in and around the bush.*

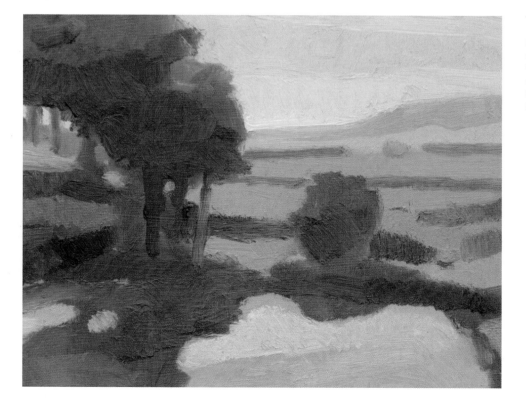

12. *I make modifications in the color temperatures of the smaller shapes. Areas are brightened or dulled as needed. I use earth colors to soften mixtures and cadmiums to brighten mixtures.*

13. Note the placement of lighter details in the mid-ground areas, as well as the additions to the reflections of the trees.

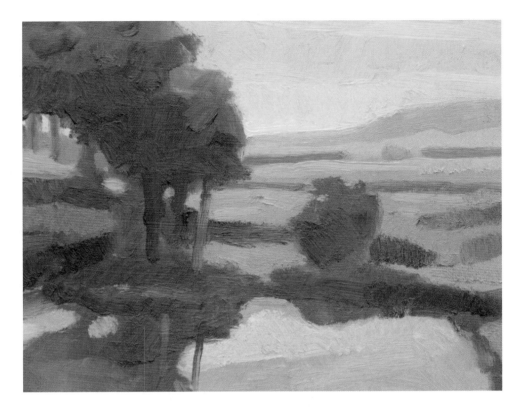

14. Additional greens are added to the tops of the trees.

15. I continue layering greens into the bush and build up its reflection in the pond. Note, too, the slightly adjusted brushwork in the middle-distance foliage.

16. Notice the additions of details around the tree reflections, the far tree trunks, and both the foreground and middle distance on the right side of the canvas.

17. Light details brighten the far edge of the middle distance as it recedes into the picture plane.

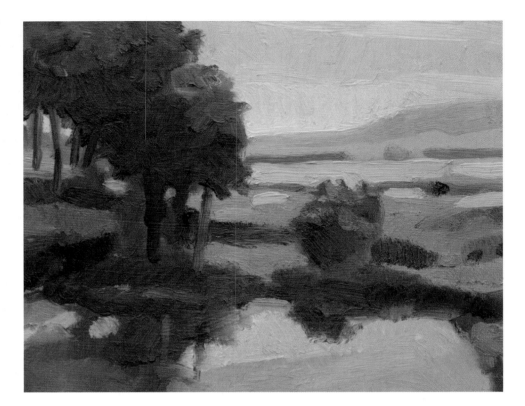

18. Additional greens on and around the bush impart some richness to the foliage, while highlights added to the pond brighten the foreground.

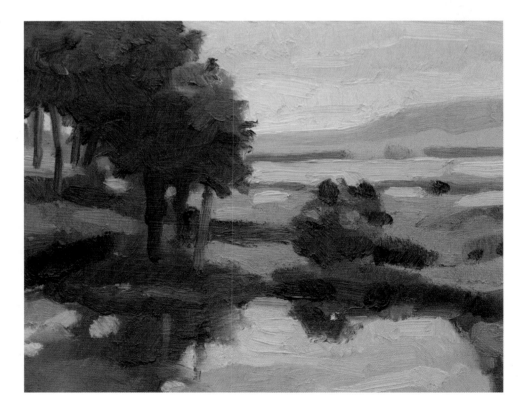

19. *As I continue, I modify textures and edges. Brush calligraphy is very important here; small, thickly loaded brushstrokes create texture variations.*

20. *The optical model of "sharper, darker, clearer comes forward, and softer, grayer, fuzzier goes back" is used to create depth.*

Here and in the final step below, finishing details and textures are added and soft blending is completed. Light blending or "dusting" with a clean, dry brush removes peaks of paint or harsh edges. Also, I add a small amount of linseed oil to the paint used for the final details, following the "lean to fat" model.

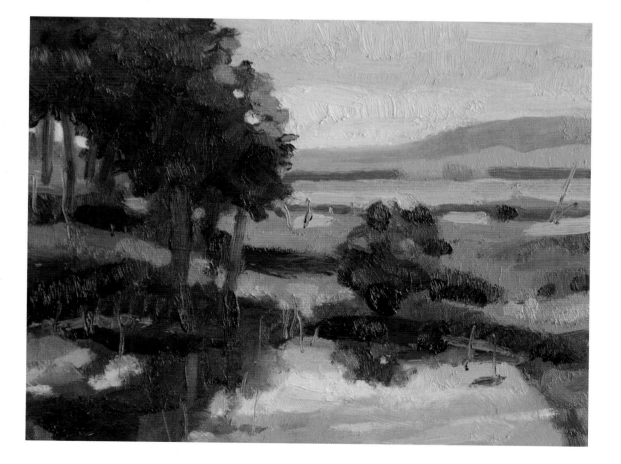

APPENDIX A: PRACTICE AND MATERIALS GUIDE

Painters, sculptors, and printmakers I talk to say that the only way they got anywhere with their art was through plain hard work. Don't paint to perform, but paint to learn. Or, even better, don't learn to paint, paint to learn.

People talk about talent and expression and creativity, but most of the time, it's about getting up in the morning, going into the studio when you really don't feel like it, picking up the tool, and making that first mark. Talent and expression and creativity will be there, but none of it will grow if you don't simply do the work.

We grow at different rates in the arts. The people for whom it seems so easy at first will run into plateaus that are not fun and easy at all. Their struggle will be to not give up when the going gets rough and to hang in there until things get moving again. They will get there. The people who feel as if they have to struggle and scrape to make any progress at all will take off when they've had enough experience and time to develop. Their struggle will be to be patient and steady until it becomes more accessible and pleasurable. They will get there, too.

In the meantime, what follows are a few recommendations of things to do in each discipline to help you get to where you want to be. Remember, be patient and just do the work.

Drawing

Anatomy

Get a good anatomy book. (See the listings for Peck and Hale on page 175.) Sketch from the illustrations. Memorize the anatomical parts and names. Place tracing paper over an image of just bones and draw the appropriate muscles, or do the opposite, starting with an image of the muscles and drawing the appropriate underlying bones. Draw the anatomy from memory. You'll learn a lot fairly quickly.

Life Drawing

Talk your friends into letting you sketch them (with or without clothes). Draw figures in public places around your city or town. Draw figures from memory. Invent compositions. Keep the figures loose and to the point, like

croquis, going for form, movement, and proportion. When time permits, execute more complete sketches in which you can experiment with line drawing, tonal drawing, *trios couleurs* (red, black, and white chalk on toned paper), and pastel.

Master Copies

If you have already been doing this, continue making copies of masterworks from reproductions. If you haven't, consider starting. This offers good opportunities to experiment with techniques you've wanted to try in drawing, pastel, or even watercolor. Making small quick copies removes the pressure of having to "perform," while teaching you new things. These quick "sketches" can be a very simple pleasure. After you get comfortable with these, you may want to try making an exact copy.

Portraits

Sketching quick portraits of strangers in cafés, restaurants, trains, and so on is a time-honored art school and travel activity. Learning to get a good likeness is directly related to making dozens of caricature sketches with a few lines in a very short time. This skill translates directly into the ability to capture a likeness quickly in more formal portrait painting, drawing, or sculpting. The sketchbooks of most great figurative artists are filled with these types of informative and often humorous drawings.

Sketchbooks

Sometimes the best thing to do is keep a journal all year long of sketches of figures, ideas for more formal works, notes and observations, landscapes, and even dreams. These keep the hand and mind working even when a full-time job and class work keeps us tired and overscheduled.

Painting

Landscape

Massing of tone and color should be the main goals of landscape sketches done in oil. These sketches should take no more than an hour or two. Practice simplifying things by focusing on individual things: warm and cool,

light and dark, masses, shapes, space, brush techniques. The studies of John Constable (1776–1837) and the early works of Camille Corot (1796–1875) are good role models. Urban landscapes, even those of the views from the windows of your school or your apartment will do nicely.

Still Life

The small compositional and color studies of simple objects are excellent practice and may become important to a larger body of work over the years. A cut flower in a water glass or a few simple forms on a windowsill create opportunities for the practice of drawing, form, color, and brush response. A small painting of a bunch of flowers in a vase or a few pears can acquire the gravity of a seemingly much more ambitious work if studied and taken seriously.

Figure

Nude models can be difficult to find outside of a class. This fact, however, leaves you with an ideal opportunity to focus on studies of rendering clothing, fabric, and clothed friends. You can draw and paint yourself nude, draw and paint a friend nude, sit in on uninstructed or evening classes, or invent figures (drawing from your imagination) as a test of your knowledge and skill.

Self-Portrait

As always, the self-portrait is not for the fainthearted but is good for discipline. You can experiment with methods, color theories, and expression in self-portraits.

Interiors

Quiet, small-scale paintings and drawings of rooms with wonderful light and shade are beautiful things (just take a look at Jon Redmond's interiors included in this book). Making small paintings and drawings of the interiors of wherever you happen to be can stretch your skills and contribute to ideas for larger studio works. Developing a strong compositional sense is a continual and essential goal that these paintings can help you achieve.

Sculpture

Clay and Wax Studies

A time-honored tradition is the making of small figure studies in clay or wax. They can be very casual or can become serious anatomical studies or copies. The various self-hardening and baking clays can be a good way to go, or simply use an oil-based clay. These studies, or *bozzetti*, can be done from life drawings or your croquis if you don't have access to a model. You can even make compositions of these studies. As Nicolas Poussin (1594–1665) and many other artists have done, set up your studies on a small "stage," and light them and make preliminary drawing sketches of them. Other good sources for sculpture studies: casts in a cast hall in a nearby museum and figures you invent yourself. You can also invent clay figures and reliefs to explore your ideas for compositions. All this is useful for painters as well as sculptors.

Chiaroscuro Studies

Once your clay or wax studies are done, place them in a shadow box, light them, and draw them as if they were a tableau of actors on a stage. This is a good way to study both light and shade, as well as composition. This was a favorite method of artists in the sixteenth and seventeenth centuries.

Materials

A Good and Useful Landscape Palette

You can add to this basic palette as your experience dictates. See page 42 for lists of palettes used by well-known landscape painters throughout history.

white (flake, titanium)	cadmium yellow light
yellow ochre	cadmium red
raw umber	permanent rose
burnt sienna	ultramarine blue
Venetian red	cerulean blue
ivory black	chromium oxide green
green earth (terre vert)	cadmium green veridian

Medium

I recommend linseed oil. Use of quick-drying mediums such as Liquin or other synthetic resins can be a real problem when painting outdoors. They dry too fast. Use only standard oils, such as linseed oil, stand oil, and so on.

Supports

Gessoed watercolor paper, Masonite, or rag mat board are available in a variety of manageable sizes (10 x 8", 12 x 9", and so on). Tone grounds in gray, tan, or transparent umber are good to start.

APPENDIX B: HOW TO USE MUSEUMS AND PHOTOGRAPHS

Museums

Visiting museums and galleries, especially small local ones, is very important, and there's an art to using a museum collection effectively. Sometimes just wandering in a museum is great and easy on the mind, but arriving with a plan for the visit is useful for the painter or sculptor.

If you know that a collection contains masterworks you admire, think through the things you want to learn from a particular master. For example, how did they render eyes? Is there evidence of grounds showing through the paint? How were highlights loaded? Look especially for how the least of what was applied produced the effect. Having a specific idea of what to look for keeps the visit and the works from becoming overwhelming.

Often, going to visit just one painting is a good idea for study (for example, Rubens's *Prometheus* at the Philadelphia Museum of Art), as is focusing just on works from a particular period (for example, classical Greek) or paintings just of a certain type (for example, nineteenth-century paintings of animals). Make notes about and drawings of the works in a sketchbook. See if the museum show has a decent reproduction of the works you're focusing on for further study and copying. Explore and look at things you have never really looked at closely before. And, importantly, avoid "museum fatigue" from being there too long.

Photography as a Visual Reference

Painters argue long and hard over the role of photography as a reference for paintings. Some approve and others condemn the practice. The fact is, from the moment photography was invented, painters were eager to add it to their toolboxes. While some disapproved of the new medium, many great painters throughout the nineteenth century used photographs to varying degrees. While rarely painting directly from photos, Courbet, Degas, Cézanne, and many others used them for purposes of design—and rather like a sketch. Eakins used them in a variety of ways. These *aides de memoire* are often seen in the studio materials of painters of all kinds.

Two factors are key in this discussion of the use of photography as a visual reference: (1) The idea of how and to what degree the painter will use a photo reference, and (2), the understanding of what a photograph can and cannot do. Many painters use photographs as part of a purely interpretative process. For example, a figure painting or landscape can benefit from photographic "notes," which help the painter work out ideas and approaches. Painters who use photographic images literally run the risk of having their paintings "look like photographs."

Photography, in a general sense, is monocular. That is, photographs rarely can create a visceral and perceptual sense of depth and form. Also, the variations of edges and tones that create depth in a painting are often missing in a photograph. A photographic image can provide information and details, but it has difficulty providing a real sense of perspective for the painter.

When using photo references, painters or illustrators must add the illusions, effects, and techniques that will give life and breadth to their work. A magnificent art—whether used as the main medium or as a reference sketch or note—photography must be used appropriately and wisely by the painter.

SUGGESTED READING

Artistic Anatomy by Dr. Paul Richer, translated and edited by Robert Beverly Hale (Watson-Guptill Publications)

The Art Spirit by Robert Henri (Basic Books)

Atlas of Human Anatomy for the Artist by Stephen Rogers Peck (Oxford University Press)

History of Color in Painting with New Principles of Color Expression by Faber Birren (Van Nostrand Reinhold)

Primary Sources: Selected Writings on Color from Aristotle to Albers edited by Patricia Sloane (Design Press)

Thomas Sully 1783–1872: Hints to Young Painters, a Historic Treatise on the Color, Expression and Painting Techniques of American Artists of the Colonial and Federal Period by Thomas Sully (Reinhold Publishing Corporation)

Vasari on Technique by Giorgio Vasari (Dover Publications)

Vasari's Lives of the Artists by Giorgio Vasari (Dover Publications)

Also Recommended

Any of the numerous drawing books by George B. Bridgman. The following are just a few of them:

The Book of a Hundred Hands (Dover Publications)
Bridgman's Complete Guide to Drawing from Life: Over 1,000 Illustrations (Sterling)
Bridgman's Life Drawing (Dover Publications)
Heads, Features and Faces (Dover Publications)

INDEX